Art and its Publics
Museum Studies at the Millennium

Edited by Andrew McClellan

Blackwell
Publishing

350 Main Street, Malden, MA 02148–5018, USA
108 Cowley Road, Oxford OX4 1JF, UK
550 Swanston Street, Carlton South, Melbourne, Victoria 3053, Australia
Kurfürstendamm 57, 10707 Berlin, Germany

First published 2003 by Blackwell Publishing Ltd

Library of Congress Cataloging-in-Publication Data

McClellan, Andrew.
 Art and its publics: museum studies at the millennium / Andrew
McClellan.
 p. cm. – (New interventions in art history; 2)
Includes bibliographical references and index.
 ISBN 0–631–23046–7 (hardcover : alk. paper) – ISBN 0–631–23047–5
(pbk. : alk. paper)
1. Art museum attendance. 2. Art museums – Management. I. Title.
II. Series.
 N435.M38 2003
 708 – dc21

 2002007858

A catalogue record for this title is available from the British Library.

Set in 10.5/13 pt Minion
by Kolam Information Services Pvt. Ltd, Pondicherry, India
Printed and bound in the United Kingdom
by T. J. International, Padstow, Cornwall

For further information on
Blackwell Publishing, visit our website:
http://www.blackwellpublishing.com

Contents

Illustrations

Contributors

Andrew McClellan
Associate Professor of Art History at Tufts University.
Stephen Bann
Professor of History of Art at Bristol University.
Christa Clarke
Curator of African Art at the Neuberger Museum of Art, Purchase College, State University of New York.
Ivan Gaskell
Margaret S. Winthrop Curator at the Fogg Art Museum, Harvard University.
Anne Higonnet
Associate Professor of Art History at Wellesley College.
Nick Prior
Lecturer in Sociology at the University of Edinburgh.
Danielle Rice
Associate Director of Program at the Philadelphia Museum of Art.
Harriet F. Senie
Director of Museum Studies and Professor of Art History at the City College and Graduate Center, City University of New York.
Alan Wallach
Ralph H. Wark Professor of Art & Art History and Professor of American Studies at the College of William and Mary.

Series Editor's Preface

New Interventions in Art History was established to provide a forum for innovative approaches to and perspectives on the study of Art History in all its complexities. Here, the crucial interface between the art object and the viewer comes under scrutiny in a set of original essays by a group of distinguished writers. Museums and galleries are where the great majority of people today experience art and this point of encounter between the art object and the viewer is explored through a consideration of strategies of display, and the ways in which museums engage their publics. The essays in this volume present a cross-section of current issues with contributions from both sides of the Atlantic, and from museum professionals as well as academics. This rich mix of voices and viewpoints presents a new kind of analysis of the relationship between art and its publics. As a result the reader is at once encouraged to take stock of present practices and their consequences for the viewing public, and to review this exciting period of change, expansion, and shifting expectations in the concept and remit of the public museum.

Museums have come to define art for the general public, typified here in the blockbuster exhibition and the promotion of objects formerly excluded from the canon of high art. Yet these opportunities for museums to fulfill their role as public institutions has also drawn criticism from the establishment, which sees it as mere commercialization. Moreover, the cause of public outreach has recently produced a good deal of experimentation in the display of art, revealing enduring tensions between aesthetic and narrative models of exhibition. These concerns are germane to the diverse range of case studies discussed in this volume. The essays provide a

rigorous interrogation of the art museum and it is hoped this book will be a prompt for future research and debate that will take museum studies in new directions. As such *Art and its Publics* is very welcome as one of the first volumes to appear in this series.

Dana Arnold
London, August 2002

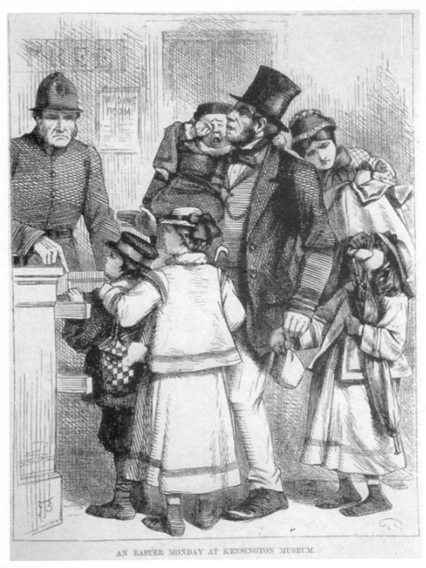

AN EASTER MONDAY AT KENSINGTON MUSEUM.

Plate 1 Jack Robinson and his family visit the South Kensington Museum under the watchful eye of a warder. *Leisure Hour*, April 1, 1870.

Introduction

This collection of essays takes as its premise that museums are where the great majority of people in the West today encounter art. This statement hinges not just on patterns of leisure and tourism among the expanding educated classes, reflected in remarkable increases in museum attendance in recent decades, but also on semantics. Since their inception two centuries ago, museums have been vested with ever greater responsibility to define what qualifies as art. Art is what is shown in museums. Art may also exist outside of museums, of course, but its status as such may be questioned in a way it never is inside a museum, especially where abstract or conceptual works are concerned. At the same time and in direct proportion, a viewer's confidence in passing aesthetic judgments decreases beyond a museum's walls. The public's confidence in such matters is never great, but museums exist to provide essential guidance and reassurance and, by and large, the public is content to follow the lead of professional curators and educators.

These tensions are the subtext of Harriet Senie's contribution to this volume, the one essay that examines art in a non-museum setting. Among her findings are that consumers of public art in urban settings are prepared to respond aesthetically but often need prompting to do so; an aesthetic response is neither automatic nor instinctive. Precisely because public art may double as bulletin board, bench, or even urinal, many don't see it as art. Yet this may also be seen as a blessing denied to museum objects. Freed from the protocols of the museum, the public enjoys a much more varied and imaginative interaction with public art. Unlike museum art, which is deliberately separated from quotidian concerns and subjected to art world narratives, art on the street, as Senie puts it, is

"adopted and adapted... to fit the parameters of everyday life." Outside the museum, "do not touch" signs are nonexistent and objects become fully interactive, even useful. The contrast is made vivid in Senie's tale about Tony Smith's *Tau*, jostled and pasted with fliers in its urban college setting, but restored for the Smith retrospective at the Museum of Modern Art in 1998 as if exhibition goers would seek it out and carry with them museological expectations. Imagine if the sculpture had been moved to MOMA with fliers and scuff marks still in place? And of course the public on the street is more colorful and diverse than it is in a museum. For better and worse, public art objects lead a more active life – a life of greater risk (of invisibility, disdain, and vandalism) but also of more varied engagement by a larger cross-section of people.

The museum's power to define whatever is displayed within its walls has animated much artistic debate and production in the past century. Marcel Duchamp's "readymades" tested the boundaries between the spaces of art and the everyday world, shocking the bourgeoisie and providing inspiration for subsequent generations of the avant-garde. The aesthetic potential as well as the shock value of such art requires an institutional setting to be realized; a bottle rack outside a museum or gallery remains just that. More recently, an installation of debris left over from a party mounted in a London gallery by Damien Hirst was swept away by a cleaner evidently oblivious to the artistic value of the "work."[1] Hirst thought the incident hilarious, but what if it turned out that the cleaner's act was no accident? If deliberate would it still be funny (a witty piece of performance art, perhaps) or an act of vandalism? In any event, such a "mistake" is unlikely to happen again if and when the "piece" finds a home in a museum and is put before the public as art. Artists have sought in various ways to subvert the consuming power of the "white cube," crafting their own spaces to become installations or removing their work to outdoor sites far away from the art world. Yet the museum is not so easily defied, for installations, like found objects, often require the legitimating recognition provided by acknowledged spaces of art, while site-specific works filter back into the commodified art world in the form of project drawings and photographs bought and sold by collectors. Some distant sites become sufficiently canonical to merit protective measures worthy of a museum, as is the case with Robert Smithson's *Spiral Jetty* (1970), recently "acquired" by the Dia Center for the Arts in New York.

It will be objected that this definition of art and its publics leaves aside and further marginalizes many community based art projects, murals,

ephemeral festive decorations and performances, crafts, and the like, together with those who pursue them. This is certainly true, and in this respect academia and museums are equally guilty of a high art bias. The turn to theory in academic art history, for all its questioning of museums and the "old" art history, has done precious little to expand the canon in such directions and remains largely fixated on the same Old Masters. It would be nice to think that a second collection of essays encompassing a different set of institutions and art forms would help many of us who teach and display art to broaden our horizons. Nevertheless it is worth reckoning with the power of modern museum culture to enforce distinctions between "high" and "low" art forms and their publics. The privileging of the "fine arts" over craft and decoration preceded the creation of museums and was born centuries ago of the struggle of painters and sculptors to gain respect as practitioners of a liberal art requiring imagination and education as well as manual training and dexterity, but once created museums unequivocally bolstered the divide.

Amongst the most significant developments of recent years is postmodernism's weakening of the high/low divide within museums, the subject of essays by Nick Prior and Alan Wallach. Fuelled in part by Pop Art's strategic confusion of high art, popular culture and consumer goods, but also by the marketing strategies of our media-saturated "buzz" culture, the aesthetic autonomy of serious painting and sculpture central to Modernism's hegemony has been compromised to the point that Frank Lloyd Wright's Guggenheim Museum, that high temple of Modernist spirit, now plays host to blockbuster exhibitions of Armani fashion, motorcycles, and Norman Rockwell. But tempting though it has been for postmodern theorists and conservative critics to see in such exhibitions the death knell of high art, and with it the opening of the museum to wider definitions of art and broader publics, Prior and Wallach both suggest that the demise of the art museum and its predominantly bourgeois public have been exaggerated. Furthermore the notion that the merger of art and sensational tabloid culture witnessed in the work of Hirst and fellow postmoderns signals the irrelevance of museums, for now aesthetic experience is everywhere and we live in the museum without walls, is countered by the dependence of those artists on the institutional setting and the expectations of its public for effect. Just when the public thought it was safe to enter a museum to escape the sordid reality of the mundane world, contemporary artists re-present that world and ask us to give it the same attention we do serious art. Seen in this light,

postmodernism is but a continuation of the avant-garde desire to *épater le bourgeois.*

The spectacular nature of much contemporary art, however, is also part of what Stephen Bann describes as a return to curiosity, a revalorization of an earlier museum paradigm suppressed by high-minded Enlightenment ambitions. Though forced underground, curiosity and "wonder" never went away and with the erosion of the high/low, art/entertainment divide, it is resurfacing in museums and spaces of high art. Curiosity is what surely motivated some 7,000 people to attend a recent opening of a Damien Hirst show at Gagosian Gallery in New York that featured a "20-foot tall anatomical figure, gynecological examination rooms submerged in tanks filled with live fish, and vitrines filled with everything from pills (8,000 of them) to dogs' skeletons."[2] Such numbers made the opening a media event, which is precisely what worries guardians of the mainstream art museum. A similar form of curiosity also animates what Anne Higonnet in her essay terms "house museums," whose idiosyncratic rejection of public museum conventions at once recalls earlier curiosity cabinets and anticipates postmodern display strategies. The irreducible personality of the owner, inscribed in the choice and installation of objects, appeals to our yearning for affect in an increasingly homogenous culture.

Beyond the contested realm of temporary exhibitions, the deconstructive impulses of postmodernism have also penetrated permanent museum displays with far-reaching implications for museum practice and public reception. For if we accept the central claim of mission statements that the function of public museums is education through the presentation of its collections, then nothing is more central to the task than the installation and interpretation of those collections. Scholarly publications and educational programming play a vital part, but they reach only a limited number of people compared to those who visit museums and pass before objects unaccompanied by docents, catalogues, or audio guides. Installation is where the dual responsibilities to collections and the public intersect. The study of exhibition strategies, therefore, is central to an understanding of the museum's engagement with its visitors. Moreover, because the precise nature of the relationship between museum and publics is difficult to assess qualitatively – demographic visitor surveys of the who, what, where, when variety leave largely unanswered what people think, feel, and learn in front of art – we are on surer ground if we consider what it is a museum aims to deliver through its installation

strategies and programs. The essays by Ivan Gaskell, Christa Clarke, and Danielle Rice point to ways in which the display and reception of art has been complicated in interesting ways in response to postmodern sensitivity to questions of identity, authority, and the potential for alternative forms of legibility within museum spaces.

At issue are the criteria for the public display of art, criteria that had gone unquestioned and substantially unchanged in western museums for most of their history. By definition, public museums of art (but also natural history, science, etc.) have consistently manifested the rationality, integrity, and public dedication of their sponsors (the state or local civic authorities) through a systematic ordering of their contents. A rational, seemingly neutral classification and display of art yielding knowledge has long been viewed as the guarantee of the museum's commitment to the public good. In the modern era, the rational classification of art has entailed the separation of art types and media, high from low, western from non-western, and organization by nationality, or "school," and historical period. Disembodied and abstract, seemingly natural and imposed from on high, these norms of classification distinguish the public museum from private collections past and present, including house museums such as the Isabella Stewart Gardner Museum, discussed by Higonnet. Lately, however, we have come to recognize what has long gone unseen, namely that public museums are also the product of individual choices and curatorial vision, and we now find curators acknowledging authorship of installations (in the form of signed wall labels) and museums experimenting with alternative, in some cases pre-modern ordering systems. Ironically, private collections like Gardner's, once the embodiment of everything rejected by the large survey museum, have become a model of sorts for progressive installations. Beginning in the 1980s, numerous museums have experimented with so-called "Salon" style hanging of paintings, thematic arrangements that disobey normal sequences of school and period, and new contextual approaches to non-western and religious art. The case studies discussed by Gaskell and Clarke examine just a few of the challenges and opportunities offered by the expanded field of display in the postmodern museum. Though viewed by some as a sure sign of institutional crisis, new approaches to display have certainly stimulated fresh ways of viewing familiar objects and, arguably, attracted new publics.

The complexity of everyday practice and multiple audiences in our shifting postmodern era is too easily underestimated by museum outsiders

according to Danielle Rice and Nick Prior. The monolithic museum posited by many critics, on both the left and the right, oversimplifies what museums do and overlooks their flexibility as institutions. More than ever, museums may be many things to many people and no one theory or discipline can do them justice. The rhetoric of transcendence dear to the right and assailed by the left obscures the fact that museums are always, to a greater or lesser extent, in flux. We are currently living through a period of great experimentation, the long-term implications of which are unclear. It is at very least an exciting time to visit, study, and work in museums. And while we can't be sure of what the future will hold, the odds are the museum will survive.

Notes

1 *New York Times*, October, 20, 2001.
2 Quoted by James Cuno, "Against the Discursive Museum," in Peter Noever, ed., *The Discursive Museum* (Vienna: Hatje Cantz, 2001), p. 48.

PUBLISHED MONTHLY PRICE TEN CENTS

BULLETIN OF
THE METROPOLITAN MUSEUM
OF ART

VOLUME V NEW YORK, SEPTEMBER, 1910 NUMBER 9

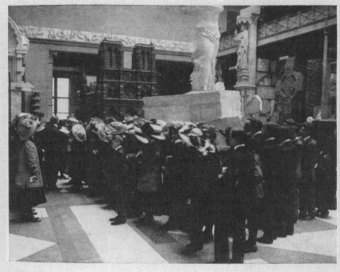

A CLASS

EXPERT GUIDANCE TO THE MUSEUM

As the BULLETIN is constantly filled with illustrations and descriptions of new accessions, readers may easily reach the conclusion that the present chief activity of the Museum is mere acquisition. Important as is the acquisition of objects of art, it is only one of the educational functions of our Museum. Interpretation of these objects of art is another. Some visitors are qualified to be their own interpreters; most visitors are not. Even those who are, suffer loss of time in finding what they most wish to see, or, perhaps, fail to find it altogether.

The rapid increase in our collections and the frequent rearrangement inherent to our healthy growth prevents any catalogue from being a perfect guide, even for a short time after publication. Our catalogues may be out of date before they have left the press. Even the old habitué of the Louvre or the Uffizi may now need help to discover what he once was sure to find in the Salon Carré or in the Tribuna.

Plate 2 A docent tour at the Metropolitan Museum of Art, New York, c. 1910. *Bulletin of the Metropolitan Museum of Art*, September 1910.

1

A Brief History of the Art Museum Public

Andrew McClellan

Writing some two hundred and fifty years ago, at the dawn of the modern museum age, the painter Charles-Antoine Coypel objected to the use of the singular "public" to describe the crowds who flocked to the exhibitions of contemporary art in Paris held at the Louvre:

> In the Salon where the paintings are displayed, the public changes twenty times a day.... This place can offer twenty publics of different tone and character in the course of single day: a simple public at certain times, a prejudiced public, a flighty public, an envious public, a public slavish to fashion....A final accounting of these publics would lead to infinity.[1]

Coypel recognized what we know so well today: there is no one public for art; the public for art is diverse and divided by interests and levels of knowledge, confidence and class, not to mention race, ethnicity, and gender. Yet this diversity stands in marked contrast to the fictive oneness of the public posited by mission statements issuing from museums themselves. Guided by ideals of public service and democratic access, museums tend to look past issues of difference towards an ultimate goal of art for all, of peoples joined together by a shared past and a common love for art.

The utopian optimism underpinning museum rhetoric should be taken seriously as an endorsement of a profound belief in the transcendent, life-enhancing potential of art, a belief that has grown in stature since its inception in the Romantic era and takes on added resonance in the wake of upheavals such as world wars, social protest, and, most recently, 9/11.

However, a closer look at mission statements reveals tensions within art museums that compromise their ability to fully extend themselves to the public, and any discussion of the museum's publics must reckon with the implications of these tensions. First, public access is always paired with a commitment to preserve objects for posterity, and if obliged to compete with each another owing to the fragility and uniqueness of the object, preservation will always win out. In a sense, then, museums serve a notional future public as much as real visitors in the present. Moreover, to the extent that curators are trained and hired to care for their collections (and the word "curator" comes from *curare*, to care), they are drawn away from public service. Care for the public is left largely to educators and volunteers who occupy a lower place in the museum hierarchy. Present in all public collections, these tendencies are especially pronounced in art museums where the objects collected are rare and valuable.

Second, despite declarations of public obligation, museums are often beholden to private interests and make little attempt to hide their descent from private collections. Indeed, art museums have long celebrated their emergence from the realm of princes by opening in royal palaces (or purpose-built imitations of them) and gratefully acknowledging gifts from private donors. Try as they might to evolve towards an ideal of full integration with the public sphere, continued dependence on private patronage for financial support and gifts of art, and the need to reward those gifts with wall plaques and special events, compels museums to live in the shadow of their aristocratic past. As one hand invites the public to partake of its treasures, the other hand courts collectors and sponsors with a deference fit for the great Mæcenas of old. For some the lingering aura of privilege is intimidating, but for just as many it is part of the allure. Like it or not, there can be no denying that without the support of private benefactors there would be no public art museums. It may be argued that the tension between public and private is a peculiarly American phenomenon absent in state-sponsored museums on the European model, but hierarchies necessarily exist there too and will only become more prominent as costs rise, government subsidies decline, and the American self-supporting model gains ground. My own experience working with underprivileged school children at a public museum in London some decades ago taught me that free admission and liberal programming still competes with an aura of exclusivity inscribed in the museum's walls. At the conclusion of their tour, I was expected to ask

the children to whom the paintings belonged. The "right" aCXnswer was, of course, to them, the public, but a more common and common-sensical response was "the Queen," for who else could have built such a magnificent palace and own such heavily guarded treasures? To realize that the visit was not only their first to an art museum but in some cases their first to the West End of London is to glimpse the larger obstacles to the creation of a common heritage centered on our institutions of high culture. Nevertheless, the idealism also built into the fabric of our museums will ensure that they will not cease in their effort to reach all those children.

The Age of Enlightenment

The emergence of art as a collectible commodity coincided with the great age of Renaissance patronage and the creation of an aesthetic discourse that favored form, pictorial conceit, and authorship over function.[2] As princes and kings turned to art to affirm wealth and power, artists saw their own status rise and moved to define their craft as a liberal art worthy of comparison to poetry and philosophy. From the bosom of newly created art academies developed a theory and history of art that articulated criteria for the proper evaluation of painting and sculpture. Emulation of princely example caused art collecting and appreciation to spread into polite society and become the mark of the gentleman. While not all aristocrats and wealthy bourgeois actively collected art, familiarity with the antique and the Old Masters conferred social distinction and indicated fitness to rule.[3] For his part, the painter Coypel had no doubt that he painted for the "enlightened and delicate public."[4] By the eighteenth century an international network of critics and dealers, artists and collectors formed the infrastructure of an elite art world bound together by social contacts and shared discourse. Admission to the art world required appropriate social standing but also a mastery of critical terms and history. André Félibien, Roger de Piles, and others wrote popular texts in which fictional characters modeled connoisseurial dialogue for would-be art lovers, who in turn brought those texts to life in private collections across Europe. Though access to such collections was limited to recognized *amateurs*, much art could still be seen in churches and public spaces, but no matter where the art was displayed the "public for art" effectively included only those who were capable of critically informed, aesthetically

disinterested judgment. Conversely those who responded to works of art with inappropriate emotion, who attended to the signified more than the sign, regardless of its setting were marked as ignorant.

Increases in wealth and education in the eighteenth century produced a concomitant expansion of the public for art, as reflected in the growth of the art market and the advent of public exhibitions and museums. Public sales and auctions became an early venue for an art hungry public, and dealers used new marketing strategies – shop windows, newspaper ads, and sales catalogues – to seduce the newly moneyed classes into the pleasures and social advantages of collecting.[5] Engraving greatly extended the reach of high art and the collecting of drawings became fashionable, but ownership of painting and sculpture required deep pockets. Speaking on behalf of those without collections of their own, critics demanded greater public access to art, and from mid-century their calls were answered. Academies sponsored regular exhibitions of their members' work, the best known being the so-called *Salon* in Paris (from 1737) and the Royal Academy exhibitions in London (1768). On one level temporary exhibitions promoted artists' careers by introducing their work to potential patrons, but they also proved enormously popular with the public at large, attracting a diverse crowd that numbered in the thousands. Overnight the public for art expanded beyond established amateurs and the cozy confines of collector's cabinet and in the process became fragmented and difficult to define, as Coypel tells us. Self-styled critics stepped forward to guide this large and uncertain public. Private entrepreneurs seized on the public's enthusiasm and created commercial venues, such as Sir Ashton Lever's Museum in London (1773) or the Colisée in Paris (1776), offering potent mixtures of art, curiosities, and popular entertainment. Then as now, the blurring of boundaries between high and low culture jeopardized the integrity of the fine arts and provoked disdain from the establishment, though the general public seemed not to care greatly about such distinctions.

For our purposes the most significant innovation in eighteenth-century Europe was the gradual opening of royal and princely collections to an increasingly broad cross-section of the public. Just as commercial entrepreneurs capitalized on public hunger for entertainment, so governments recognized the propaganda value accruing from making dynastic art collections accessible. In the middle decades of the century, private and princely collections in Paris, Rome, Florence, London, Stockholm, Vienna, Dresden, Dusseldorf, Kassel, and elsewhere, opened to the public with

varying degrees of liberality.[6] Accessible and well-ordered collections, indicative in themselves of a ruler's taste and enlightenment, seemed all the more so when offered to his people as a means of public instruction. Patronage of museums and related institutions for the public good replaced ceremonial pomp and grandiose monuments as the Age of Absolutism gave way to the Age of Enlightenment. Responsibility for the collections was entrusted to the same class of advisors and dealers that had helped form them, giving rise to the prototype of the modern museum curator. Once opened to the public, royal collections came to be seen as national patrimony, stewardship of which became a measure of good government. These fundamental transitions, part and parcel of the evolution towards modern nationalism, occurred at different rates in different countries, but the crucial moment was undoubtedly the French Revolution and the creation of the Louvre as the paradigmatic public art museum.

Founded in 1793 at the height of the Revolution, the Louvre was the embodiment of liberty, equality, and fraternity.[7] The museum was housed in a royal palace turned palace of the people; its collection of paintings, sculptures, and drawings was the confiscated and nationalized property of Church, Crown, and exiled aristocrats. Admission was free to all and shared enjoyment of the nation's new found artistic heritage aimed to cement the bonds of equality and citizenship. But Revolutionary rhetoric notwithstanding, the stratified publics of the *ancien régime* could not so easily be made one. "The lowest classes of the community" did come to the Louvre in significant numbers, as foreign visitors were quick to note, but their physical appearance and inability to respond appropriately to the high art on view made them conspicuous.[8] Even Republican journals told jokes at their expense, inaugurating a long tradition of satirizing the uninitiated, and revealing the true bourgeois underpinnings of the museum (and the Revolution itself).[9] At odds with the symbolic role of the Louvre as embodiment of a regenerated, egalitarian society was its value as showcase of Republican culture. To counter the impression of an anarchic society governed by mob rule, summary justice, and contempt for tradition, the Louvre presented itself as the supreme manifestation of aesthetic ideals shared by all civilized Europeans. At least as important as the local public, therefore, were educated foreign tourists who would take away with them a lasting image of canonical masterpieces preserved and displayed according the highest standards. To ensure that they did, a number of days each week were set aside for their exclusive

enjoyment. Tourists flocked to the Louvre, as they have done ever since. However, the seasoned travelers among them understood that the museum had altered the way in which people engaged with works of art: the adventure of the Grand Tour and pleasures of private viewing had been displaced by something new and *public*. John Scott remarked that the combined glories of the new museum shone "with a lustre that obscures every thing but itself. In it are amassed the choicest treasures of art, that have been taken from their native and natural seats, to excite the wonder of the crowds instead of the sensibility of the few."[10] For others, such as the party traveling with John Dean Paul, future banker, knight, and author of *The ABC of Fox Hunting*, the Louvre was little more than a novel spectacle and rendezvous for the exchange of society gossip.[11] Balancing the needs of the poor and the elite, the art lover and tourist, democracy and diplomacy, remains a central challenge for art museums and the source of ongoing tension among its publics. It speaks volumes that on July 14, 1989, two hundredth anniversary of the fall of the Bastille, the Louvre was closed to the general public in order to host a special event for visiting dignitaries.

One further public conscientiously served by the Revolutionary Louvre was practicing artists, who, together with tourists, were given privileged access to the museum for the purpose of copying the Old Masters. The study and selective imitation of past art had been a cornerstone of artistic theory and training for two hundred years and this practice was institutionalized at the Louvre and other museums. Art schools were often associated with and built near art museums well into the twentieth century. But over the past century the decline of copying, the accelerated pace of avant-garde movements, and the reluctance of most museums to invest in contemporary art have together reduced the profile of living artists among the museum's publics.

In the aftermath of Napoleon's defeat at Waterloo and the repatriation of his war booty, new museums and galleries modeled on the Louvre sprung up all over Europe. The combined political benefits of a public, state-sponsored art museum proved irresistible to the governments of the emerging democratic nation states of the nineteenth century. By the end of the century every capital and virtually every major city in Europe boasted a public art museum of its own. And in every case those museums featured an at times uneasy blend of democratic ideals and elite aesthetic values.

Victorian Ideals

With the gradual integration of museums into the cultural apparatus of the modern state, the question of the public became not so much who was admitted, for in time virtually all were welcome, but how museums could be called upon to shape the public in keeping with perceived political and social needs. In what ways could museum going benefit the public, and thus the nation as a whole? During the Victorian era and beyond, the museum public was commonly represented as an idealized projection of what liberal politicians and social critics hoped it would become. The rhetoric of aspiration informed official discourse and mission statements and tells us more about what a museum aimed to do for its visitors than what it actually did. Throughout the nineteenth century, utility and progress, instruction and innocent recreation, were the watchwords for all public institutions, including art museums. As Gustav Waagen, director of the Berlin Museum, put it in a testimonial to the British Parliament in 1853:

> As [a] Gallery is erected at the Nation's expense, it must of course be rendered as generally useful as possible, every one being admitted capable of deriving from it enjoyment or instruction.[12]

For Waagen, everyone did not include those "whose dress is so dirty as to create a smell obnoxious to the other visitors" or babes in arms escorted by their wet nurses. In his opinion, both groups were too plentiful at London's National Gallery, obliging him "more than once . . . to leave the building." Waagen's opinions carried great weight owing to his preeminent status as an art expert and his experience at the helm of the much admired Berlin museum, yet in London, rather than dismiss the indigent and the young, it was precisely for their benefit that new initiatives in museum policy were developed.[13] The esteem of international connoisseurs continued to matter, but pressing social needs made the Victorian museum above all an engine of social and economic progress and national cohesion.

Museum policy in Victorian Britain was driven by the unprecedented challenges arising from the Industrial Revolution. An explosion of urban populations teetering on the edge of poverty, immorality, and anarchy prompted the need for new social controls and systematic education. The

desire to control and civilize the masses was all the more pressing as successive political reforms gave voting rights to larger segments of society. Together with state schools and libraries, it was hoped that museums would contribute to the moral and intellectual refinement of "all classes of the community" and the formation of "common principles of taste," to quote from a Parliamentary report of 1853.[14] For Matthew Arnold, writing in 1869, a common culture disseminated through educational institutions should take the place of organized religion as the necessary adhesive for the new society in the making.[15] Like Arnold, John Ruskin spoke for many of his time when he advocated the role of museums in educating and controlling "the laboring multitude" by offering an "example of perfect order and perfect elegance...to the disorderly and rude populace."[16] Both men believed in the top-down imposition of what we would today call canonical values as the means of lifting all people up to a more enlightened level of existence. The embrace of "the raw and unkindled masses of humanity" in the "sweetness and light" of high culture, to quote Arnold, was a preferable solution to "the present difficulties" than the radical alternative put forward by Karl Marx. Socially conscious museums, supported by the state and the rich, would do their share to avoid anarchy and promote the gradual assimilation of the working classes into the bourgeoisie. The hero of Walter Besant's novel *All Sorts and Conditions of Men* (1883) took the belief in the softening effect of culture to the point of caricature when he insisted that the arts could tame "the reddest of red hot heads":

> He shall learn to waltz....This will convert him from a fierce Republican to a merely enthusiastic Radical. Then he shall learn to sing in part: this will drop him down into advanced liberalism. And if you can persuade him to...engage in some Art, say painting, he will become, quite naturally, a mere conservative.[17]

London's National Gallery went beyond the museums of Paris and Berlin by actively encouraging visits by the laboring classes. More than the symbolic benefits of citizenship, working class visitors would now enjoy escape from what Charles Kingsley called "the grim city-world of stone and iron, smoky chimneys, and roaring wheels"[18] into the pure and uplifting realm of great art. Despite Waagen's concerns that the smoky chimneys and noxious breath of the poor threatened the nation's pictures, the gallery remained in central London within reach of the grim city-

world of stone and iron. A survey of area businesses discovered that the gallery was indeed a popular venue among neighboring tradesmen and workers. Visits were organized by the Working Men's Club and Institute, and the *Pall Mall Gazette* published a guide aimed at laborers that went through many editions from the 1880s.[19]

For those with firsthand experience of conditions in London's East End, however, Trafalgar Square was too remote to make a difference, and rather than oblige the poor to travel to the West End the founders of the Whitechapel Gallery, the Reverend Samuel Barnett and his wife, Henrietta, brought high art to the poor. Starting in the early 1880s, the Barnetts organized an annual exhibition of paintings borrowed from artists and collectors that aimed to stimulate moral sentiments, patriotism, and a feeling for beauty among the residents of the East End slums and settlements houses. As the Vicar of St. Jude's, Whitechapel, Barnett spoke with authority when he said that "pictures in the present day take the place of [biblical] parables."[20] By his reckoning 95 percent of the local population did not attend church; organized religion had lost its moral force where it was most needed.[21] Open every day, including Sundays, for two to three weeks around Easter, the exhibitions proved enormously successful. In its first year, 1881, the exhibition drew 10,000 visitors; a decade later attendance had risen to 73,000. In 1898, the temporary exhibitions became the basis of a permanent gallery (the present Whitechapel Gallery) erected alongside the public library. For her part, Henrietta Barnett was an important advocate of philanthropy and among the first to suggest that women had a special role to play in outreach efforts in museums and galleries. "Why should the poor spend their hardly earned pence in taking the journey to see treasures the beauty of which they do not half understand, having never been educated to see and appreciate them?" she asked. If women devoted themselves to bringing "beauty home to the lives of the poor," through the loan of pictures or by taking "groups of her poor friends to see galleries or exhibitions," "they would find a field of work but yet little trodden, a wealth of flower-rewards only waiting to be plucked."[22] Women would soon follow her example by becoming the mainstay of education departments and volunteer programs in twentieth-century museums.

Alongside these efforts to popularize high art, an equally powerful variation on the museum theme took shape in the form of the South Kensington Museum (later Victoria & Albert Museum), founded in the West End of London in 1857.[23] While public museums and libraries of all

sorts contributed to the moral and intellectual refinement of the people, the special needs of modern industry could be met with a new brand of museum devoted to applied arts and crafts. Where traditional art museums supported the training of painters and sculptors, the applied arts museum targeted the makers and consumers of new manufactured goods with a view to raising standards of domestic taste and stimulating the nation's economy. The museum was the brainchild of Henry Cole and built on the popular success and implicit challenges to native industry of the Great Exhibition of 1851, staged in the Crystal Palace in nearby Hyde Park. The exhibition's success suggested the great social and economic benefits that could follow from a permanent display along the same lines, while demonstrating as well that "the largest masses of people may recreate themselves, even in the neighbourhood of London, with propriety and freedom from moral harm."[24]

To be of maximum utility to manufacturers, objects were arranged by type: metalwork, pottery, textiles, and so on. They were chosen from around the world based on criteria of good taste and design, rather than rarity, authenticity, or monetary value. Where originals could not be had, copies sufficed. Promotion of everyday aesthetics and the conscious rejection of the art connoisseur's priorities contributed to making the South Kensington Museum the most popular museum in Britain. Annual attendance rose from 456,000 in 1857 to over a million in 1870. The combination of free admission, evening hours, and a popular holiday could boost single day attendance above 20,000.

Though the main impetus for South Kensington was economic, Cole shared the view that museums would improve public mores by providing a wholesome recreational alternative to procreation and the pub. "Let the working man get his refreshment there in company with his wife and children" he told an audience in Liverpool in 1875; "don't leave him to find his recreation in bed first, and in the public house afterwards."[25] Cole took his message on the road following the success of South Kensington, for it was his hope that "every centre of 10,000 people will have its museum" and that thereby "the taste of England will revive [among] all classes of the people."[26] Just as medieval England once "had its churches far and wide," so the modern world would have its engines of social reform in the form of museums.[27] Surveying Britain in the late 1880s, Thomas Greenwood found that Cole's example had taken root. Greenwood's book, *Museums and Art Galleries* (1888), among the first texts devoted to the subject, documents the extraordinary spread of museum culture brought

about by the collaboration of civic effort and philanthropic largesse. New museums in cities across the industrial heartland, in Sheffield, Preston, Liverpool, Manchester, and Birmingham, gave particular cause for optimism. Like the men he found running those institutions, Greenwood was inspired by the ideas of Cole, Ruskin, and Arnold to believe that museums would foster in the public, including the working classes, or at least the "most intelligent" of them, a "craving" for knowledge, "a reverential sense of the extent of knowledge possessed by his fellow man," "the duties and privileges of citizenship," and a pride in the nation.[28] Though Greenwood believed the state should support museums, as it did schools, the police and the maintenance of public roads, he celebrated the generosity of local businessmen, describing gifts to, and of, museums as "twice blessed,"[29] blessing him that gives and the public that continues to receive long after the donor's death.

As we might expect given the capitalist underpinnings and trickle-down aesthetics of the Victorian museum, the ideal public consisted of those most eager to help themselves. Virtually everyone who spoke on the subject agreed with Ruskin when he said that museums, while instructive for the multitude, must not be "encumbered by the idle, or disgraced by the disreputable." He wrote to a correspondent in Leicester:

> obstruct The movement of

> You must not make your Museum a refuge against the rain or ennui, nor let into perfectly well-furnished, and ... palatial rooms, the utterly squalid and ill-bred portion of the people. There should indeed be refuges for the poor from rain and cold, and decent rooms accessible to indecent persons ... but neither of these charities should be part of the function of a Civic Museum.[30]

The setting for Ruskin's own model museum at Walkley was carefully chosen. Located on the outskirts of Sheffield, "only two miles away from the black heart of the grimy kingdom of industry ... the flames and smoke and sordid ugliness of Steelopolis," as one journalist put it, it offered workers a refreshing and useful respite from daily toil.[31] While many other industrial cities were well qualified for his experiment in cultural uplift, Ruskin chose south Yorkshire because he believed its people were possessed above others of the old English virtues of honesty and piety and thus especially likely to want to improve themselves.[32] To discourage the idle, only those who were prepared to walk two miles uphill to reach the museum on their day off reaped its rewards.

imitating

Excluding the squalid and ill-bred was as much for the benefit of the aspiring laborer as for the comfort of the privileged, for, as Tony Bennett has argued, the Victorian museum was a "space of emulation" where watching others and being seen was as important as scrutinizing the art. To the extent that museums functioned as an instrument "for the self-display of bourgeois-democratic" values, they had to ensure an environment in which appropriate civil behavior was encouraged and its opposite forbidden.[33] For Arnold, the purpose of culture was "to do away with classes; to make all live in an atmosphere of sweetness and light," which in effect entailed the eventual "embourgeoisiement" of society.[34] To achieve societal progress, "all our fellow-men, in the East End of London and elsewhere, we must take along with us in the progress towards perfection"[35] and this could best be achieved by helping those who most wanted to help themselves. "The best man is he who most tries to perfect himself, and the happiest man is he who most feels that he *is* perfecting himself," said Arnold.[36] It is essential to note that, for Arnold, the spread of culture would address not only the brute ignorance of the working classes but also the shallow materialism of the expanding middle classes. The problem was particularly acute in Protestant countries where industrial progress had been greatest and the "temptation to get quickly rich and to cut a figure in the world" had become a corrosive force. Material wealth was not an end in itself to be pursued for individual satisfaction but the means to lift all towards an "ideal of human perfection and happiness."[37] The beauty of philanthropy was, and remains, that it allowed those who supported museums to prove that they themselves were not philistines even as they discharged their civic duty by lifting those around them towards the light.

The Victorian museum rode the tide of progress and optimism but problems were there for those who looked closely enough. By the last quarter of the nineteenth century, if not sooner, many believed that the South Kensington model had failed to inspire better industrial design, much less alleviate the demeaning nature of mechanized labor. Few industries encouraged their designers to study at the museum, while its West End location deterred visits from the artisan class it was designed to serve; Thomas Greenwood observed that South Kensington was mostly patronized by the well-to-do residents of the borough.[38] Others faulted the logic of the South Kensington system by arguing that examples of past design could not inspire, and could even deaden future innovation; the painter Hubert von Herkomer declared "William Morris had done more in a few years to promote true decorative art than had been done by South

Kensington during the whole of its existence"[39] By century's end the South Kensington Museum, renamed the Victoria & Albert Museum in 1899, focused increasingly on collecting fine objects and serving a curious, antiquarian public, as it has done ever since.

With respect to the art museum's contribution to a society joined as one by a common culture, the challenge was, as Arnold recognized, making art a means of unification rather than "an engine of social and class distinction, separating its holder, like a badge or title, from other people who have not got it," as it had been in the past. [40] Yet in a society still dominated by class, in which art and cultural knowledge continued to circulate as an elite commodity and museums depended on the rich for support, it was at best highly idealistic to expect art to cease to function as a badge of privilege. Indeed a society that encouraged self-improvement needed tangible criteria to measure effort, and museum-going and demonstrable assimilation of culture was clearly one. The goal of museum advocates was to produce a society in which a working-class family outing to a museum on a Sunday afternoon or perhaps of an evening became a natural activity. Here is how Henry Cole envisaged the benefits of evening hours at South Kensington:

> The working man comes to this Museum from his one or two dimly lighted cheerless rooms, in his fustian jacket, with his shirt collars a little trimmed up, accompanied by his threes, and fours, and fives of little fustian jackets, a wife, in her best bonnet, and a baby, of course, under her shawl. The looks of surprise and pleasure of the whole party when they first observe the brilliant lighting inside the Museum show what a new, acceptable, and wholesome excitement this evening entertainment affords to all of them.[41]

Quite apart from the effort and expense entailed by such an expedition, the experience of pleasure would surely have been diminished by the painful sensation of being out of place and the prospect of returning home to those dimly lighted cheerless rooms. Though many nineteenth-century images of the museum public bodied forth Cole's ideal (Fig. 1), an equal number satirized the inadequacy of the novice's response, his faulty comprehension, and the meanness of his attire.[42] The space of emulation was also a space of contempt and condescension; the hard won *politesse* of the bourgeoisie was not graciously forsaken in the interests of class harmony. Furthermore, the bourgeois ideal of elevated aesthetic contemplation, witnessed in Hazlitt's famous account of the Angerstein collection

– "We are transported to another sphere...we breathe the empyrean air....The business of the world at large, and of its pleasures, appear like a vanity and an impertinence. What signify the hubbub, the shifting scenery, the folly, the idle fashions without, when compared to the solitude,...the unfading forms within"[43] – became difficult to achieve when the Angerstein pictures went to the National Gallery and the presence of laborers and wet nurses tainted the empyrean air with noxious fumes. On those days most popular with the broad public, the likes of Hazlitt and Waagen were inclined to stay at home. For utilitarians like Greenwood, "art should not be approached as something unusual...for the aristocratic few, and not for the many,"[44] but for the true art lover it was precisely what made art unusual, rarefied, and difficult to grasp that mattered.

As for the objects of Victorian philanthropy, the working poor, anecdotal evidence suggests that the material differences of class were not easily left behind at the museum's threshold, obliterated by the bright lights and opulence of what was on display. Henrietta Barnett, eavesdropping at the Whitechapel in the hope of gleaning evidence of some good rubbing off on her East End flock, tired of people wondering how much the pictures were worth and at times overheard the voice of daily struggle:

> *Lesbia*, by Mr. J. Bertrand, explained as "A Roman Girl musing over the loss of her pet bird," was commented on by, "Sorrow for her bird, is it? I was thinking it was drink that was in her" – a grim indication of the opinion of the working classes of their "betters"; though another remark on the same picture, "Well, I hope she will never have a worse trouble," showed a kindlier spirit and perhaps a sadder experience.[45]

Following a visit to the same gallery in 1903, Jack London concluded that the poor "will have so much more to forget than if they had never known or yearned."[46]

Another impediment to popular instruction was the growing clutter of the Victorian museum. Swelling collections and increased attendance raised visitor fatigue and diminished the visibility of what were considered the most important objects on display. William Stanley Jevons, though a staunch advocate of public libraries, had his doubts about the utility of museums owing to the failure to make them comprehensible and appealing to the broad public. In particular he lamented the lack of attention paid to presentation and the visitor's physical comfort. At

South Kensington, for example, "The general mental state produced by such vast displays is one of perplexity and vagueness, together with some impression of sore feet and aching heads."[47] Jevons led a growing chorus of voices recommending simpler displays, clearer organization, and public education. Recognizing different publics with different needs, Jevons and others called for a distinction to be made between public galleries featuring highlights for general consumption and research collections containing everything else for the use of students and scholars. One Professor Herdman of Liverpool went so far to say that "It should always be remembered that public museums are intended for the use and instruction of the general public . . . and not the scientific man or the student."[48] Not only should the public's attention be focused on masterpieces, but the underlying system of classification should also be made visible. For Greenwood, "the usefulness of a museum does not depend entirely so much on the number or intrinsic value of its treasures as upon proper arrangement, classification, and naming of the various specimens in so clear a way that the uninitiated may grasp quickly the purpose and meaning of each particular specimen."[49] This attitude was taken to an extreme in the 1890s by the Smithsonian's George Brown Goode when he reduced the museum to "a collection of instructive labels each illustrated by a well-selected specimen."[50]

Beyond the instructional value of individual labels, however, the proper classification of public collections had the virtue of inculcating a respect for the principle of order within society itself. "The first function of a museum," wrote Ruskin, "is to give an example of perfect order and perfect elegance . . . to the disorderly and rude populace."[51] The museum with its spatialized divisions and hierarchies constituted a mirror of the well-disciplined social sphere. Visual symmetry, concise presentation, and clear labels were all vital, but so was the demonstration of progress through the sequencing of objects and management of traffic flow. A stroll through the well-ordered museum illustrated human progress in all fields of endeavor and induced a new respect for institutions. Once more, Thomas Greenwood:

> The working man or agricultural laborer who spends his holiday in a walk through any well-arranged museum cannot fail to come away with a deeply-rooted and reverential sense of the extent of knowledge possessed by his fellow-man. It is not the objects themselves that he sees there, and wonders at, that causes this impression, so much as the order and evident science he

cannot but recognize in the manner in which they are grouped and arranged.[52]

The respective achievements of different nations could be measured, and manipulated to show a home field advantage. Fostering pride in local achievement has always been a function of museums and rationale for funding. Meanwhile, the very capacity to produce "art" distinguished the European races from those lower down on the evolutionary ladder whose cultural artifacts became the domain of anthropology and the natural history museum. Patriotic instruction motivated the spread of "period rooms" around the turn of the century following the success of similar national displays at World Fairs. Combining arts and crafts in an evocative setting (be it authentic, simulated or a combination of the two), period rooms captured regional characteristics threatened by the homogenizing pressure of modernization. More directly related to everyday life than paintings and sculpture, they proved popular with the public and were thought to stimulate appreciation for domestic consumer goods.[53] Justus Brinckmann, acknowledging the failure of the applied arts museum to improve industrial design, nevertheless insisted that period rooms and the combined display of art and furniture introduced to German art museums by Wilhelm von Bode would raise "the general taste of the nation" by appealing to "the non-professional classes of the people."[54] Recognition of the patriotic potential of period rooms quickly spread across Europe to the United States where their popular appeal qualified them for the indoctrination of new immigrants. "Through sight they may come to know our land and to appreciate and respect its beauty, its history, and its principles," wrote Alfred Mayer in 1903.[55] Twenty years later the new American Wing at the Metropolitan Museum in New York justified itself in the following terms:

> Traditions are one of the integral assets of a nation. Much of America today has lost sight of its traditions.... Many of our people are not cognizant of our traditions and the principles for which our fathers struggled and died. The tremendous changes in the character of our nation, and the influx of foreign ideas utterly at variance with those held by the men who gave us the Republic, threaten and, unless checked, may shake its foundations.... The American Wing cannot fail to revive those memories, for here for the first time is a comprehensive, realistic setting for the traditions so dear to us and so invaluable for the Americanization of our many people, to whom much of our history is little known.[56]

The Progressive Era: Museums for a New Century

The issues and challenges facing the Victorian art museum were transported to the United States where the light of progress and social reform burned bright and merged in the early twentieth century with the ideology of the Progressive era. Befitting a land of merchants and manufacturers, America's first museums in New York and Boston were modeled on South Kensington as a "resource whence artisanship and handicraft of all sorts may better and beautify our dwellings, our ornaments, our garments, our implements of daily life."[57]

Boston's Museum of Fine Arts (1870) had as its motto "Art, Industry, Education" and was built, like South Kensington, in terracotta in a Ruskinian Gothic style next to the public library. By the end of the century, however, the museum had outgrown its location, the South Kensington philosophy was in retreat, and its wealthy patrons had begun to think the city deserved better than a utilitarian collection of plaster casts and applied arts. In the first decade of the twentieth century a new museum was built, this time in granite and in the Greek style, at some distance from the city center. Original works of art took the place of casts and applied arts and aesthetics replaced practical utility as the guiding philosophy. Museums "are not now asking how they may aid technical workers," wrote Benjamin Ives Gilman, the museum's long-time secretary and chief advocate of the new aesthetic philosophy: "The problem of the present is the democratization of museums: how they may help to give all men a share in the life of the imagination."[58] Recalling Matthew Arnold's endorsement of culture as the antidote to the soulless materialism of the modern age, all too prevalent in America, Gilman rejected any suggestion of utility and insisted that the proper business of the art museum was to "transplant us amid perfection" through the contemplation of superior examples of past art.[59] Where the South Kensington Museum had contributed to industry and progress, the value of original art for Gilman and fellow aesthetes lay in the emotional, compensatory power of timeless, transcendent beauty. At the opening of the Cleveland Museum in 1916, Charles Hutchinson, President of the Art Institute of Chicago, stated that "the principal function of an art museum is the cultivation and appreciation of beauty," a "vital factor in the…materialistic age in which we live."[60] A year later Mariana van Rensselaer recommended museums to "combat the ambitious materialism…the bread-earning routine and

money-grasping adventure" of contemporary life.[61] Set apart from the social and economic pressures of contemporary society, the art museum was a respite from and antidote to the modern world. The idea was not new, as we have seen, but it acquired added urgency in the face of rapid modernization and world wars, and now its therapeutic benefits extended to both the working poor and the burgeoning middle classes (who were greatly in need of culture, according to Arnold).[62] For wealthy collectors and museum patrons, the purchase and subsequent donation to museums of eternal and priceless art absolved the taint of materialism and conspicuous consumption, while simultaneously yielding the social distinction that came with art.[63] The extent to which this universal conception of art took hold in the twentieth century and became an article of faith among museum men may be measured in remarks made by the much respected curator and director Otto Wittmann in 1974:

> In these precarious and unsettled times in which we all live, there is a great hunger for a sense of lasting significance. We live among objects designed to be bought, used and thrown away without ever acquiring any sense of identity or relationship to ourselves. The very nature of art and of the museums which preserve and present works of art reassures people of the continuity of human thought and of the importance of their place in the vast stream of significant developments over centuries of time. A Mayan figure in Manhattan, a T'ang figure in Toledo...can tell us much about humanity....These silent witnesses of the past can bridge the gap of time and place if we will let them....The universal truths of all art should be shared.[64]

For Gilman as for Wittmann, the use value of museums lay in their ability to transport the viewer from the here and now to a higher, abstract plane of essential humanity, hence the validation of selected world art traditions in twentieth-century museums.

The challenge to Gilman and subsequent museum professionals was to make those silent witnesses speak and to ensure that they could be shared by all. In practical terms, that meant making works of art easily accessible to the eye through the manner of their presentation and then helping people to appreciate what they saw. It was taken for granted that only authentic works of the best quality had sufficient power to serve as messengers of universal truth and beauty. In sum, the primary goals of museology in the modern era amounted to the selection, display, and interpretation of art deemed worthy of preservation; and where contro-

versy has arisen, it inevitably concerns the criteria of selection, mode of display, and nature of interpretation. Each of these issues had been aired before – quality and authenticity had always been important to art lovers and the arrangement and interpretation of art much preoccupied the Victorians, as we have seen – but they were combined at the new museum in Boston after 1909 in a way that struck contemporaries as novel and even revolutionary.[65] While secondary objects were relegated to reserve collections designed for scholars and students, the most important works of art were displayed in spacious and well lighted public galleries where "nothing may attract the eye of the visitor from the objects therein displayed. In a word, installation has been carefully studied to help the visitor to see and enjoy each object for its own full value."[66]

Under Gilman's leadership the first systematic education programs came into being. In 1916, for example, the "docent" service he had invented twenty years earlier employed some thirty trained guides and served 4,300 visitors ("of both sexes and all classes")[67] without charge; during the year the museum accommodated 5,600 school children and their teachers, and a further 2,380 students who came on their own. Teacher training was offered, also free of charge, and museum staff visited every school in Boston and distributed some 25,000 reproductions for classroom use. During the summer 6,800 underprivileged children were bused to the museum from settlement houses, and a further 850 children attended story hour on Saturday afternoons (repeated on Sundays for Jewish children).[68] The effort to cultivate interest among the young was particularly forward looking. "If the children of Boston can learn to enjoy works of art as children," wrote the Director, Arthur Fairbanks, "a more wide and real and intelligent enjoyment of art may be expected in another generation than exists today."[69] Sunday opening hours at Boston and other museums, though controversial at first for religious reasons, greatly expanded the public. "The Sunday visitors especially represent the American public at its best," wrote Gilman; "All sorts and conditions of men contribute their quota to the well-behaved, interested, almost reverent throng."[70] From 1918 admission fees were abolished (the museum had been free hitherto only on certain days) to encourage adult visitors and attendance soon doubled. In 1924, Gilman's last year at the museum, attendance rose above 400,000 and more than 9,000 people took advantage of docent tours. As at many other art museums in America in the early decades of the twentieth century, the educational services at Boston's Museum of Fine Arts equaled if not exceeded what is on offer today.

For all Gilman's good intentions and energetic initiatives, his dogmatic stance and high minded aesthetic philosophy made him an easy target for those who disagreed with him, especially those who clung to the utilitarian ideals passed down from the South Kensington Museum. For Gilman, art museums allowed people to see and even feel beauty, and interpretation, provided by lectures and handbooks, facilitated what he called "close companionship in beholding." The docent's task was not to offer a watered down art history but to direct the viewer's attention to "the vital elements in a work of art, . . . insuring that it is really perceived in detail, and taken in its entirety." Teaching everyone to become a "beholder of works of art" was not only possible but necessary because it was "left aside in our educational system."[71] However, for John Cotton Dana, Gilman's contemporary and antagonist, institutions like Boston's Museum of Fine Arts were simply "gazing museums" serving the "culture fetishes" of the privileged classes.[72] Following Thorstein Veblen, Dana saw the collecting of art and patronage of art museums as a prime example of "the conspicuous waste of the rich" and "another obvious method of distinguishing their life from that of the common people."[73] The air of wealth and hushed reverence combined with the "splendid isolation of a distant park" made art museums the antithesis of the useful, community-based institution Dana believed all museums should be. Where Gilman advocated isolation and silence as necessary conditions for contemplation and respite from which we emerge "strengthened for that from which it has brought relief," Dana insisted that museums must serve their constituents through active involvement in their everyday lives. Instead of importing European art and values, a museum must be grounded in its community and respond to its specific needs. Ideas more than objects, the present not the past, material progress not spiritual uplift must guide the modern American museum; the "undue reverence for oil paint" and "unique and costly objects" promoted by the art museum must give way to "the arts of living" and "the display of objects which have quite a direct bearing on . . . daily life."[74] The museum founded by Dana in Newark in 1909 on these principles became (and remains) a model of the community museum.

Though Gilman and Dana differed in fundamental respects and defended seemingly alternative museum ideals, they also shared much in common. Both men believed that museums were democratic and democratizing institutions with a moral responsibility to educate the broad public; though they disagreed on the content and purpose of museum education, they both vigorously supported school programs and docent

services, and their example was followed in museums across the country and abroad. While Dana mocked Gilman's contention that aesthetic instruction could produce ecstasy in the previously uninitiated or dispel the public's desire to understand an object's cultural significance, others criticized Dana for his refusal to grant the power of beauty and wonder embodied in great works of art.[75] Most art museums from the 1920s pursued a middle course between the two philosophies, blending appreciation and history in their educational programs.[76] Both shared a concern for visitor psychology and the ways in which the museum environment affected an individual's experience. Gilman's training in psychology inspired the first empirical study of museum-going and led him to implement changes in lighting and hanging, seating and signage in the interests of alleviating what he termed "museum fatigue." Dana was more concerned with developing an individual's skills for daily living in a given community, but both implicitly addressed the question of how museums could help the individual negotiate his or her way in a complex, shifting world.

Dana and Gilman's commitment to public access also led them to be suspicious of grandiose architecture and the growing scholarly inclinations of museum curators. For Dana, palatial museum architecture, because intentionally reminiscent of noble residences, could only intimidate ordinary visitors, and for Gilman the building and its decoration threatened to overwhelm the art on view. By the 1920s the museum profession had become decidedly anti-architectural. The Grecian temples of Boston, Philadelphia, and Cleveland, though only recently completed, seemed dangerously anachronistic to the generation of curators who came after Gilman and Dana. As Richard Bach, curator at the Metropolitan Museum in New York put it: "to make [the museum] palatial, pompous or grand is to build up a kind of psychological barrier to its greatest use."[77] New museums, such as the Fogg Art Museum (1927) and the Museum of Modern Art (MOMA, 1939), accommodating inside and out to both visitors and works of art, became the models for the modern age, and they remained so until Frank Lloyd Wright's iconoclastic Guggenheim Museum (1960) rekindled the symbolic potential of museum architecture.

The curatorial backlash against architecture was accompanied, however, by a growing scholarly introversion among curators that both Gilman and Dana feared would have negative implications for the museum public. The need to develop consistent standards of classification and display, and to discriminate between primary objects for public consumption and

secondary objects of interest to scholars, first recognized in the Victorian era, led to the formation of national and international museum associations and the emergence of a professional identity for museum curators.[78] In the case of art museums that identity took shape around the ideals of aesthetic judgment and connoisseurship, the ability to tell good from bad and authentic from fake. As we have seen, these criteria had long defined the true *amateur* of art, but they hardened into professional criteria secured by university degrees and verified by museum publications. The quality and originality of new acquisitions became, and arguably still remains, the ultimate measure of the curator; conversely, according to Thomas Munro, Director of the Cleveland Museum in the 1940s, "there is nothing more damaging to his prestige than buying a fake."[79]

Perhaps the most important figure in this process of professionalization was Paul Sachs, who founded the famous Museum Course at Harvard that ran from the 1920s through the 1950s and was responsible for training many of the most powerful museum men (and a few women) of modern times.[80] (Sachs was also involved in the creation of the Courtauld Institute of Art in London, which in effect performed a similar service for the museum world in Britain.) Among the skills Sachs thought necessary to run a successful museum were a solid (preferably Ivy League) education, genteel background, good social skills (particularly useful for raising money and negotiating with collectors and dealers), and bureaucratic competence; but the ideal curator must also possess sound connoisseurial judgment and scholarly potential. As he told the dignitaries assembled for the opening of MOMA in 1939, only by defending the highest standards of quality and scholarship could the museum move forward:

> Let us be ever watchful to resist pressure to vulgarize and cheapen our work through the mistaken idea that in such fashion a broad public may be reached effectively. In the end a lowering of standards must lead to mediocrity and indeed to the disintegration of the splendid ideals that have inspired you and the founders. . . . The Museum of Modern Art has a duty to the great public. But in serving an elite it will reach . . . the great general public by means of work done to meet the most exacting standards of an elite.[81]

Needless to say, meeting the "most exacting standards of the elite" inevitably meant that it was the narrow cut of collectors, critics and fellow museum professionals, and not the general public who constituted the

curator's primary audience. Dana had warned that, "once enamored of rarity," curators were at apt to "become lost in their specialties and forget their museum....its purpose....[and] their public."[82] And according to Theodore Low, a pupil of Sachs' who took an unusual turn (for a man) into education, that is precisely what happened. Writing in 1942, Low lamented the failure of American art museums to live up to the democratic promise of their founding charters and laid much of the blame on the seductive "charms of collecting and scholarship."[83] The mutual interest of benefactors and directors (drawn from the ranks of curators) in collection building on the European model had reduced education to a "moral quarantine" within the museum, "a necessary but isolated evil."[84] "As a result museum men have drifted further and further away from the public."[85] At the root of the problem, Low felt, was the narrow focus on connoisseurship in graduate art history programs; even in Sachs' Museum Course, "the approach to the public" had been ignored in favor of "the training of connoisseurs for curatorial work."[86] Three years later, the Director of the Metropolitan Museum, Francis Henry Taylor, followed suit by arguing that Americans, "of all the peoples of history, have had a better, more natural, and less prejudiced opportunity to make the museum mean something to the general public," and yet they had failed.

> We have placed art...both literally and figuratively, on pedestals beyond the reach of the man in the street....He may...visit the museum on occasion, but he certainly takes from it little or nothing of what it might potentially offer him. This is nobody's fault but our own. Instead of trying to interpret our collections, we have deliberately high-hatted him and called it scholarship.... There must be less emphasis upon attribution to a given hand and greater emphasis upon what an individual work of art can mean in relation to the time and place of its creation....There must also be a more generous attitude on the part of the scholar toward the public.[87]

What Taylor and Low were really speaking to is the proper balance between the goals of collecting and interpretation, an equilibrium difficult to establish owing to the imbalanced power structure within the museum: on one side, collectors and directors upholding elite standards inherited from Europe, and on the other, educators mindful of a broad public hungry for knowledge. Low meant it as a compliment when he said of Dana: "He was an American rather than a pseudo-European...and thought in broad terms of the American social scene."[88] Certainly both Taylor and Low were well aware that the 1930s, decade of the New Deal

and the WPA, witnessed an extraordinary expansion of educational activity in American museums, much of it dealing with issues of social relevance and cultural history. Indeed Low quoted prominent museum men such as Victor d'Amico, head of education at MOMA, who believed that "art is an expression of a culture and society" and that "To isolate a work of art from its background and set it up alone in a glass case is to deprive it of the fullness which gives the work significance and beauty."[89] That tendency to segregate art from life was described by Philip Youtz, Director of the Brooklyn Museum, as the gravest symptom of "museumitis," a disease that could only be cured by "a new kind of art education that shall stress the vital social connection of art." "Appreciation courses have failed," he said, because they neglected "the rich fabric" of a culture and made an "idol" of art.[90] Before going to Brooklyn, Youtz had run the 69th Street Branch of the Philadelphia Museum of Art, following the example of Dana's branch libraries (significantly Dana began his career in public libraries before moving to Newark). Like Dana, Youtz believed that museums had much to learn from department stores and commercial ventures in their effort to reach the community and he located his branch museum in a storefront opposite a supermarket and a five-and-dime. Objects attractively displayed in street level windows lured passersby and the museum remained open daily until 10 p.m. Whereas at most museums the collection was arranged "according to the tastes and interests of the staff and trustees" and the public encountered only the guards, at the branch museum the interests of "the public at large" were borne in mind and the "staff... maintained intimate contact with the public it serves." "It is high time that museums of all kinds became more definitely oriented toward the public," Youtz concluded. "The aloof policy inherited from old private collections must be abandoned and museums must accept the leadership in public education." [91]

Yet Low and Taylor surely knew full well that such efforts amounted to a rear guard action against the rising tide of aestheticism. Everywhere one turned, Newark and Brooklyn excepted, one found Gilman's "appreciative acquaintance" alive and well.[92] Even museums commended by Low for their educational initiatives, such as the Toledo Museum, revealed a bias for Gilman in their dedication to the "public appreciation of art."[93] Under the leadership of Sachs' disciple Alfred Barr, MOMA established new curatorial ideals of quality acquisitions and shows, immaculate installations, and meticulous scholarship. Consistent with the clean, autonomous interiors of the museum, yet evidently at odds with the

philosophy of his education staff, the exhibitions organized by Barr in the 1930s and the exemplary catalogues he wrote to accompany them were steadfastly visual in nature: their aim was to encourage familiarity with the "formal" properties of modern art and the stylistic influences linking one artist and school to another. Meyer Schapiro criticized Barr for his neglect of the social and political contexts for modern art, but Barr was indifferent to such concerns and his example proved enormously influential for later museums.[94] The intensity of gaze facilitated by the neutral white cube provided the necessary conditions for proper (visual, non-political) consumption of serious painting, and only serious painting could hold up to scrutiny in such conditions.[95] The autonomy of the work of art found its reflection in the autonomy of the individual viewer left to aesthetic contemplation in a space free of diversion.

As the work of interpretation was left increasingly to education departments, often housed in basements and staffed by women, curators became increasingly concerned with refining conditions of display. An international conference of museum professionals held in Madrid in 1934 revealed an overwhelming consensus in favor of isolating works of art for purely visual consumption. Three years later at the Exposition Internationale in Paris an exhibition displaying the latest trends in museum design noted the movement towards viewing art as an "autonomous, individual [and] purely formal" phenomenon:

> The modern sensibility, no longer seeking in a work of art an historical witness but an individual aesthetic phenomenon, has led museums to efface themselves behind the masterpieces they display. Walls stripped of decor are nothing more than an abstract background against which objects may be seen; those objects are well-spaced in order that the visitor may examine each one without distraction, all in keeping with the demands of the modern aesthetic.[96]

Distractions included wall labels and even the voice of the well-meaning docent. Masterpieces spoke for themselves and any attempt to speak on their behalf could only compromise their integrity. Gilman himself had asked: "In a museum of fine arts, are the labels really more important than the exhibits; or are the exhibits more important than the labels?"[97] When the new Boston museum was under construction Gilman experimented with a gallery without labels: "The impression was that of ideal conditions, surely to be realized in the museum of the future." Without labels the works of art "were able to create about themselves

a little world of their own, most conducive to their understanding."[98] Arthur Melton, a Yale psychologist who studied museums in the 1930s, concluded that what labels there were were written as if "the typical visitor [was] not unlike those individuals who manage museums" and omitted "essential information which is assumed to be the knowledge of every-one."[99] The left-leaning museum critic, T. R. Adam, bemoaned the "mystification in this belief in the power of great paintings to communi-cate abstract ideas of beauty to the uninformed spectator."[100] But museum professionals were undaunted. In 1945, Kenneth Clark, Director of the National Gallery, London, insisted that with works of art, "the important thing is our direct response to them. We do not value pictures as docu-ments. We do not want to know *about* them; we want to know *them*, and explanations may too often interfere with our direct responses."[101] And the still prevalent approach to labeling is clearly expressed in a publication of 1971 from the Cleveland Museum:

> The Museum's permanent galleries and special exhibitions are designed as quiet areas where the individual visitor can see and respond to the individ-ual work of art. This personal encounter between the viewer and the object is the deep and particular satisfaction a museum offers. Explanatory gallery labels usually keep their text to a minimum to avoid intruding between the visitor and the work of art.[102]

In spite (or because) of its popularity with the untutored public, period décor also fell out of favor with curators as another kind of noise that hindered direct appreciation of great art. Even docent work became a problem. Though gallery tours were in wide use by the 1930s, there was a sense in which active voices in a gallery had the unfortunate effect of drowning out the silent voice of the master. As a pioneer of the docent system, Gilman understood that most people needed instruction to help them appreciate what they saw, yet his support was tinged with regret as "the use of galleries for *vive voce* instruction may become a disturbance of the public peace for him who would give ear to the silent voices therein."[103] Similarly, Walter Pach writing in 1948 vigorously defended the broad public use of museums but thought that the spread of education programs threatened "to overshadow [their] original purpose," which was to collect and display masterpieces. "Today we must leave every person free to form his own convictions," he concluded, "and the way to do that is

to concentrate on the collections themselves, allowing the masters and the schools to say their say, independent of interpretations by educators."[104]

Education departments were there to stay but Low's description of their "moral quarantine" was scarcely an exaggeration. In the eyes of some directors and curators, the public itself became a nuisance to be tolerated but not indulged. Take the case of Sir Eric Maclagen, Director of the Victoria & Albert Museum in the 1930s. When asked if his museum had become "a mere museum for connoisseurs and collectors," he agreed it was a fair description "but for the insertion of the word 'mere'."[105] A few years later he had this to say to a gathering of fellow museum professionals:

> If we were to be entirely candid as to the view taken by museum officials with regard to the public I fear we should be bound to admit that there are occasions when we have felt that what is wanted might be described in the language of the cross-word puzzle, as a noun of three letters beginning with A and ending with S. We humour them when they suggest absurd reforms, we placate them with small material comforts, but we heave sighs of relief when they go away and leave us to our jobs.[106]

And lest we dismiss such sentiments as an attempt at after-dinner humor from an aloof British aristocrat, we find much the same relief expressed by John Walker, Director of the National Gallery, Washington, no less, as he anticipated the departure of the day's last visitors:

> When the doors are closed a metamorphosis occurs, and the director or curator is transformed into a prince strolling alone through his own palace with an occasional bowing watchman accompanied by his dog the only obsequious courtier. The high vaulted ceilings, shadowy corridors, soaring columns, seemed to have been designed solely for his pleasure, and all the paintings and sculpture, those great achievements of human genius, to exist for no one else. Then, undisturbed by visitors, he experiences from time to time marvelous instants of rapt contemplation when spectator and work of art are in absolute communion. Can life offer any greater pleasure than these moments of complete absorption in beauty?[107]

If characteristic images of the Victorian museum show healthy crowds seeking wholesome recreation, the twentieth-century curatorial ideal in the form of the "installation shot" rids the gallery of visitors altogether leaving only the disembodied eye to roam freely without distraction.[108]

Given that social history had found a natural home in the art museums of the Soviet Union (where "art for art's sake" and connoisseurship were proclaimed incompatible with Marxism) and was preferred in the USA by labor unions and populist educators, is it any wonder that it had so little purchase with western collectors and curators?[109] And what support it had was washed away in the wake of World War II and the rise of the Cold War, an era that sealed the ascendance of a universal conception of art in landmark exhibitions such as MOMA's *Timeless Aspects of Modern Art* (1948–9) and *The Family of Man* (1955).[110] In 1955 Richard Nixon, Vice President and leading McCarthyite, gave the keynote address at the American Association of Museums. Where art had been reduced to propaganda under Nazi and Communist regimes, in the west it became the embodiment of individual freedom, and this freedom extended to the public to enjoy a museum's contents without interpretation, at least of a social nature. In art history graduate programs social art history experienced the same eclipse. At Harvard the famed Museum Course was taken over by Jakob Rosenberg who directed the program, and future curators, still further towards connoisseurship.

Though perhaps not intended, the triumph of silent contemplation in the museum had the effect of reversing the social activism of the 1920s and '30s and with it the appeal of museums for the uninitiated. In Britain, an official report on the arts of 1946 found that museum attendance had dropped 25 percent in the previous twenty years and concluded: "the numbers might be very much greater if the directors and their staffs were as interested in attracting and educating the public at large as they are in the specialist needs of students and connoisseurs."[111] One wonders if the same causes were behind a similar decline registered at the Metropolitan Museum over the same period, notwithstanding extensive educational programming. An intriguing survey carried out by Low at the Met in the early 1940s found that a clear majority of visitors, just under half, favored aesthetic appreciation in the way of gallery instruction; only five percent asked for "art and daily living." Low doesn't tell us how the survey was conducted or who was asked and it would be wrong to assume a direct correlation between survey response and socioeconomic status to the effect that only one in twenty visitors were working class. On the other hand, Low had no doubt that the Met's visitors came disproportionately from the "upper circles" and he noted furthermore that educational services at all art museums tended to be monopolized by the "upper layer of cultured residents," hampering the efforts of educators to expand

the public.[112] Low pleaded with his colleagues to look beyond visitor statistics at who comes to museums and what they derive from the experience, but his words fell on deaf ears for close to thirty years.

Postmodernism: The End of Innocence?

It is a mark of how completely social activism had disappeared from museum discourse that its return in the late 1960s, following widespread social unrest and financial crisis, seemed radical and without precedent. Or perhaps it would be more accurate to say that while many education programs carried on as they had for decades and directors and trustees continued to be believe they were serving their institutions and communities, the world beyond the museum had changed dramatically and many museums, especially ones in urban settings, awoke to find themselves out of touch with social developments.

Recommendations for change came from an unlikely place. In the wake of race riots, anti-war demonstrations, student activism, and presidential reports concluding that America was two countries – privileged and poor, black and white – Thomas Hoving, the ultra-privileged but maverick director of the Metropolitan Museum, used an address to the American Association of Museums (AAM) in 1968 to urge his colleagues to "get ourselves involved and become far more relevant."[113] His talk was sprinkled with knowing references to the New Left and SDS, "happenings" and zonked out hippies, and he used the word "relevant" no fewer than seven times. "In order to survive, to be relevant," he wrote, "we must continually re-examine what we are, continually ask ourselves how we can make ourselves indispensable and relevant."[114] In the case of the Met, he went back to the Charter of 1870 and determined that if it were re-written in modern times it would likely not include such liberal talk of embracing all sections of the community. We might argue with Hoving's generous assessment of his predecessors, but his point was to hold his institution accountable to both the rhetoric of its charter and the social dynamics of his own day. To that end, he promised (and to some extent delivered) changes in education, outreach, staffing (from the trustees to the guards), and exhibition programming.[115] For better or worse, Hoving is best remembered for his promotion of the "blockbuster" exhibition and his inaugural show, *Harlem on my Mind*, a bold attempt to bring pressing social issues and underrepresented constituencies crashing into

a mainstream art museum. Everything about the exhibition was miscalculated, from its reliance on documentary photography (not really an art) to its multi-media packaging and frank treatment of race relations in New York, but at bottom the biggest mistake was its desire to force an activist agenda on an unwilling institution.

A more successful experiment in "relevance" was the Anacostia Museum, created in 1967 in Washington, D.C. under the aegis of the Smithsonian Institution and still going strong. Harking back to the idea of the neighborhood branch museum, Anacostia opened in a depressed section of the city. Whereas *Harlem on my Mind* represented the white man's conception of black history and experience, Anacostia was run by members of the local community, led by John Kinard, and focused on "social issues affecting its constituents and neighbors."[116] The museum was conceived by the Smithsonian's director, S. Dillon Ripley, who in light of recent upheavals was tested by the problem of how to extend the museum's benefits to "all our people, those . . . who most deserve to have the fun of seeing, of being in a museum."[117] Though Ripley was himself thoroughly at home in the corridors of high culture (he felt no "generation gap" separating him from the great masterpieces of the past, for example), he understood that owing to their continued dependence on the "dominant forces in the community, the civic boosters and the wealthy," art museums had neglected various constituencies, including artists and art historians, but above all "the poor people, products of a self-perpetuating disease found in our cities." He continued:

> Such people were neither objects of pride to our civic boosters nor particular objects of concern to our aggressive middle class who had responded to the urge to better themselves. If the art museum had become a symbol only to the community leaders and those conditioned to the concept of getting ahead, who realized that art was a subject of elitist veneration and that culture should be subscribed to and taken in doses like vitamin pills, then of course it had failed.[118]

Hoving and Ripley's initiatives were part of a broader trend of self-evaluation and response that preoccupied the museum field in the 1970s and '80s and once again heightened tensions between the goals of collections care and public outreach found in mission statements. The annual meeting of the AAM in 1970, for example, though punctuated by protests against the Vietnam War and the persecution of the Black Panthers and other political activists, produced an uneasy standoff between the two. On

the one hand, it was recognized that as collections of objects museums "are not those organizations best suited to cope with the social and political concerns of the moment." On the other hand, "neither are museums, surely, doing everything they might to bring to bear their own special resources on what now shakes the peace of mind of their visitors."[119] High among the demands made of the profession was the "democratization" of museums, all the more imperative given the federal subsidies they received. Nancy Hanks, Chair of the National Endowment for the Arts, concluded: "I do not think we can any longer spend time discussing the role of the museum as a repository of treasures versus its public role. It simply has to be both."[120] Further conferences and reports tracked the gradual shift within museums towards public service.[121] Added incentives to move in this direction came from government agencies and private corporations that offered museums, now plagued by rising costs, much needed financial assistance in exchange for increased accountability in the form of higher attendance and more public programming.

The social activism of the period also fuelled revisionist art history and the first wave of academic museum critique. Reviving observations made earlier by Meyer Schapiro, T. R. Adam and others, social art historians criticized museums for "mystifying" art and neglecting the original context and meanings of the objects they displayed. Art appreciation, connoisseurship and formalism became code words for elitism and lost ground in academia to various forms of semiotic and contextual analysis. Notions of genius, quality, tradition, and the canon were denounced as the constructs of a privileged, western ideology. Built on false premises, the argument ran, museums are inherently flawed and illegitimate institutions. Though in fact the "new" art history has left the canon largely unchanged (we still prefer Manet to motorcycles or William Morris), the terms of engagement with it are more theoretical and contextual than connoisseurial or object based, and as a result museums and academia have been pulled apart.[122] One thing many academics and curators share, however, is a reluctance to deal with the untutored public.

Artists and academics from neighboring disciplines joined the fray. Museums as bastions of tradition had long been a target of avant-garde disdain, but from the 1960s they also became the *subject* of much contemporary art. Conceptual and postmodern artists, including Marcel Broodthaers, Hans Haacke, Louise Lawler, Andrea Fraser, and Fred Wilson, have used visual means to expose the ideological underpinnings

of the art museum, sometimes invading the museum itself to make their point. In the late 1960s the sociologist Pierre Bourdieu undertook an empirical study of art museum visitors and concluded that museums, by assuming knowledge and skills that could only be acquired outside the museum through upbringing and superior education, were the preserve of the privileged and thus served to reinforce class distinctions. Works of art speak for themselves only to those who come to the museum already possessed of the "aesthetic codes" to decipher their mysteries, he argued. Theodore Low and others had said much the same decades earlier but Bourdieu's analysis struck a chord and became essential reading.[123] The anthropologist Margaret Mead joined the chorus of critique by recommending that museums invest in shops, restaurants, and other amenities in an effort to "welcome those people unaccustomed to the way of seeing and being of museums."[124]

Invest they did, to the point that shops, restaurants and other attractions now seem to vie with art for the visitor's attention. Related to these developments was the spread of blockbuster exhibitions, which simultaneously increased attendance and revenues. Temporary exhibitions had long been recognized as a means of attracting new visitors, but in the 1970s, following the popular success of Hoving's *other* blockbusters at the Met, *In the Presence of Kings*, *The Year 1200*, and *Before Cortes*, they became a way of life at most institutions.[125] At the Boston Museum of Fine Arts, for example, the need to impose admission charges to offset mounting operating costs resulted in significant declines in attendance, the solution to which was to program special exhibitions the public was willing to pay for. Visitors responded in record numbers, and the MFA, like many other museums, has grown dependent on such shows to keep revenues flowing. To house these special events and ancillary services, museums have embarked on extensive physical expansion. I. M. Pei's West Wing at Boston, opened in 1981, houses special exhibition spaces, three restaurants, a cloakroom, bathrooms, an ATM, an ever-expanding shop, an information desk, and the education department and school reception area (with its own shop-on-wheels for school children). Where once architecture was criticized as a barrier to public use, now new buildings are hailed as democratic and an attraction in themselves. Pei's Boston wing was described as a "temple of cultural democracy" and during the '80s his high profile additions to the National Gallery in Washington (East Wing) and the Louvre in Paris (Pyramid) helped to re-define the art museum as a multi-purpose leisure destination.[126]

There can be no doubt that the novel attractions have succeeded in attracting more people. As is well known, annual attendance at art museums continues to rise and outdraws professional sporting events. It would be safe to conclude that those who now come to art museums have never been happier. Nevertheless the new blockbuster culture has been criticized from both left and right, from within and outside the museum. Critics on the left have observed that audiences may have grown but their class profile has not changed. Forty years ago, as visitor numbers began to rise, Rudolph Morris doubted "that larger attendance also means a breakthrough to social classes formerly not affected by the existence of art museums." He predicted that further increases were likely to be among "individuals of higher socio-economic status and better educational background."[127] Precisely so, Alan Wallach has argued: gains in audience size at art museums are the product of a swelling population of educated and affluent "culture consumers" (to borrow the resonant title of Alvin Toffler's 1964 book) whose appetite for art has been whetted by university art history courses and television specials by the likes of Kenneth Clark and Sister Wendy.[128] Increasing costs associated with blockbusters (transportation, insurance, publications, etc.) compelled museums to seek financial support from private corporations, which, in return for their investment, expected large audiences, and the more affluent the better. Larger crowds also meant more profit for museums (and area businesses) as popular shows boosted parking fees, retail sales of food and specialized merchandise, and package deals with hotels and airlines. Visitors became customers and populism descended into cynical marketing as museums and corporations both pursued exhibitions that would "sell"; hence the steady diet of Impressionism, mummies, and anything with "gold" in the title. In recent times, these strategies have been taken to their logical postmodern, late-capitalist conclusion by Thomas Krens, the entrepreneurial director of the Guggenheim museums.[129] Having built the enormously successful new museum in Bilbao and transformed the original Guggenheim into what some would describe as a virtual rental hall for the display of commercial products (most recently, motorcycles and Armani fashion), Krens has now done the unthinkable by taking high art to Las Vegas. In defense of his newest Guggenheim in the land of casinos, he has said "you go where the heathens are," and his new partner in this enterprise, the director of the Hermitage Museum in Russia, added, turning Marxism on its head in the capital of decadent capitalism, "we work for the masses, and art belongs to the masses."[130]

Though clearly driven by short-term commercial ambition, these ventures have opened the doors of high culture to new art forms and, arguably, new publics. But at what cost? Krens's critics – and he would seem to have few friends in museums or academe, on the left or right – fear that he is taking the museum the way of commercial television, reducing high culture to the lowest common denominator under the guise of postmodern populism. Whatever sells to the largest number regardless of standards, who comes or what they experience. This has been the argument against mass culture for half a century, but lately it has triggered both a wistful nostalgia for a time when culture seemed to matter to those who cared and a vigorous call to arms. Adam Gopnik, in an article that used the Guggenheim past and present as his example, lamented the "death" of a serious audience in the face of an ephemeral, equalizing buzz culture.[131] Larger attendance does not equal heightened interest, he argued, and those who used to attend serious exhibitions, loyal to the museum because it was theirs, have been lost, squeezed out in the postmodern shuffle. Even liberal minded academics tend to share this view though a fear of sounding elitist makes them reticent.

At the same time, refusing to concede defeat, museum professionals and art critics have rallied around and re-emphasized the centrality of traditional values – aesthetic contemplation, scholarship, collections care – to the art museum's mission. Those values never went away so much as underground in the face of recent activism. The 1984 report *Museums for a New Century* could at one and the same time say that the previous fifteen years had seen unparalleled movement in the direction of "democratization," access, and involvement "in our nation's social and cultural life" *and* note the growing gap between education and curatorial departments and an ongoing tendency to keep audiences in the dark about choices that are made.[132] In other words, while educators had furthered outreach efforts, it was still business as usual among curators; social and political forces had brought the former out of the "moral quarantine" Low had described but left curatorial practices largely unchanged. The two faces of the museum's mission served by parallel branches of the staff, separated from each other by a different ethos, training and different publics. Tensions between the two resurfaced in the early 1960s with the arrival of "mass society." In an essay responding to recent trends, the Guggenheim's first director, James Johnson Sweeney, railed against the coming of education programs and visitor statistics "simply because museum trustees or perhaps even museum directors are ambitious to

embrace the broadest possible public and, in our democratic age, have not the courage to face the fact that the highest experiences of art are only for the elite who have 'earned in order to possess.'"[133]

Resistance continued through the 1970s even as museums adopted, or re-adopted, pro-active outreach efforts. Across the Potomac River from Anacostia, John Walker bemoaned the pursuit of "relevance" and hoped the future would return museums to "their original mission, which once was to assemble and exhibit masterpieces."[134] He held fast to the notion, shared by many before and since, that art museums best serve the public by providing secluded spaces for aesthetic contemplation. With Hoving's Met as well as Anacostia in mind, he declared: "I am indifferent to their function in community relations, in solving racial problems, in propaganda for any cause."[135] Though in hosting the *Mona Lisa* at the National Gallery in 1963 he was responsible for one of the most popular exhibitions of all time, he was baffled by the crowds and continued to believe his primary responsibility was to his collection and the small minority who really understood it:

> I was, and still am, an elitist, knowing full well that this is now an unfashionable attitude. It was my hope that through education, which I greatly promoted when I became a museum director myself, I might increase the minority I served; but I constantly preached an understanding and a respect for quality in works of art....The success or failure of a museum is not to be measured by attendance but by the beauty of its collections and the harmony of their display.[136]

Elsewhere, a similar message was delivered, albeit in more moderate terms. Sherman Lee, influential director of the Cleveland Museum, was openly critical of Hoving's *Harlem* exhibition and took issue with the idea of the museum as instrument of mass education or social action. "Merely by existing – preserving and exhibiting works of art," he wrote in the early 1970s, "it is educational in the broadest and best sense, though it never utters a sound or prints a word."[137] He supported education programs so long as they respected the silence and integrity of the visual experience of great art, and consequently also rejected the hoopla of blockbuster exhibitions, fund-raising cocktail parties, and audio tours, suggesting that such activities, if necessary at all, should be held at a separate site, like a branch museum.[138]

Since the 1980s the banner of traditional values has been carried by Hoving's successor at the Met, Philippe de Montebello, and more recently

by James Cuno, until recently Director of the Fogg (and now Director of the Courtauld Institute). Sharing Sweeney's fears about mass culture and alarmed by the extent to which they have been realized by Krens and others, they have argued that important functions that only museums can perform, notably scholarship, conservation, and an engagement with beauty, are being taken for granted and drowned out by the noise of shops and superficial exhibitions. "I know it sounds old-fashioned" Cuno wrote, "but I believe that an art museum's fundamental purpose is to collect, preserve, and exhibit works of art as a vital part of our nation's cultural patrimony."[139] Both Cuno and Montebello have stressed that such work is by definition "elitist," though no more so than the pursuit of scholarship in a university or excellence in schools and anything else we judge in terms of quality. The crime is to pretend that quality doesn't matter and to act as if audience size counts for more than what people experience.

The challenge to defenders of the status quo is to make good on the commitment to meaningful aesthetic experience. Encouraging visitors to *look* and *see* has long been recognized as the principal task of the mainstream art museum, but how to do that for the uninitiated without the aid of labels, acoustiguides, educational aids, and theme park attractions remains an open question.[140] Recent attempts to stimulate vision and dialogue between eye and objects through the rearrangement of the permanent collection at the Tate Galleries, MOMA, and elsewhere have been blasted by conservative critics as so much postmodern nonsense, as was a similar effort at the Orsay Museum in Paris in the 1980s to heighten public understanding through juxtaposition of progressive and academic nineteenth-century art.[141] In those important spaces, maintained the critics, the art that really mattered could no longer be apprehended thanks to the excessive architecture and fashionable juxtaposition with lesser art.

Another option for traditionalists is to deny that the mainstream art museum can ever be for everyone. Despite his efforts to spread art appreciation, Gilman wondered long ago if it were possible "to make a museum of fine art in any vital sense a popular institution" and Cuno has echoed these doubts by suggesting that art museums are "of interest to only a relative few (perhaps 20 percent of our population)."[142] Working in a wealthy private university museum afforded Cuno the luxury of such sentiments, no doubt, but is he wrong? His position begs the question of why it is we care if museums serve everyone, especially when we don't care or monitor who attends sporting events or other cultural events. The short

answer is that we continue to harbor utopian expectations about the role of art and museums in western societies. Because they are educational and good for us, however defined, they should be made available to all. The 1984 museum report makes this clear when it states that museums contribute to the "national crusade" of education, which is "a pillar of democracy" and key to "American optimism."[143] At the same time, however, because we don't fund museums or compel people to attend them as we do schools, they are left to attract visitors as best they can (with shops and shows, etc.), making them most accessible to those who are willing to pay the price of admission.

Back in the 1920s a collaborative effort between the Art Institute of Chicago and the city's public schools gave R. L. Duffus great cause for hope:

> The result is, or will be, that a bowing acquaintance with the A–B–C of the arts will cease to be a mark of caste or class. Any child in Chicago who really wishes to do so may take in art along with his grammar, arithmetic and geometry. The fact that his father works in the stockyards or that he himself has been brought up in the streets and encouraged to take not more than one bath a week is no real obstacle. There is at least a potential democracy.... Twenty years from now, perhaps, we shall be able to measure the tangible results attained by what is being done at this moment among the public school children of Chicago under the patronage and encouragement of the Art Institute.[144]

Needless to say this and countless other long forgotten initiatives evaporated, leaving critics to observe that museums can't provide acculturation on their own.[145] Museum educators do their best, but it is remarkable how many creative outreach projects must continue to rely on short-term financial support from private corporations.[146] We don't count on private philanthropy to run our schools. Given the way we fund museums and arts education, it should come as no surprise that recent visitor studies have confirmed all over again that, despite decades of outreach, those who go to art museums are still the well educated who view the cost and experience as a worthwhile investment in a process of lifelong learning, for both themselves and their children.[147] In other words, museum going is above all a chosen leisure pursuit of the educated, affluent, upwardly mobile middle classes. The same study concludes that school involvement, such as it is, is much less effective for developing lasting interests than family encouragement. Every fifth grader in the Boston school system visits the Museum of Fine Arts, but a casual glance

at the fee-paying public on any given day strongly suggests those children are not returning as adults. This would tend to support Bourdieu's thesis that upbringing and milieu, what he calls "habitus," largely determine attitudes to culture. But if upbringing is so important, how can museums ever substitute for it?

If people can't be made to go to museums, they will go only out of (self-) interest. The visitor study cited above suggests that if museums want to attract presently under-represented constituencies, they will have to be "thoughtfully wooed by special marketing promotions, and served by programs and exhibitions that cater to its specific cultural and historical backgrounds and interests." Some museums have begun to do this through special exhibitions and programs, but unless deeper changes are made to the structure of the collections and staff it is naïve to think such visitors will ever become loyal patrons. When you get past the temporary exhibitions and education programs, mainstream art museums appear to have changed very little in recent decades. Despite calls in the 1970s for museums to become more diverse, boards of trustees and the people they hire to run their institutions are still overwhelmingly white, well off, and well educated. The poor and marginalized people interviewed by Robert Coles many years ago who knew instinctively that art museums were "for other people, not for us" would scarcely have any reason to think differently today.[148] Why should we expect the public to become more diverse when the museum itself does not? Is it not patronizing to assume that the disenfranchised should want elite culture, especially when so little is done to welcome theirs? A hundred years ago, the first director of the Toledo Art Museum, George Stevens, toured local factories at lunchtime touting the benefits of high culture, but such proselytizing would hardly be acceptable today.[149] In Great Britain museums have been asked to attract a certain percentage of ethnic minorities (British Museum, 11%; Tate Gallery, 6%, etc.) to qualify for funding.[150] Apart from the problems of defining and counting "ethnic minorities," what would it take to make museums attractive to those groups? Should existing collections and their curators be abandoned for new? Anything less and we are back to the assumption that "our" culture is good for "them," and surely we have gone beyond considering "a visit to a museum ... to be the civilizing ritual it was in Victorian England," as one British politician recently put it.[151]

Those who argue for access would respond that knowledge of art is a form of cultural capital without which advancement in the world is barred. Vera Zolberg has said "anything short of complete democratization is the

maintenance of hegemony."[152] But is it clear in our postmodern age that hegemony of high culture translates into other spheres? Put otherwise, is it the case that a lack of cultural knowledge, or more specifically knowledge of high art, stands in the way of social, political, or material success? There is a clear correlation between higher education and a higher standard of living, but is knowledge of art a necessary part of that education? For many knowledge of sports would be more useful around the water cooler than an understanding of Rembrandt. It may be that museum trustees are rich and powerful but many rich and powerful people live happily ignorant of art. And for the poor and dispossessed there are surely more pressing concerns than access to canonical western art.

One positive development in recent years has been the emergence of new museums for different publics. As social activism and critical theory have discredited the aesthetic philosophy of the universal survey museum and the rhetorical oneness of the public for art, we now see that no one museum can please, or serve, all of the people all of the time. Nor can it serve everything we might want to call art. A hundred years ago mainstream art museums stood alone at the center of a community defining art and embracing all citizens; now those same museums struggle to represent everything we want to call art and patently serve some sectors of the public better than others. They are now joined by dozens of alternative museums and display spaces accommodating a range of artistic production and targeting previously under-served interests and publics. Where the Metropolitan Museum fails to serve the ethnically diverse communities of New York or the burgeoning interest in contemporary art, the Studio Museum of Harlem, the Museo del Barrio, the Jewish Museum, the Asia and Japan Societies, and a host of other small museums and commercial galleries may fill the gap. If the British Museum displays its Benin bronzes as art and fails to acknowledge the disputed circumstances of their acquisition, the Horniman Museum in south London provides an alternative perspective and moreover includes the opinions of Nigerians living in London. Where the Boston Museum of Fine Arts displays African masks as autonomous works of art, the Peabody Museum across the river in Cambridge provides a rich sociocultural context for the same class of objects. This is not to say that the Met or any other museum should stop trying to expand its appeal, but to suggest that institutional constraints within a given museum may circumscribe the way it displays and interprets its art and the publics to whom it will appeal. At the same time, the Met is clearly serving its current visitors very well, as is the Fogg whose primary public

(students, professionals) is more specialized than the Met's. Those museums may be in a position to resist the changes taking place in art museums around them and if they do all the better for those of us who know how to enjoy them. But blockbusters serve a purpose as well, and in any case they are here to stay for the foreseeable future. Temporary exhibitions in the postmodern era have expanded the possibilities of what may be shown in an art museum and, at least to some extent, the publics who attend. Though such exhibitions, and the shops and visitors that come with them, may offend traditional sensibilities it is worth pointing out that in most art museums, even those that have thoroughly espoused the blockbuster mentality, the galleries housing the permanent collection are as quiet and open to aesthetic contemplation as they ever were.

Increasingly different in themselves, museums serve different purposes for different people; and of course they also serve different purposes for the same people. It is the diversity and flexibility of art museums – their ability to give various publics a variety of experiences across a broad museological landscape – that will ensure their survival in the long run.

Notes

1 Quoted by Thomas Crow, *Painters and Public Life in Eighteenth-Century Paris* (New Haven and London: Yale University Press, 1985), p. 10.
2 See Krzysztof Pomian, *Collectors and Curiosities: Paris and Venice 1500–1700*, trans. E. Wiles-Portier (Cambridge: Polity Press, 1990), especially the essay "Between the Visible and the Invisible." Also Hans Belting, *Likeness and Presence: A History of the Image before the Era of Art* (Chicago: University of Chicago Press, 1993).
3 See John Barrell, *The Political Theory of Painting from Reynolds to Hazlitt* (New Haven and London: Yale University Press, 1986) and Iain Pears, *The Discovery of Painting: The Growth of Interest in the Arts in England 1680–1768* (New Haven and London: Yale University Press, 1988).
4 Quoted by Philip Conisbee, *Painting in Eighteenth-Century France* (Oxford: Phaidon, 1981), p. 46. Coypel was no doubt following the abbé Du Bos who earlier (1719) had expanded the public for art to include the bourgeoisie, but "only those who have attained enlightenment, either by reading, or by commerce with the world." *Réflexions sur la poésie et sur la peinture*, vol. II, 4th edn. (Paris: P.J. Mariette, 1740), p. 279.
5 See Andrew McClellan, "Watteau's Dealer: Gersaint and the Marketing of Art in Eighteenth-Century Paris," *Art Bulletin* 78 (September 1996), pp. 439–53.
6 On early modern European museums, see Edouard Pommier, ed., *Les musées en Europe à la veille de l'ouverture du Louvre* (Paris: Klincksieck, 1995); also Germain

Bazin, *The Museum Age*, trans. Jane van Nuis Cahill (New York: Universe Books, 1967).

7 See Andrew McClellan, *Inventing the Louvre: Art, Politics, and the Origins of the Museum in Eighteenth-Century Paris* (Berkeley and London: University of California Press, 1999) and Carol Duncan, *Civilizing Rituals: Inside Public Art Museums* (London and New York: Routledge, 1995).

8 William Shepherd, *Paris in 1802 and 1814* (London: Longman, 1814), p. 52.

9 McClellan, *Inventing the Louvre*, pp. 8–12.

10 John Scott, *A Visit to Paris in 1814* (London: Longman, 1815), p. 57.

11 Sir John Deal Paul, *Journal d'un voyage à Paris au mois d'août 1802* (Paris: Picard, 1913).

12 Dr. G. F. Waagen, "Thoughts on the New Building to be Erected for the National Gallery of England," *Art Journal* V (May 1, 1853), p. 123. On the museum as utilitarian institution, see Tony Bennett, *The Birth of the Museum* (London and New York: Routledge, 1995).

13 On Waagen and the Berlin museum, see Carmen Stonge, "Making Private Collections Public: Gustav Friedrich Waagen and the Royal Museum in Berlin," *Journal of the History of Collections* 10 (1998); and James Sheehan, *Museums and the German Art World* (Oxford University Press, 2000).

14 Quoted by Louise Purbick, "The South Kensington Museum: The Building of the House of Henry Cole," in Marcia Pointon, ed., *Art Apart: Art Institutions and Ideology Across England and North America* (Manchester and New York: Manchester University Press, 1994), p. 77.

15 Matthew Arnold, *Culture and Anarchy*, edited by Samuel Lipton (New Haven and London: Yale University Press, 1994).

16 *The Works of John Ruskin*, edited by E. T. Cook and A. Wedderburn, 39 vols. (London: Geo. Allen), vol. 30 (1907), p. 53; vol. 34 (1908), p. 247. On Ruskin, see Catherine W. Morley, *John Ruskin: Late Work, 1870–1890. The Museum and Guild of St. George: An Educational Experiment* (New York: Garland, 1984).

17 Quoted by Frances Borzello, *Civilizing Caliban: The Misuse of Art, 1875–1980* (London and New York: Routledge, 1987), p. 109.

18 Quoted by Charlotte Klonk, "Charles Eastlake and the National Gallery of London," *Art Bulletin* LXXXII (June 2000), p. 331.

19 Borzello, *Civilizing Caliban*, pp. 42–4.

20 Quoted by Seth Koven, "The Whitechapel Picture Exhibition and the Politics of Seeing," in Daniel J. Sherman and Irit Rogoff, eds., *Museum Culture: Histories, Discourses, Spectacles* (Minneapolis: University of Minnesota Press, 1994), p. 34.

21 Borzello, *Civilizing Caliban*, pp. 33, 51ff.

22 Henrietta O. Barnett, "Women as Philanthropists," in Theodore Stanton, ed., *The Woman Question in Europe* (New York: G. P. Putnam, 1884), pp. 124–5; and "Pictures for the People," in *Practicable Socialism* 2nd edn. (London: Longman, 1894).

23 See the excellent history of the V & A by Anthony Burton, *Vision & Accident: The Story of the Victoria & Albert Museum* (London: V & A Museum, 1999).

24 William Stanley Jevons, *Methods of Social Reform* (London: Macmillan, 1883), p. 8.

25 Sir Henry Cole, *Fifty Years of Public Work*, 2 vols.(London: George Bell, 1884), vol. II, pp. 368.

26 Ibid., vol. II, 346.

27 Ibid., vol. II, p. 302; in a lecture at the École centrale d'architecture in Paris in 1867, he described museums as "une espèce de monument socialiste, où le niveau est le même pour tous."

28 Thomas Greenwood, *Museums and Art Galleries* (London: Simpkin, Marshall & Co: 1888), pp. 20, 26–7. Also see Giles Waterfield, *Palaces of Art: Art Galleries in Britain* (London: Dulwich Picture Gallery, 1991).

29 Greenwood, *Museums*, p. 153.

30 Ruskin, *Works*, vol. 34, p. 250. Echoing Ruskin, a National Gallery report of 1886 said the museum should avoid becoming, "especially on cold and wintry nights, the resort of a class of persons whose presence would be most undesirable." Quoted by Borzello, *Civilizing Caliban*, p. 42.

31 Edward Bradbury, "A Visit to Ruskin's Museum," *Magazine of Art* 3 (1879–80), p. 58.

32 Ruskin, *Works*, vol. 30, p. 48ff.

33 Bennett, *The Birth of the Museum*, p. 98 and passim. Codes of behavior were also put in place in France; see Daniel J. Sherman, *Worthy Monuments: Art Museums and the Politics of Culture in Nineteenth-Century France* (Cambridge, MA & London: Harvard University Press, 1989).

34 Arnold, *Culture and Anarchy*, p. 48.

35 Ibid., p. 128.

36 Ibid., p. 90.

37 Ibid., p. 106–8.

38 Greenwood, *Museums*, p. 249ff.

39 Burton, *Vision & Accident*, 127ff.

40 Arnold, *Culture and Anarchy*, pp. 29–30.

41 Cole, *Fifty Years of Public Work*, vol. II, p. 293.

42 See the essays by Luce Abélès and Dominique Poulot in Chantal Georgel, ed., *La Jeunesse des Musées*, (Paris: Musée d'Orsay, 1994), pp. 316–50; and Borzello, *Civilizing Caliban*.

43 William Hazlitt, "The Angerstein Gallery," *The London Magazine* XXXVI (December 1822), pp. 489–90.

44 Greenwood, *Museums*, p. 11.

45 Barnett, "Pictures for the People," p. 185.

46 Quoted by Borzello, *Civilizing Caliban*, p. 118.

47 William Stanley Jevons, "The Use and Abuse of Museums," in *Methods of Social Reform*, p. 60.

48 Greenwood, *Museums*, p. 182.

49 Ibid., pp. 7–8.

50 George Brown Goode, "Museum History and Museums of History," *Report of the Smithsonian Institution* (1897), part II.

51 Ruskin, *Works*, vol. 34, p. 247.

52 Greenwood, *Museums*, p. 26.

53 "Visitors to Pennsylvania Museum Express Preference for Period Rooms," *Art News* 28 (December 7, 1929), p. 9.

54 Justus Brinckmann, *Das Hamburgische Museum für Kunst und Gewerbe* (Hamburg, 1894), pp. v–vi; cited by Burton, *Vision & Accident*, pp. 158–9.

55 Alfred Mayer, "Educational Efficiency of our Museums," *North American Review* 177 (July–December 1903), p. 565.

56 R. T. H. Halsey and Elizabeth Tower, *The Homes of our Ancestors, as shown in the American Wing of the Metropolitan Museum of Art* (New York: Doubleday, 1925), p. xxii.

57 General Luigi Palma di Cesnola, *An Address on the Practical Value of the American Museum* (Troy, NY: Stowell Printing House, 1887), p. 10. Cesnola was the first director of the Metropolitan Museum in New York.

58 *Museum of Fine Arts Bulletin*, VII (1909), p. 19. On this historical moment, see Walter Muir Whitehill, *Museum of Fine Arts Boston. A Centennial History*, 2 vols. (Cambridge, MA: Belknap Press, 1970), and Alan Wallach, *Exhibiting Contradiction. Essays on the Art Museum in the United States* (Amherst: University of Massachusetts Press, 1998).

59 Benjamin Ives Gilman, *Museum Ideals of Purpose and Method*, 2nd edn. (Boston: Museum of Fine Arts, 1923), p. 42. Gilman mentioned the low opinion held by foreigners of American culture, pp. 70–2.

60 Charles L. Hutchinson, "The Democracy of Art," *American Magazine of Art* 7 (August 1916), p. 398.

61 Mrs. Schuyler van Rensselaer, "The Art Museum and the Public," *North American Review* 205 (January 1917), pp. 81, 90; also see Florence Levy, "The Service of the Museum of Art to the Community," *American Magazine of Art* 15 (November 1924), pp. 581–7.

62 T. J. Jackson Lears, *No Place of Grace: Antimodernism and the Transformation of American Culture, 1880–1920* (Chicago and London: University of Chicago Press, 1994).

63 To this day museums flatter potential donors in these terms; see, for example, *Merchants and Masterpieces*, a VHS video co-produced by the Metropolitan Museum of Art and WNET/13 (1989) and narrated by Philippe de Montebello.

64 Otto Wittmann, *Art Values in a Changing Society* (Toledo, OH: Toledo Museum of Art, 1974), pp. 18–19.

65 Frank Jewett Mather, "Two Theories of Museum Policy," *The Nation* 81 (December 28, 1905), pp. 518–19; also *Burlington Magazine* IX (1906), pp. 62–3; XIII (1908), 319–22.

66 *Bulletin of the Museum of Fine Arts, Boston* VII (December 1909), p. 44.

67 *Bulletin of the Museum of Fine Arts, Boston* VIII (August 1910), p. 28. The docent service was first offered in 1895, two years after Gilman joined the museum.

68 *Museum of Fine Arts, Boston. Forty-First Annual Report for the Year 1916* (Boston: Metcalf, 1917).

69 *Bulletin of the Museum of Fine Arts, Boston* IX (August 1911), p. 40.

70 *Bulletin of the Museum of Fine Arts, Boston* VII (April 1909), p. 18.

71 Gilman, *Museum Ideals*, pp. 61, 68, 303.

72 John Cotton Dana, *A Plan for a New Museum* (Woodstock, VT: The Elm Tree Press, 1920), p. 16; and *The New Museum* (Woodstock, VT: The Elm Tree Press, 1917), p. 32. Carol Duncan is currently preparing a study of Dana and the Newark Museum.

73 John Cotton Dana, *The Gloom of the Museum*, (Woodstock, VT: The Elm Tree Press, 1917), pp. 6, 8. Two important articles by Paul DiMaggio apply these insights to Boston's Museum of Fine Arts, "Cultural Entrepreneurship in Nine-teenth-Century Boston, I and II" *Media, Culture, and Society* 4 (1982), pp. 33–50, 303–22.

74 Dana, *The Gloom of the Museum*, pp. 14, 20–1; Dana, *Should Museums Be Useful?* (Newark, NJ: The Museum, 1927), p.2

75 Theodore L. Low, *The Educational Philosophy and Practice of Art Museums in the United States* (New York: Columbia University Press, 1948), p. 46.

76 The Toledo Museum of Art is a good example, see *The Museum Educates* (Toledo, OH: Toledo Museum of Art, 1935). A fine history of museum education is provided by Terry Zeller, "The Historical and Philosophical Foundations of Art Museum Education," in N. Berry and S. Mayer, eds., *Museum Education: History, Theory, and Practice* (Reston, VA: Art Education Association, 1989), pp. 10–89.

77 Richard Bach, "The Fogg Museum of Art," *Architectural Record* 61 (June 1927), p. 476; also Clarence Stein, "Making Museums Function," *Architectural Forum* 56 (June 1932), p. 612.

78 Greenwood, *Museums and Art Galleries*, p. 178. The British Museums Associa-tion was founded in 1889; in 1932 it published guidelines for the recruitment of curators, the top priorities being a university education and a deep knowledge of a chosen field, *Mouseion* 6 (1932), pp. 130–1. The American Association of Museums was founded in 1906; the Deutscher Museumbund in 1917.

79 Thomas Munro, "The Place of Aesthetics in the Art Museum," *College Art Journal* VI (Spring 1947), p. 183. Gisela Richter, curator of Classical Art at the Met, defined the curators four main priorities as the selection of new acquisitions, conservation, installation, and publication, "What is the Proper Training for Museum Work From the Point of View of the Curator?" *Museum News* XIII (January 2, 1936), p. 7.

80 On Sachs and his Museum Course, see Sally Anne Duncan, *Paul J. Sachs and the Institutionalization of Museum Culture between the World Wars* (Ph.D. Disserta-tion, Tufts University, 2001).

81 Paul J. Sachs, "Why is a Museum of Art," *Architectural Forum* (September 1939), p. 198.

82 Dana, *The Gloom of the Museum*, p. 23. For Gilman scholarship was a secondary function of the museum, *Museum Ideals*, pp. 95–7, 108.

83 Theodore L. Low, *The Museum as Social Instrument* (New York: Metropolitan Museum of Art, 1942), p. 9; also *The Educational Philosophy and Practice of Art Museums*, pp. 10, 88–90.

84 Low, *The Museum as Social Instrument*, p. 17.

85 Ibid., p. 9.

86 Low, *The Educational Philosophy and Practice of Art Museums*, p. 190.

87 Francis Henry Taylor, *Babel's Tower. The Dilemma of the Modern Museum* (New York: Columbia University Press, 1945), pp. 22–3, 51.

88 Low, *The Museum as a Social Instrument*, p. 11.

89 Victor d'Amico "The Museum of Art in Education," *Art Education Today* (1941), p. 51, quoted by Low, *Educational Philosophy*, p. 80.

90 Philip Youtz, "Museumitis," *Journal of Adult Education* 6 (1934), pp. 387, 391; also "Museums Among Public Services," *Museum News* XI (September 15, 1933), pp. 7–9.

91 Philip Youtz, "The Sixty-Ninth Street Branch Museum of the Pennsylvania Museum of Art," *Museum News* X (December 15, 1932), pp. 6–7. On branch museums, also see Paul M. Rea, *The Museum and the Community* (Lancaster, PA: The Science Press, 1932); and *Museum News* XIII (January 1, 1936) p. 1.

92 See, for example, the monthly bulletins of the Wadsworth Atheneum, Hartford and the Art Institute of Chicago from the early 1930s.

93 *The Museum Educates*, not paginated. Elsewhere the brochure states that in "art appreciation" classes "Students grow familiar with emotional and mental pleasures derived from textures, line, color, volume, space, rhythm, tone. They are acquainted with these qualities emerging at their highest potency from master works."

94 See Mary Anne Staniszewski, *The Power of Display: A History of Exhibition Installation at the Museum of Modern Art* (Cambridge, MA and London: MIT Press, 1998), p. 81 and passim.

95 See Thomas Crow, "The Birth and Death of the Viewer: On the Public Function of Art," in Hal Foster, ed., *Discussions in Contemporary Culture* 1 (Seattle, WA: Bay Press, 1987), pp. 1–8.

96 *Exposition Internationale de 1937. Musées et expositions. Section 1: Muséographie* (Paris: Denoel, 1937), pp. 18–19 (my translation). For the Madrid conference, see *League of Nations: International Study Conference on the Architecture and Equipment of Museums* (Madrid, 1934).

97 Gilman, *Museum Ideals*, p. 78.

98 Ibid., pp. 342–3.

99 Arthur Melton, *Problems of Installation in Museums of Art* (Washington, D.C.: American Association of Museum, 1935), p. 11.

100 T. R. Adam, *The Civic Value of Museums* (New York: American Association for Adult Education, 1937), p. 25.

101 Sir Kenneth Clark, "Ideal Picture Galleries," *Museums Journal* 45 (November 1945), p. 133.

102 James R. Johnson and Adele Z. Silver, *The Educational Program of the Cleveland Museum of Art* (Cleveland, OH: Cleveland Museum of Art, 1971), p. 26.

103 Gilman, *Museum Ideals*, p. 109.

104 Walter Pach, *The Art Museum in America. Its History and Purpose* (New York: Pantheon, 1948), p. 210.

105 Quoted by Burton, *Vision & Accident*, p. 179.

106 Eric Maclagen, "Museums and the Public," *Museums Journal* 36 (August 1936), p. 182.

107 John Walker, *Self-Portrait with Donors. Confessions of an Art Collector* (Boston: Little, Brown & Co., 1974), pp. 51–2.

108 See Brian O'Doherty, *Inside the White Cube. The Ideology of the Gallery Space* (San Francisco: Lapis Press, 1986), p. 42.

109 On Soviet museology, see Theodore Schmit, "Les Musées de l'Union des Républiques Socialites Soviétiques," in P. d'Espezel and G. Hilaire, eds., *Musées* (Paris: Cahiers de la République des Lettres, des Sciences et des Arts, n.d.), pp. 206–21; on labor union views on museums, see Mark Starr, "Museums and the Labor Unions," *Museum News* 26 (January 1, 1949), 7–8. Starr was Educational Director of the International Ladies' Garment Workers' Union in New York.

110 See Staniszewski, *The Power of Display*.

111 *The Arts Enquiry. The Visual Arts. A Report Sponsored by the Dartington Hall Trustees* (Oxford University Press, 1946), p. 145; quoted by Burton, *Vision & Accident*, p. 186.

112 Low, *The Museum as Social Instrument*, pp. 24–30.

113 Thomas P. F. Hoving, "Branch Out!" *Museums News* 47 (September 1968), p. 15.

114 Ibid., p. 16. On the 1960s and beyond, see Neil Harris, "The Divided House of the American Art Museum," *Daedalus* 128 (Summer 1999), pp. 32–56.

115 Hoving gives a brief account of these changes in his autobiography, *Making the Mummies Dance* (New York: Simon and Schuster, 1993).

116 I. Michael Heyman, "A New Day Begun," *Smithsonian Magazine* (August 1999; *http://www.smithsonianmag.si.edu/smithsonian/issues99/aug99/heyman_aug99.html*); also see Caryl Marsh, "A Neighborhood Museum that Works," *Museums News* 47 (October 1968), pp. 11–16; John Kinard, "To Meet the Needs of Today's Audience," *Museum News* 50 (May 1972), pp. 15–16; and Emily Dennis, "Seminar on Neighborhood Museums," *Museum News* 48 (January 1970), pp. 13–18.

117 S. Dillon Ripley, *The Sacred Grove. Essays on Museums* (Washington, D.C.: Smithsonian Press, 1969), p. 105.

118 Ibid., p. 73.

119 "New York Annual Meeting: Going to Meet the Issues," *Museum News* 49 (September 1970), p. 18. Among the strident resolutions proposed by a set of AAM delegates was more organized effort to address the problems of "racism, sexism, repression and war" and increased opportunities for women, minorities and "other oppressed people."

120 Ibid., p. 19.

121 See, for example, Detroit Institute of Art, *Two Years Later: A Report on "Project Outreach" to the National Endowment for the Arts* (ca. 1971); *Museums: Their New Audience* (Washington, D.C.: AAM, 1972); *Museums USA* (Washington, DC: NEA, 1974); *Museum News* 55 (January/February 1977). A meeting of the International Council of Museums in 1974 agreed that museums were becoming more like "cultural centers for the communities within which they operate"; not merely "storehouses or agents of preservation...but powerful instruments of education." Quoted by Kenneth Hudson, *Museums for the 1980s* (New York: Holmes & Meier, 1977), p. 1. In Britain from the 1960s the Labour Party has urged greater social responsibility on museums, see Mark Wallinger and Mary Warnock, eds., *Art For All? Their Policies and Our Culture* (London: Peer, 2000), pp. 146–9 and passim. A useful survey of recent trends is provided by Stephen E. Weil, "From Being *about* Something to Being *for* Somebody: The Ongoing Transformation of the American Museum," *Daedalus* 128 (Summer 1999), pp. 229–58.

122 Donald Preziosi has reflected a good deal on the relationship between museums and the discipline of art history; see, for a start, "The Art of Art History," in his *The Art of Art History: A Critical Anthology* (Oxford and New York: Oxford University Press, 1998), pp. 507–25.

123 Pierre Bourdieu and Alain Darbel, *The Love of Art: European Art Museums and Their Public* [1969], trans. C. Beattie and N. Merriman (Cambridge: Polity Press, 1991); Pierre Bourdieu, *Distinction: A Social Critique of the Judgement of Taste* [1979], trans. R. Nice (Cambridge, MA: Harvard University Press, 1984).

124 Margaret Mead, "Museums in a Media-Saturated World," *Museum News* 49 (September 1970), pp. 23–6.

125 See Michael Conforti, "Hoving's Legacy Reconsidered," *Art in America* (June 1986), pp. 19–23.

126 Franz Schulz described the Pei wing as "a temple of cultural democracy," *Art News* 80 (November 1981), p. 132.

127 Rudolph Morris, "Leisure Time and the Museum," *Museum News* 41 (December 1962), pp. 17–18.

128 Alan Wallach, "Class Rites in the Age of the Blockbuster," *Harvard Design Magazine* 11 (Summer 2000), pp. 48–54.

129 See Rosalind Krauss, "The cultural logic of the late capitalist museum," *October* 54 (1990), pp. 3–17, who anticipated much of what Krens has done.

130 Jonathan Maher, "High Culture Hits the Strip," *Talk* (May, 2001), pp. 84–5. On Krens also see, Michael Kimmelman, "The Globe Straddler of the Art World," *New York Times* (April 19, 1998) and Peter Plagens, "In a Spiral," *Newsweek* (May 20, 1996).

131 Adam Gopnik, "The Death of an Audience," *The New Yorker* (October 5, 1992), pp. 142–6. On mass culture, entertainment, and nostalgia see the essays by Edward Shils and Hannah Arendt in N. Jabobs, ed., *Culture for the Millions? Mass Media in Modern Society* (Princeton, NJ: D. Van Nostrand, 1961).

132 *Museums for A New Century*, pp. 19, 60, 104.

133 James Johnson Sweeney, "The Artist and the Museum in Mass Society," in Jacobs, *Culture for the Millions?* p. 95.

134 Walker, *Self-Portrait*, p. xiv

135 Ibid., p. 28.

136 Ibid.

137 Sherman Lee, "The Art Museum in Today's Society," *Dayton Art Institute Bulletin* 27 (March 1969), quoted by Zeller, "Historical and Philosophical Foundations," p. 31.

138 Grace Glueck, "The Ivory Tower Versus the Discotheque," *Art in America* (May–June 1971), pp. 80–5.

139 James Cuno, "Art museums should get back to basics," *Boston Globe* (October 26, 2000); and "In the Crossfire of the Culture Wars: The Art Museum in Crisis," Occasional Papers, Harvard University Art Museum, no. 3 (1995); Philippe de Montebello, "Musings on Museums," *CAA News* (March–April 1997); Calvin Tomkins, "The Importance of Being Elitist," *The New Yorker* (November 24, 1997); "Hip vs. Stately: The Tao of Two Museums," *The New York Times* (February 20, 2000), pits Krens and Montebello against each other, much as Hoving and Lee were pitted against each other thirty years earlier. Also see the forthcoming collection of essays by Cuno, Montebello and others, delivered as a series of lectures, "Art Museums and the Public Trust," at Harvard University in 2001–2.

140 See John Coolidge, *Some Problems of American Art Museums* (Boston: Club of Odd Volumes, 1953), p. 18; and Nelson Goodman, *Of Mind and Other Matters* (Cambridge, MA: Harvard University Press, 1984), p. 179.

141 David Sylvester, "Mayhem at Millbank," *London Review of Books* 22 (May 18, 2000); Jed Perl, "Welcome to the Funhouse," *The New Republic* (June 19, 2000). For an explanation of the Tate philosophy, see Nicolas Serota, *Experience or Interpretation: The Dilemma of Museums of Modern Art* (London and New York: Thames & Hudson, 1996) and Iwona Blazwick and Francis Morris, *Tate Modern: The Handbook* (Berkeley and London: University of California Press, 2000). On the Orsay, see Andrea Kupfer Schneider, *Creating the Musée d'Orsay: The Politics of Culture in France* (University Park, PA: Penn State Press, 1998).

142 Cuno, "In the Crossfire of the Culture Wars," p. 3.

143 *Museums for a New Century*, p. 55.

144 R. L. Duffus, *The American Renaissance* (New York: Knopf, 1928), p. 239.

145 Bryan Roberston, "The Museum and the Democratic Fallacy," in Brian O'Doherty, ed., *Museums in Crisis* (New York: Braziller, 1972), p. 79. T. R. Adam had said much the same in 1937, *Civic Value of Museums*, p. 54.

146 See, for example, Beth B. Schneider, *A Place for All People* (Houston, TX: Museum of Fine Arts, 1998), which documents an extraordinary outreach program funded by a host of institutional grants. *Museums for a New Century*

(1984), p. 57, noted that most of the outreach efforts described in *Museums: Their New Audiences* of 1972 no longer existed.

147 John H. Falk, "Visitors: Who Does, Who Doesn't and Why," *Museum News* (March–April 1998), p. 38ff.

148 Robert Coles, "The Art Museum and the Pressures of Society," in Lee, *On Understanding Art Museums*, pp. 185–202.

149 Blake-More Godwin, "What the small museum can do," *American Magazine of Art* (October 1927), p. 529.

150 *The Art Newspaper* (July–August 2000), p. 10.

151 Lord Freyberg, House of Lords debate, November 1999, quoted by Wallinger and Warnock, *Art for All?* p. 55.

152 Vera L. Zolberg, "Tensions of Mission in American Art Museums," in Paul Di Maggio, ed., *Nonprofit Enterprise in the Arts* (Oxford and New York: Oxford University Press, 1986), p. 185.

Plate 3 I. M. Pei, Pyramid, Louvre Museum, Paris, 1983–9. Photograph by Andrew McClellan.

Having One's Tate and Eating It:
Transformations of the Museum in a Hypermodern Era

Nick Prior

Manet's barmaid, a Degas ballerina – all are gleefully slashed. Behind him,
The Joker's ugly goons have their work cut out for them. Spraying paint on
every canvas their boss man missed. He finally stops at Edward Munch's The
Scream *and cocks an eyebrow. 'I kinda like this one. Leave it.'*
<div align="right">(Batman: The Art of Crime, DC Comics)</div>

In the new terrain of hyperactive consumer culture, the museum is caught
in a bind. It can't turn itself into a successful "distraction machine"[1] –
providing diversion in a world already saturated with entertainment –
without, it seems, threatening the aura of its grand traditions and the
presence of a culturally elevated audience. Where William Hazlitt once
extolled England's National Gallery, then at Angerstein's house in Pall
Mall, as a "sanctuary, a holy of holies, collected by taste, sacred to fame,
enriched by the rarest products of genius,"[2] today's expansive audience
descends on the museum with a more secular thirst for visual experience.
Indeed, it's become an orthodoxy in academic writings on postmodern
culture to record the death rattle of the project of the museum as it
was forged in the crucible of European Enlightenment.[3] Here, aesthetic
contemplation has been replaced by amusement, silence by bustle, educa-
tion by infotainment, respect by relativism. Museums, it is said, are an

endangered species, lumbering dinosaurs of a Victorian era of "rational recreation" and bourgeois solemnity, already displaced by a new breed of easy-learning playgrounds, science centers, and high-tech pleasure domes. In the following essay, I will attempt to assess this vision of a museological endgame, drawing not only upon the theoretical commentaries common to cultural studies, but also an emerging sociological literature on museums.

Whilst museums are certainly at a crucial juncture in their history, this chapter suggests a more complex diagnosis involving the rise of hybridized "hypermodern" organizations.[4] The most successful of these tap into a key feature of contemporary cultural trends – that of double-coding. The museum might have mutated to cater for a more fickle audience hankering after spectacle, but in many ways it has done so by combining elements of tradition with consumer populism, drawing on, whilst transforming, cultural modernity. Indeed, the most astute and dynamic directors of artistic institutions are those who understand and exploit the dualistic nature of museums, tapping into and enlarging the rich vein of meanings possible in contemporary culture. This suggests that museums are not just passive loci of external patterns and processes but self-reflective agents of social and cultural change themselves. A contemporary sociological approach to museums is more revealing of these ambiguities and more precise in its characterization of the issues and challenges facing the art museum today.

But for a moment, let us consider why critics are heralding a profound transformation of the museum such that it is flung headlong into a world of cultural hedonism and fragmentation fit for an audience *The Joker* would not look out of place in.

Museums and the Trans-Aesthetics of *Sensation*

During the autumn of 1997, the Royal Academy in London hosted one of the most controversial exhibitions of recent times, *Sensation*. Nestled within the spaces of this formerly patrician institution were the works of a feisty generation of *agents provocateurs* famous for their cut-up sheep, stained bed-sheets, and self-portraits cast in blood. Already subject to the kind of hype and branding reserved for new cars and designer fragrances, the "yBas," young British artists, comprised a synergistic package that included Irvine Welsh's *Trainspotting*, football, "new laddism," and an

outpouring of national self-confidence known as "cool Britannia." And it was a profitable package. What united the objects in *Sensation* was Charles Saatchi, one of a new breed of super-patrons whose collection this was. Famous for heading up one of the most dynamic corporate advertising companies of the modern era, Charles Saatchi has become a new Medici of modern Britain, exercising a virtual monopoly over contemporary British art.[5]

The collection spewed out of Saatchi's private London gallery into the public sphere and turned the swaggering artists (Damian Hirst, Tracey Emin, Rachel Whiteread) into household names. Scandal attracting exhibits like Marcus Harvey's portrait of child-killer Myra Hindley – a huge canvas composed of prints from the cast of a child's hand – fuelled the outrage.[6] And whilst the Royal Academy defended its exhibition by appealing to a respectable tradition of severed limbs and polymorphous perversity in European art history, controversy wasn't bad for business either. After attracting 300,000 people to the Royal Academy, the show toured venues in Berlin and New York, the latter after attempts by the Mayor to close it down on moral grounds failed.[7]

As a powerful social metaphor and as an instrument of historical representation, museums are crucial barometers of social change.[8] Like the Royal Academy, their role and function have been transformed over the last thirty years to cater for complex and sometimes contradictory demands.[9] From the introduction of plural funding strategies and tougher-minded boards of trustees, to heightened accountability and intensified public scrutiny, museums have been placed in a supercharged climate in which adaptation, flexibility, and product diversification are the watchwords.

One way of characterizing these changes is to subsume them under the category of postmodernity – a term designated to describe a sea-change in the social, economic, and political organization of Western societies[10] – and then analyze the contemporary museum as a particular product of this condition. The museum, in this analysis, has become a key exemplar of postmodern trends. Stripped of the Enlightenment values of authenticity, progress, and judgment, the postmodern museum, instead, feeds the "inflationary era" of late capitalism and its "anything goes" market eclecticism. European modernism's pantheon, it follows, no longer stands for aesthetic progress but extends the culture of spectacle – feeding an art of a relentlessly expanding world of commerce and merchandising.[11]

This form of analysis has been particularly influential amongst postmodern writers linked to the cultural studies tradition, such as Frederic Jameson, Jean Baudrillard, and Mike Featherstone. According to these critics, the postmodern museum has become, like other spaces of entertainment, an "apparatus of capture"[12] – a region of cultural intensity designed to control movement, order desire, and translate them into habits of consumption. At the Louvre, for instance, once the exemplar of artistic progress and French cultural domination, the confluence of commerce and art is seen as both a cause for concern and a postmodern delight.[13] In 1993, a shopping mall was installed in the Richelieu Wing, running directly into the heart of Europe's first great museum and lavishly promoted in Metro station posters exploiting the Louvre's most well-known image, the *Mona Lisa*.[14] One such advert juxtaposed the icon with oversized text declaring the presence of "51 stores at her feet," a reference to the location of the mall below the galleries where the painting is housed. A further advertisement depicted a detail of the *Mona Lisa*'s hands above a list of the various shops in La Carrousel du Louvre. Not only can one now access the permanent collections through the underground shopping mall – from Virgin Megastore to Raphael's *The Virgin* in one fell swoop – but bathe in the postmodern interplay of art and commodity in a universe of declassified signs and images.

The effect is suitably capped by I. M. Pei's immense glass pyramid entrance to the "Grand Louvre," itself a forceful emblem of an ambient culture in which architecture – the "new cool" – competes with the art object for attention.[15] It's somehow only half surprising that Robert Venturi, architect of the Sainsbury Wing of the National Gallery in London (an extension financially endowed, incidentally, by a British supermarket chain), pairs the gallery with sports stadia in the scale and crowds attracted to both.[16] For commerce and culture are now increasingly melded into a seamless entity, further withering the line between high culture and popular culture, and turning the museum into a playpen of consumption.[17] The visual art complex itself has grown massively to accommodate accelerated levels of entertainment and sense experience, drawing the museum into the ruthless business of crowd-pulling. Hence, the shop and the café – definitively postmodern spaces, in this argument – are now lodged at the heart of the museum: not necessarily somewhere to go *after* the visit as an adjunct to aesthetic experience, but a prime locus of consumption itself.[18]

And this is happening, in many cases, at the behest of directors and boards of trustees. Since the mid-1980s, established boards of trustees have been replaced with enterprise culture managers whose sole purpose has been to bring museums into line with the "for-profit" sector of the economy. One such instance has been the Victoria and Albert Museum in London, which has undergone a series of makeovers since the 1980s, including a Saatchi and Saatchi campaign in the 1990s stating it to be "an ace caff with quite a nice museum attached." It has lent paintings to Harrods, put on co-exhibitions with Habitat and Burberry's and arranged a pre-auction exhibition of Elton John memorabilia. In 1985, Sir Roy Strong of the V&A stated that the future of the museum was bright and predicted that the museum "could be the Laura Ashley of the 1990s" (quoted by Robert Hewison).[19] In 1988, the V&A marketing manager, Charles Mills, in a similar vein, declared the museum to be a place as attractive, popular, and replete with consumers as the top London stores. The implication is clear: if culture is "show business"[20] then the art museum (or rather the museum "experience") is one stage where the business of culture is unfolding in ever more concentrated ways.[21]

But where does all this leave the audience for art? What norms of perception instruct the visitor's relationship to the museum's objects? What, in short, is a postmodern museum public? For writers like Baudrillard, Featherstone, and Virilio,[22] the expansive crowds going to the new "supermarkets of culture" move through at a bewildering speed, impatient and carnivorous, no longer searching for aesthetics but agitated in an aesthetics of the search, scanning the cultural horizon for more intense forms of entertainment. Inside the Pompidou Center in Paris, for instance, Baudrillard spies a contradiction between the static objects of a frozen modernist canon and the mass of people who "swarm to enjoy it."[23] And they do swarm, for Baudrillard, like fomented locusts devouring a crop – seeing everything, eating everything, touching everything. The masses "charge at Beaubourg," he says, "as they do to the scenes of catastrophes, and with the same irresistible impulse...their number, their trampling, their fascination, their itch to see and touch everything comprises a behavior that is in point of fact, catastrophic."[24] The catastrophe, in this case, is the collapse of high culture and its meanings – pathos, depth, transcendence – under the weight of mass consumption. The commodity has succeeded, in other words, where avant-garde

groups like the Futurists failed, destroying the very essence of the museum as a realm of autonomy and elite distinction. In its place the masses summon a culture of "simulation" and popular enthrallment, a "manipulatory play of signs without meaning."[25] Or, as Baudrillard himself puts it:

> They are summoned to participate, to interact, to simulate, to play with the models . . . and they do it well. They interact and manipulate so well that they eradicate all the meaning imputed to this operation and threaten even the infrastructure of the building. Thus, a type of parody, of oversimulation in response to the simulation of culture: the masses, meant only to be cultural livestock, are always transformed into the slaughterers of a culture of which Beaubourg is just the shameful incarnation.[26]

The advent of the agitated mass implies a collateral change in the perceptual conventions brought to the museum. Jameson declares new postmodern arenas of visual consumption to be dependent upon a kind of "aleatory" or "schizoid" orientation in which the images of contemporary culture rush towards the senses in random fragments. Under these conditions, the eye is never allowed to settle, but is constantly distracted, drawn into a culture of simultaneous presence, what Jameson calls "the permanent inconsistency of a mesmerising sensorium."[27] The very extension of visual culture – from fashion and advertising to Hollywood and cyberspace – undermines the possibility of aesthetic judgment precisely because aesthetic experience is everywhere. Speed and motion have drowned out the deliberative sensibilities of the disinterested or "pure gaze" called for by Kant and other Enlightenment thinkers. The audience yearns not for the lineaments of moral betterment, refined judgment, or gentlemanly conduct, but for a permissive and hedonistic "trans-aesthetics" characteristic of postmodern sensation. This means, for Virilio at least, "that, as in narcotic states, the series of visual impressions become meaningless. They no longer seem to belong to us, they just exist, as though the speed of light had won out, this time, over the totality of the message."[28]

The age of computer-aided perceptions and wall-to-wall visuals has, from this perspective, colonized sight and dissolved aesthetics. As in McLuhan's description of an "outering of the senses,"[29] consumers of the visual wear their brains on the outside of their skulls, maximally exposed

to the post-aesthetics of titillation and sensation. Naturally, the audience becomes tolerant of art designed to shock (as in *Sensation*) because it has already seen it in the plethora of screens and sensorial domains that constitute the postmodern regime of signs and signification.[30] Just as the dissolution of emotional intensities associated with the bourgeois ego leads to what Jameson calls the "waning of affect" in contemporary culture, so, to use the parlance of postmodern theory, the "derealized" subject is lost in the dizzying universe of an unmappable hyperspace and can only submit to the immediacy of the "hysterical sublime" – "a free-floating and impersonal feeling dominated by a peculiar kind of euphoria."[31]

So, where Malraux once declared photography to have diffused artistic images throughout society, giving rise to the "museum without walls,"[32] commentators are now pointing to a more current metamorphosis that spells the end of the museum itself.[33] It's not just that the rise of "virtual museums" and "24-hour museums" expands the sites through which the museological is accessed, doing away with the physical boundaries of the museum, but that visual culture itself has reached a level of intensity and circulation that makes it no longer possible to differentiate between different domains of the image.[34] In essence, the museum, the theme park, the bank lobby, and the mall are transferable, all equally appreciated in a state of distraction. By this transformation, the foundational principles of the museum – the pure aesthetic, bourgeois contemplation, the disciplinary efforts of the nation-state – disintegrate. I. M. Pei's glass pyramid becomes a headstone on the grave of the project of the museum.

The Audience is Not a Mass

But seductive as this analysis is, there are theoretical and empirical lacunae to be addressed. Cultural commentators are too often disposed to look for indicators of postmodernity in order to make larger sweeping claims about social change, in the process ignoring counter-examples and evidence that falls outside this grand schema. How different social groups "read" museums according to their own social backgrounds and cultural experiences is certainly glossed in these theories. Characterizing the audience as a "mass" fails to capture the sociological coordinates

of the viewing public as well as the complex motivations behind the museum visit. Any analysis of the art museum must move beyond cursory dismissals of the audience as an undifferentiated aggregate in order to grasp the meanings and agendas that shape the visit.

It's clear, for instance, that visiting the art museum remains a fairly *restricted* (rather than mass) social phenomena. Recent surveys have overwhelmingly demonstrated that museum visiting in the UK, Europe as a whole, and the United States is largely a middle-class pastime, despite a new wave of arts policies and culture initiatives. Reference to these studies provides a grounded counterpoint to the often high-falutin rhetoric of postmodern cultural theory.[35] Studies in the United States, for instance, reaffirm DiMaggio, Useem, and Brown's survey of 300 surveys,[36] which found little or no recent change in the socio-economic profile of arts attenders.[37] Efforts to increase access to the arts for those on low incomes have clearly failed, as arts attendance and participation increase dramatically for those in higher income groups and with higher educational status. Whilst figures recently released by the National Endowment for the Arts indicate that around 35% of American adults visit an art museum or gallery at least once during the year, these figures also reveal that, for every arts activity, participation rates increase with higher educational attainment and household income. Only 4.9% of the art gallery public earn $10,000 or less, and only 8% earn $20,000 or less; to put it another way, only 16% of the 15 million people earning an annual income of $10,000 or less visit an art museum at least once a year.[38]

In Britain, museum attendance is significantly lower amongst social groups C2, D, and E – the lower middle and working classes. Individuals from social groups A, B, and C1 – professionals, managers, and the upper/middle strata of the middle classes – are much more likely than other social groups to visit museums. As figure 2.1 below shows, 34% of ABs visited museums in 1993/4, as did 23% of C1s. Lower down the social scale, however, museums appealed to significantly less of the population, only 14% in the case of C2s and 10% in the case of DEs (*Cultural Trends*, 1995: 40). The frequency of visits to museums among lower social groups is also smaller, the norm being just one visit a year.[39] Non-visitors (those who have never visited a museum) are disproportionately represented amongst lower class groups and those who left school at an early age.[40]

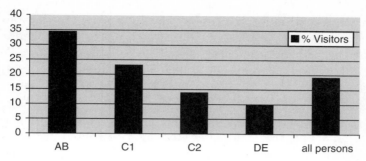

Figure 2.1 Participation at UK museums by social class, 1993/4.
Source: Adapted from *Cultural Trends*, 1995, no. 28.

Museums as Class Distinction and Exclusion

What figures like these show is that the visit maps a relationship between cultural preference and social background, pointing up the importance of sociological links between visiting museums and social class. Bourdieu and Darbel's survey of art museum audiences in 1969[41] may now be a little dated, but the overall conclusion that visiting art museums is a form of cultural distinction remains relevant today.[42]

According to Bourdieu's analysis, social differentials in visiting museums make sense if we accept that high culture legitimates social differences. The "love of art" does not express universal or *a priori* faculties towards aesthetic pleasure, but rests on the possession of class-specific "cultural capital" – particular cultural competences and systems of perception acquired through formal and informal processes of socialization. The sensitivity to experience higher artistic pleasures, a pleasure that for Kant, at least, may be experienced by any human being, is revealed by Bourdieu as the privilege of those who have access to the conditions in which "pure" and "disinterested" dispositions are acquired. Taste, in other words, is not a neutral or free-floating sensibility dependent on individual preferences – as in the phrase "each to their own" – but is a function of one's social position and a means by which higher social groups are marked out as superior.[43] Museum visiting is, therefore, unveiled as a socially differentiated activity relying on the possession of educational and cultural dispositions towards art works and, as such, "almost exclusively the domain of the cultivated classes."[44]

"Free entry," in short, "is also optional entry,"[45] in practice put aside for those who feel at home in the museum's confines. The art museum, for

Bourdieu, comprises a space symbolically opposed to the vulgarities of mass culture, where the values of civilized bourgeois culture are coded and decoded by this class itself. In fact, the very importance of the art museum rests with the fact that it operates within a symbolically potent system of classification, valorized by appropriate cultural experts, discourses, and nationally ordained institutions (orchestras, theatres, and other "serious" civic institutions with established conventions of public demeanor and cultural restraint) that bind elites ever closer to consecrated culture.[46] Museums, therefore, act as the meeting point of class formation and social reproduction, reinforcing the cultural separation of different social classes, and underpinning the sense of belonging of "cultivated" individuals and families in the museum.

By this logic, art museums are felt to be repellent, formidable, or unwelcoming places to visit by lower demographic groups. In the minute details of their functioning, museums demand respectful distance. The hushed reverence, the intimidating atmosphere, the sacred possessions, all serve to separate the aesthetic from the popular, institutionalizing refinement and reinforcing the sense that art has no clear purpose or benefit. In fact, one of the assets of recent *qualitative* social studies of the museum is the focus on the interpretations and meanings given to the visit by attenders and non-attenders alike.[47] Many of these indicate that the working classes find art museums to be irrelevant, that the arts are for "other people," "for the toffs ... people with money. Not for us, simple as that" (cited by Moore).[48] Infrequent visitors are more likely to enter the museum for non-specific or casual reasons – to shelter from the rain, to use the toilets, to pass the time, or to fulfill the requirements of other agencies, such as schools. They are also less likely to see the museum as some kind of library or cultural resource than to see it as a monument to the dead.[49]

Unable to shake the image of the quiet, formal, dusty enclave, museums have, for sociologists like Bourdieu, become low-priority places for the disadvantaged, not least because they make ordinary people feel inferior. On an ethnographic level, Bourdieu and Darbel note that museums provide few, if any, concessions to visitors who lack knowledge of art and artists.[50] Far from being some kind of manic excursion to the fun-house, a trip to an art museum is still suffused with a sense of gentility and religious awe, a fact guaranteed by the solemn and dignified arrangements, as well as vigilant security guards. They are daunting places for these groups, crammed with exhibits that mean nothing to them – "dingy places with different kinds of bits."[51] Unsurprisingly, the lower classes tend to

favor accessible, popular, and affordable forms of entertainment and leisure that provide the stuff of everyday sociability. The highest levels of attendance for these social groups are for the pub, the short-break holiday or the cinema, the latter attracting 38% of C2DE respondents and 48% of the unemployed in one recent survey in Britain.[52]

All this reaffirms the notion that museum meanings are "diversely determined in relation to the class trajectories of the subjects."[53] What people bring to the museum in the way of "cultural capital" is as important as "supply side" issues concerning the museum's artefacts, display arrangements, or norms of behavior. Not only do audience studies show a stark contrast to the postmodern image of a teeming mass descending on the gallery, but they reinforce Bourdieu's declaration that "culture is only achieved by denying itself as such, namely as artificial and artificially acquired."[54] If access to and understanding of high culture express cleavages between low and high social groups, then the result is the widespread symbolic legitimation of the latter as culturally superior. But exclusion is never as effective as when it is self-exclusion, and, inasmuch as the uninitiated lower classes respect (or "misrecognize") the divisions as natural or right, accepting their inability to "play the game," they are complicit in their own definition as inferior.[55] Patterns of social and cultural inequality are thereby internalized and legitimated, a process Bourdieu and Passeron call "symbolic violence."[56]

But, again, some questions and doubts arise here. More than one theorist has noted an implicit functionalism or circularity in Bourdieu's theories. In the main, a Bourdieusian analysis is better at analyzing how culture works to stabilize social arrangements or legitimate a status quo than examining the complexities of social change or rupture.[57] Whilst it might historically be true that one of the main functions of the museum has been to maintain bourgeois norms of distinction and purify itself of lower-class tendencies, we have to ask to what extent it can be reduced to this unitary function today. Is the museum really such a hermetically sealed space hived off for the middle classes? Are lower social groups really so passive and universally excluded? And, if museums are merely conservative agents of social reproduction, how can they ever reflect upon their own function and power, or attempt more open-ended and democratic forms of representation? There remains a need to understand why some groups consistently avoid entering museums, but also, in the wake of an expansion in visual art and museum attendance, as well as, in Britain at least, the scrapping of entry charges for national institutions,

why museums are increasingly self-reflective, popular, and spectacular places.

The Museum as Reflexive Allotrope

Ready-made characterizations of the populist/postmodern museum or the restricted/elite museum are misplaced and imprecise. Both explanations have obvious credibility but they are somewhat too closed and neat to be singularly plausible in these complex times. Graña, for instance, sets up a fairly rigid distinction between patron-oriented museums, represented by the Boston Museum of Fine Arts, and public-oriented museums, represented by New York's Metropolitan Museum of Art.[58] Where the former defends a traditional object-oriented approach, letting the museum's artefacts "do the talking," the latter is a more contemporary manifestation of visitor-centered values, articulating with utilitarian intentions to engage the community in the museum's educational aims. For Graña, these two models of the American museum express distinctions between the orientations of those that run them – the patrician and didactic tendencies of Boston's elite versus the more democratic, status-hungry dispositions of New York's industrialists and financiers.

There is certainly truth in this claim: typological distinctions should be made, for instance, between big "Universal Survey Museums"[59] – often trustee-based, lacking experimental autonomy, and tending to defend values of connoisseurship – and smaller, local art galleries, where institutional obligations towards conventional models are less pressing. If nothing else, then, Graña's distinction alerts us to the sociological conditions under which different museums are founded and run. And yet, such a characterization also overlooks the more complex truth that *all* museums contain elements of *both* orientations. Zolberg points out, for instance, that even in supposedly populist museums, like the Metropolitan Museum of Art and the Art Institute of Chicago, there is as much evidence of institutional elitism and the pursuit of pure scholarship as there is the encouragement of a broad-based public.[60] This is despite the rhetoric claiming a wholehearted commitment to increasing visitor numbers in these institutions. McTavish, similarly, recognizes the residual presence of an elite defense of high art in today's Louvre museum, despite the recent development of La Carrousel du Louvre and the potential declassification of high and low culture.[61] In this case, the cultural authority and national

identity of the Louvre have been reinscribed through a number of strategies – including vetting shops for propriety and excluding undesirable groups from the mall – the ultimate effect of which has been to increase the number of conceptions of the museum that exist simultaneously.

All of this points to the museum as a radically syncretic institution in which variant tendencies coexist – aesthetic contemplation *and* entertainment, connoisseurship *and* consumption, private delectation *and* public provision. Few, if any, museums have pursued a single tendency if it has meant systematically abandoning others.

A case in point is Britain's summer blockbuster of 2001, *Vermeer and the Delft School* at the National Gallery, London. Possessing all the trappings of the *über* exhibition, the show, at first sight, stands as the ideal candidate for the postmodern spectacle. The thirteen Vermeer works at the center of the exhibition generated the kind of media frenzy reserved for football matches and pop concerts.[62] More than 10,000 advance tickets were sold for the exhibition, the highest number of advance bookings in the National Gallery's history; opening hours were extended on Saturdays and Sundays to accommodate 270,000 visitors during the three-month exhibition run; and the commercial spin-offs included a film, an opera, poetry, five works of fiction, a new biography, study tours, websites, customer reviews, as well as the usual selection of souvenirs. Inside the gallery, viewing conditions were, at times, reminiscent of Baudrillard's swarming mass at the Pompidou Center. One bruised and battered reviewer described the "jostling, anxious sea of arty humanity...heaving, shoving and pleading to get into the exhibition," the queues for advance tickets "already stretched back to the street door and the National Gallery's ticket computers, used to running at a more sedate pace...showed dangerous signs of wobble."[63] On television, Vermeer mania swept arts review programs and news items alike, sparking a series of spin-off documentaries and gallery-side snippets of *vox pop*. Vermeer's tranquil, domestic interiors now found themselves at the center of a mass-appeal show, transforming the canon into a commercial fetish.

And yet, at the same time, alternative meanings flourished around the exhibition, including those denoting a more "exclusive" relationship to the art works. We should note, for instance, that patrician magazines like *Country Life* heaped praise on this exhibition of "pure painting" despite "the obnoxious advertising hype surrounding the exhibition."[64] Critics throughout the broadsheet press, similarly, waxed lyrical about the exhibition's artistic charms, predictably invoking traditional art-historical standards of form, contemplation, and beauty – the very stuff of the

educated middle-class *habitus* and a still intact high culture.[65] We should note, further, that the National Gallery decided to limit its visitor numbers to 270,000 by extending the opening hours precisely because it wanted to preserve an air of "quiet contemplation" for its visitors, especially in the "sacred" Vermeer rooms. This doesn't quite square with the image of a flat post-culture in which visitors search for and submit to conditions of perceptual overload and immediate gratification. Nor does it fit *tout court* with the tightly bounded values of a purified bourgeois culture. It rather suggests the complex coexistence of meanings and experiences contained within the hybrid form of the museum: not less (or post) modern but more modern, deepening tendencies towards ambiguity that were, perhaps, inherent in the museum from the start.[66]

The point is, contemporary museums are complex, double-coded organizations in which composite tendencies are absorbed and played out. It's disingenuous to apply an either/or, before/after, modern/post-modern logic to museums and their publics because this short-circuits a more precise examination of how these dynamic institutions adapt and survive. Like chemical allotropes,[67] museums can exist in two or more forms whilst inhabiting a broad (museological) state of matter. As a result, they can, and do, package themselves in different ways to different audiences. Scholars can study, hedonistic tourists can "do" the blockbuster exhibitions at speed, "informed" visitors can regularly tackle the intricacies of the permanent collection, and computer-literate schoolchildren can scan the museum's objects from their desktops. If not quite all things to all people, then the museum (and, indeed, the audience) is a great deal more multifaceted than is assumed by contemporary mass-culture theorists. Indeed, the very proliferation of discursive sites through which collections are rendered guarantees this plurality: not just interactive websites and CD-Rom technology but traditional art-history monographs and academic conferences; not just cynical business sponsorship and Hollywood, but workshops for local schools and organized visits.

"Museums," write Boniface and Fowler, "are wonderful, frustrating, stimulating, irritating, hideous things, patronizing, serendipitous, dull as ditchwater and curiously exciting, tunnel-visioned yet potentially visionary." And they continue: "The real magic is that any one of them can be all those simultaneously."[68] Once, museums may have been able to survive on the basis of one or two experiential repertoires or modes of presentation: now they must multiply the range of services and events on offer – a trend that parallels developments towards flexible accumulation and rapid in-

novation in industry at large.[69] The success of institutions like the Getty Center in Los Angeles, the Burrell Museum in Glasgow, the Tate Gallery in London, and the various Guggenheim Museums, as well as lesser-known museums such as the Museum for Contemporary Art in Helsinki, can be assigned to the rich mix of objects and experiences tendered and, by implication, the range of visitor perceptions possible. These are places which combine wide-ranging collections with spectacular architecture and elaborate settings – places to eat and loiter as well as to view the exhibitions.

Indeed, perhaps the most innovative and clear-sighted museum directors are those who have recognized and exploited the plasticity of the museum idea in order to overlay various levels of aesthetic experience. What makes the likes of Thomas Krens and Nicholas Serota so notable, for instance, is the way their respective institutions have caught up with (and in some cases out-sprinted) trends towards the hypermodern in contemporary culture – the massive expansion of a high-tech visual art complex, the rise of mass higher education, and the globalization of the art market, in particular. This breaks the orthodox relationship between the museum and society, in which the former plays the role of historical conservator, lagging behind the most exciting developments in the latter. It also suggests that directors are social actors who may cultivate possibilities arising from conscious separations between their own and other institutions.

In Serota's case, the doubling of visitor numbers to the Tate Gallery demonstrates an abandonment of rather sedate norms of museum management in favor of advanced rotation policies and a more thorough understanding of the expectations of the audience. As Serota himself reveals, the intensification of the gallery experience lies with the promotion of "different modes and levels of 'interpretation' by subtle juxtapositions of 'experience'... in this way we can expect to create a matrix of changing relationships to be explored by visitors according to their particular interests and sensibilities."[70] The museum does not just rest on the (curatorial) authority of its collection, in other words, but finds ways of responding to the different frames of reference of the audience – encouraging unexpected readings of the collection and inviting visitors to discover alternative routes. By implication, the museum sets itself up for the critic as well as the tourist, the artist as well as the "ordinary" visitor: in its design it strives for "interpretation" and "contemplation" as well as "spectacle" and "experience."

It is at this level that the Tate Modern, Serota's most recent allotropic museum, works. Housed in a disused power station on the south bank of the River Thames, the gallery extends across a range of services and points of contact in a way that heightens the bourgeois canon of international modernism whilst transforming the conventional means of viewing modern art. From the glass-topped café and iconic industrial chimney, to the on-line shop and smattering of "reading places" (where visitors can consult books relating to nearby works), the Tate Modern aggregates, exploits, and translates the old and the new. On the one hand, it switches between ambiences and modes of presentation, self-consciously inflating the sphere of contemporary art and generating scales of display reminiscent of totalitarian regimes. On the other hand, the very grandeur of the Tate Modern has injected a degree of interest – if the three million visitors in the first six months are anything to go by – in an art which, traditionally, has had limited appeal in Britain.

The Tate Modern, in many ways, echoes the megalomaniacal vision of the Massachusetts Museum of Contemporary Art (Mass MoCA), planned in the late 1980s by Thomas Krens. Krens, who has a specialist degree in public and private management, directs modern art museums with immense popular appeal. Mass MoCA was his consumerist vision of a branded mega-museum, bursting with shops, cafés, hotels, condos, and high-tech exhibition spaces, but which, by spreading the museum idea itself, exposed new audiences to "inaccessible" movements like Minimalism and Conceptualism. Lauded as an economic savior for the de-industrialized mill town of North Adams, Massachusetts, MoCA ultimately flopped as a business venture in the early 1990s (to be resurrected in a more down-scaled form). However, Krens's more recent projects symbolize the same aims of economic convergence, cultural synergy, and multifunctionalism that underpin the recent cycle of museum innovation. Indeed, as director of the Guggenheim, Krens has undoubtedly transformed the international art museum to resemble a diversified superproduct, replete with all the inevitable paradoxes and consequences (intended and unintended) of such an endeavor. And whilst the likes of Serota and Krens are harangued as "dumbing down" contemporary art, they have certainly helped clear the way towards museums that circulate a broader spectrum of experience.

I want to suggest, then, that one *can* have one's (traditional) Tate and yet still eat (in) it. Competing with other leisure domains has not, on the whole, meant museums abandoning *in toto* the cultural conventions and

grounds on which they were established. Directors are increasingly running their museums as open-ended compendia that must appeal to various constituencies. And recognizing this involves the reflexive acceptance (if not celebration) that contradictory tensions that once might have threatened the idea of the museum are now permanent fixtures within it. Museums face significant dilemmas, of course: how to deal with a more diverse, savvy, and critical audience, fulfilling directives of an expectant government or board of trustees, and keeping up with a spectacular consumer culture. In fact, the museum is under scrutiny as it has never been before. But fatal characterizations are all too loose, ahistorical, and inexact. Rumors of the death of the museum are much exaggerated.

Indeed, museums still thrive, albeit in transmuted form. For not only is the number of museums increasing across the globe – the US alone has spent $4 to $5 billion on building museums in the last decade[71] – but they are also diversifying in form and content, recycling (and perhaps enhancing) the modernist impulse whilst transforming it. They still, on the whole, celebrate values worked up by nineteenth-century aesthetics, including ideas of genius, expression, and cultural transcendence, but to these they have added new approaches, technologies, and flamboyant modes of exhibition more suitable to a hypermodern era. And they have done so, in the main, by acts of an increasingly reflexive nature – a fact picked up recently by a new academic literature on museums.[72] It is no longer possible for museums to ignore the social and epistemological bases on which they work. Like other complex institutions, museums are having to contemplate their own efficacy and socio-historical location in order to satisfy both internal monitoring procedures and external calls for legitimation.

Institutional self-consciousness is an increasingly predominant feature of the modernization of all organizations in contemporary society, according to sociologists like Beck, Giddens, and Lash.[73] Decision-making now happens under conditions of "reflexive modernization" – a transition in the character of social organization which brings into question expert systems, scientific and technological progress, and rapid economic growth. For the museum, "institutional reflexivity" is a process of self-examination through which the institution comes to know itself better, questioning its own auspices and social function. But the instigation of filter-back mechanisms also bestows on museums the opportunity to pioneer more socially inclusive and progressive initiatives and exhibition strategies, responding

more thoughtfully to the local community. A case in point is the attempt by some museums (the Geffrye Museum and the Museum of London, for instance) to bring ethnic minorities and local communities more meaningfully into the museum through local schemes and outreach projects, as well as stage exhibitions dedicated to the representation or inclusion of previously silent voices and marginalized cultures.[74] Theoretically speaking, reflexive modernization has afforded more "agency" to the museum – more powers of productive introspection and action in relation to broader structural constraints. And, whilst one should not underestimate the continued class constraints and incessant commercialization of the museum, it has, at least, become possible for museums to inhabit a more democratic, open-ended "third space," beyond elitism and consumerism, giving a positive twist to the Enlightenment's vision of cultural modernity.

Under these conditions, museums cannot be considered as passive providers of didactic materials, delivering the same product to all visitors. Nor are they inert reflectors of preconstituted social and economic relations, or one-dimensional conservative agents of social reproduction and bourgeois culture. Reorganized and reshaped from the late twentieth century, they are more plural, open, and contingent than the mass culture or elite image suggests – self-aware and able to confront their own limitations and reifications. Which is to say that the contemporary museum is not irredeemably scoured with the practices of a monolithic postmodernity. It is not a symptom of an end of modernity, but an extension, acceleration, and radicalization of it: consumerist, global, virtual, corporate, for sure, but still modern – an institution where opportunity and constraint are balanced in equal measure. In this respect, as far as museums are concerned, today is like yesterday, only more so.

Notes

1 F. Guattari, *Chaosmosis: An Ethico-Aesthetic Paradigm* (Bloomington: Indiana University Press, 1995); P. Virilio, *The Vision Machine* (London: British Film Institute, 1994).
2 William Hazlitt, "Sketches of the Principal Picture Galleries in England and Notes of a Journey Through France and Italy, 1824" in *The Complete Works of William Hazlitt*, ed. P. P. Howe (London and Toronto: J. M. Dent, 1932), vol. 10, p. 7.
3 Jean Baudrillard, "The Beaubourg Effect: Implosion and Deterrence," *October*, vol. 20 (Spring 1982), pp. 3–13; Frederic Jameson, *Postmodernism, or, The Cultural*

Logic of Late Capitalism (Durham, NC: Duke University Press, 1991) and *The Cultural Turn: Selected Writings on the Postmodern, 1983–1998* (London: Verso, 1998); Mike Featherstone, *Postmodernism and Consumer Culture* (London: Sage, 1991); Robert Hewison, "Commerce and Culture," in *Enterprise and Heritage: Crosscurrents of National Culture I*, ed. J. Corner and S. Harvey (London: Routledge, 1991).

4 As will become clear towards the end of this chapter, the term "hypermodern" is preferred to "postmodern" in the more precise meanings attached to the former as a term that captures the present as an extended and radicalized moment of change, as opposed to a definitive break with the past implied in the latter (see A. Pred, "Re-Presenting the Extended Present Moment of Danger: A Meditation on Hypermodernity, Identity and the Montage Form," in *Space and Social Theory*, ed. G. Benko and U. Strohmayer (Oxford: Blackwell, 1997).

5 Lisa Jardine, "Modern Medicis: Art Patronage in the Twentieth Century in Britain," in *Sensation: Young British Artists from the Saatchi Collection* (London: Thames and Hudson in association with the Royal Academy of Arts, 1997).

6 In this case the portrait made news when protesters pelted it with ink and eggs. Three weeks later, after special restoration, it was reinstalled, but this time protected by glass and dedicated security guards.

7 P. Wollen, "Thatcher's Artists," *London Review of Books*, October 30, 1997, pp. 7–9; R. Cook, "The Mediated Manufacture of an 'Avant-Garde': A Bourdieusian Analysis of the Field of Contemporary Art in London, 1997–99," in *Reading Bourdieu on Society and Culture*, ed. B. Fowler (Oxford: Blackwell, 2000).

8 R. Lumley (ed.), *The Museum Time-Machine: Putting Cultures on Display* (London: Routledge, 1988).

9 E. Hooper-Greenhill (ed.), *Cultural Diversity: Developing Museum Audiences in Britain* (London: Leicester University Press, 1997); E. Barker, *Contemporary Cultures of Display* (London: Open University Press, 1999).

10 Z. Bauman, *Postmodernity and its Discontents* (New York: New York University Press, 1997); S. Lash, *The Sociology of Postmodernism* (London: Routledge, 1990); D. Harvey, *The Condition of Postmodernity* (Oxford: Blackwell, 1989); A. Huyssens, "Mapping the Postmodern," *New German Critique*, no. 33 (Fall 1984), pp. 5–52.

11 Barker, *Contemporary Cultures of Display*; D. Crimp, "On the Museum's Ruins," in *Postmodern Culture*, ed. H. Foster (London: Pluto, 1985).

12 G. Deleuze and F. Guattari, *A Thousand Plateaus* (London: Athlone Press, 1988), pp. 424ff.

13 Hewison, "Commerce and Culture"; P. Boniface and P. Fowler, *Heritage and Tourism in the "Global Village"* (London: Routledge, 1993); J. McGuigan, *Culture and the Public Sphere* (London: Routledge, 1996).

14 L. McTavish, "Shopping in the Museum? Consumer Spaces and the Redefinition of the Louvre," *Cultural Studies*, vol. 12, no. 2 (1998), pp. 168–92.

15 The provision of striking display spaces (the Tate Modern, the various Guggenheim museums, the Pompidou Center, the Musée d'Orsay) has become a recent feature of museum building. Designed by celebrated postmodern architects or

refashioned out of erstwhile industrial spaces, such iconographic buildings feed the expanding cultural economy of Western cities (see A. Scott, *The Cultural Economy of Cities* [London: Sage, 2000]). The very fate of cities in a post-industrial era is increasingly dependent on their status as cultural centers, placing more emphasis on the symbolic goods, images, and lifestyle experiences that make up a city's "cultural capital" (S. Zukin, *The Cultures of Cities* [Oxford: Blackwell, 1995]; Featherstone, *Postmodernism and Consumer Culture*). Not surprisingly, private corporations, city administrators, and national policy-makers are increasingly disposed to invest in aesthetic and symbolic forms as cultural value is inextricably linked with economic value.

16 Barker, *Contemporary Cultures of Display.*

17 Featherstone, *Postmodernism and Consumer Culture.*

18 In a rush of postmodern irony, two of the artists exhibiting at *Sensation*, Sarah Lucas and Tracey Emin, opened a shop in Bethnal Green, London, which sold T-shirts, badges, prints, drawings, and sculptures and was open all Saturday night to self-consciously meld art, shopping, and clubland.

19 Hewison, "Commerce and Culture," p. 162.

20 Umberto Eco, *Travels in Hyperreality* (London: Pan, 1987), p. 151.

21 The most recent reinvention of the V&A has seen the opening of the "British Galleries," a 31 million-pound refurbishment conceived by the out-going director, Alan Borg, to boost visitor numbers. The scheme comprises fifteen new galleries displaying the history of British design from 1500 to 1900, supported by high-tech lighting and contextual displays. Daniel Libeskind's proposed architectural extension – a collapsing, twisting, geometrical spiral – has also been heralded as the savior of the museum, a significant rebranding device that might root the museum in a more contemporary era.

22 Baudrillard, "The Beaubourg Effect"; Featherstone, *Postmodernism and Consumer Culture*; P. Virilio, *The Aesthetics of Disappearance* (New York: Semiotext(e), 1991) and *The Vision Machine.*

23 Baudrillard, "The Beaubourg Effect," p. 5.

24 Ibid., p. 7.

25 Ibid., p. 6.

26 Ibid., p. 7.

27 Jameson, *The Cultural Turn*, p. 112.

28 Virilio, *The Vision Machine*, p. 9.

29 Marshall McLuhan, *Understanding Media* (London: Sphere, 1966).

30 Jean Baudrillard, *The Ecstasy of Communication* (Paris: Semiotext(e), 1987); S. Lash, "Discourse or Figure? Postmodernism as a 'Regime of Signification,'" *Theory, Culture, and Society*, vol. 5 (1988), pp. 311–36.

31 R. Krauss, "The Cultural Logic of the Late Capitalist Museum," *October*, vol. 54 (1990), pp. 3–17, at p. 14.

32 André Malraux, *Museum Without Walls* (London: Secker and Warburg, 1967).

33 Crimp, "On the Museum's Ruins"; D. Roberts, "Beyond Progress: The Museum and Montage," *Theory, Culture and Society*, vol. 5 (1988), pp. 543–57.

34 Lash, "Discourse or Figure?"

35 See *Cultural Trends*, Issue 2 (London: Policy Studies Institute, 1988). Interesting as the essay is, we might reasonably ask, for instance, how Baudrillard's characterization of mass implosion at the Pompidou Center sits with surveys of audience composition at around the same time, which showed a strong bias towards the educated middle classes at this museum (see N. Heinich, "The Pompidou Centre and its Public: The Limits of a Utopian Site," in *The Museum Time-Machine: Putting Cultures on Display*, ed. R. Lumley (London: Routledge, 1988). Are postmodern authors generalizing the middle-class experience as the limits of the social world? If so, what does this say about the limits of postmodern theory itself? Is it a form of what Murray Bookchin (*Remaking Society* [Montreal: Black Rose, 1988], p. 165) calls "yuppie nihilism"?

36 P. DiMaggio, P. Useem, and P. Brown, *Audience Studies of the Performing Arts and Museums: A Critical Review*, National Endowment for the Arts, Research Division, Report no. 9 (New York: Publishing Center for Cultural Resources, 1979).

37 J. Heilburn and M. Gray, *The Economics of Art and Culture: An American Perspective* (Cambridge: Cambridge University Press, 1993).

38 National Endowment for the Arts, *Demographic Characteristics of Arts Attendance: 1997*, Research Division, Report no. 71 (Washington, DC: National Endowment for the Arts, 1999).

39 *Cultural Trends*, Issue 25 (London: Policy Studies Institute, 1995), p. 40; *Cultural Trends*, Issue 12 (London: Policy Studies Institute, 1991).

40 N. Merriman, "Museum Visiting as a Cultural Phenomenon," in *The New Museology*, ed. P. Vergo (London: Reaktion Books, 1989).

41 Pierre Bourdieu and A. Darbel, *The Love of Art: European Art Museums and their Public* (Cambridge: Polity Press, 1991).

42 This study was based on a series of surveys conducted between 1964 and 1965 on the visiting publics of various art galleries and museums in Europe, mainly in France. The authors identified different viewing orientations to the museum and related these to the social characteristics of the visitors. Despite its fairly obvious conclusions, the study provided a social-scientific rejoinder to an intransigent truth of art discourse, that art appreciation was somehow autonomous from, or beyond, social forces. The study also reinforced one of Bourdieu's central claims, that capital and class should be conceived in both economic and cultural terms (see Bourdieu, *Distinction* [London: Routledge and Kegan Paul, 1979]).

43 P. DiMaggio, "Classification in Art," *American Sociological Review*, vol. 52 (August 1987), pp. 440–55.

44 Bourdieu and Darbel, *The Love of Art*, p. 14.

45 Ibid., p. 113.

46 P. DiMaggio, "Cultural Entrepreneurship in Nineteenth-Century Boston, I: The Creation of an Organizational Base for High Culture in America," *Media, Culture, and Society*, vol. 4 (1982), pp. 33–50.

47 J. Moore, "Poverty and Access to the Arts: Inequalities in Arts Attendance," *Cultural Trends*, Issue 32 (1998), p. 31; J. Harland, K. Kinder, and K. Hartley, *Arts in Their View: A Study of Youth Participation in the Arts* (Slough: National Foundation for Educational Research, 1995); G. Fyfe and M. Ross, "Decoding the Visitor's Gaze: Rethinking Museum Visiting," in *Theorizing Museums*, ed. S. Macdonald and G. Fyfe (Oxford: Blackwell, 1996).

48 Cited in Moore, "Poverty and Access to the Arts," p. 60.

49 N. Merriman, "Museum Visiting as a Cultural Phenomenon."

50 Bourdieu and Darbel, *The Love of Art*.

51 Cited in *Cultural Trends*, Issue 12, p. 77.

52 *Cultural Trends*, Issue 32 (London: Policy Studies Institute, 1998).

53 Fyfe and Ross, "Decoding the Visitor's Gaze," p. 127.

54 Bourdieu and Darbel, *The Love of Art*, p. 110.

55 V. Zolberg, "American Art Museums: Sanctuary or Free-For-All?" *Social Forces*, vol. 63, no. 2 (December 1984), pp. 377–92.

56 Pierre Bourdieu and J. Passeron, *Reproduction in Education, Society and Culture* (London: Sage, 1977).

57 R. Jenkins, *Pierre Bourdieu* (London: Routledge, 1992).

58 C. Graña, *Fact and Symbol: Essays in the Sociology of Art and Literature* (New York: Oxford University Press, 1971).

59 C. Duncan and A. Wallach, "The Universal Survey Museum," *Art History*, vol. 3, no. 4 (December 1980), pp. 448–69.

60 Zolberg, "American Art Museums," p. 385.

61 McTavish, "Shopping in the Museum?"

62 The show in London followed a stint at the Metropolitan Museum of Art in New York, where more than half a million people visited the show, with queues of up to 10,000 visitors a day.

63 Michael Kennedy, "Vermeer Matchless When it Comes to Brass Tacks," *Guardian* (June 19, 2001), p. 1.

64 B. Gray, "Vermeer and the Delft School," *Country Life* (June 2001) *http://www.countrylife.co.uk/ArtsAntiques/ FineArt/exhi_vermeer.htm, p. 1.*

65 Reviews of *Vermeer and the Delft School* were most obviously coded for an informed and cultivated middle-class audience familiar with the language of high culture. Reviewers spoke of "the anonymity of surface, the determinedly uncalligraphic brush strokes, the dispassionate attention which gives every part of the canvas the same look" (P. Campbell, "At the National Gallery," *London Review of Books* [July 5, 2001], p. 26); the "naturalistic rendering of daylight, an interest in optics and the careful application of the laws of perspective" (A. Searle, "Only Here For Vermeer," *Guardian* [June 21, 2001], p. 12); the "silent stillness we admire in Vermeer…the transience of earthly pleasures" (W. Januszczak, "The Show We've Been Waiting For," *Sunday Times: Culture Section* [June 24, 2001], pp. 8–10). These extracts confirm the boundaries between high and low even if, at the same time, they inhabit an increasingly commodified (journalistic) space. Bourdieu's concept of *habitus* – a system of socially acquired dispositions which

function "at every moment as a matrix of perceptions, appreciations and actions" (*Outline of a Theory of Practice* [Cambridge: Cambridge University Press, 1977], p. 72) – proves to be a useful analytical tool in deciphering the frames of reference and cultural codes through which particular class groups make sense of art. In particular, it points to the way social agents act and react to particular situations or products in a way that is neither necessarily calculated, nor simply generated mechanically according to rule obedience. This is what Bourdieu refers to as *sens pratique* (*The Logic of Practice* [Cambridge: Polity Press, 1990]), the practical sense or logic which is often characterized as a "feel for the game." It is this "feel for the game," embodied in the *habitus*, that somehow propels agents to act and react in the ways they do.

66 T. Bennett, *The Birth of the Museum* (London: Routledge, 1995); Nick Prior, *Museums and Modernity: Art Galleries and the Making of Modern Culture* (Oxford: Berg, 2000). For at one level, museums have *always* been ambiguous institutions, oscillating between the governmental aims of the nation-state, the exclusionary aspirations of ascendant social classes, and the recreational trends of new leisure regimes. In fact, to quote Nochlin ("Museums and Radicals: A History of Emergencies," *Art in America*, vol. 54, no. 4 [1971], p. 646): "As the shrine of an elitist religion and at the same time a utilitarian instrument of democratic education, the museum may be said to have suffered schizophrenia from the start."

67 According to the *Columbia Electronic Encyclopedia* (*http://www.encyclopedia.com*): "A chemical element is said to exhibit allotropy when it occurs in two or more forms in the same physical state; the forms are called allotropes. Allotropes generally differ in physical properties such as color and hardness; they may also differ in molecular structure or chemical activity, but are usually alike in most chemical properties."

68 Boniface and Fowler, *Heritage and Tourism in the "Global Village,"* p. 118.

69 Flexible accumulation and flexible production are seen as features of a restructured political economy in which "postindustrial" or "postfordist" methods of production predominate (Harvey, *The Conditions of Postmodernism*). Firms are, on the one hand, more likely to produce smaller batches of a product and, on the other hand, to widen the range of goods on offer. This allows for quick response and just-in-time forms of production which are catalysts for rapid innovation in both culture and economy.

70 Nicholas Serota, "Experience or Interpretation: The Dilemma of Museums of Modern Art" (1996), reprinted in *Art and its Histories: A Reader*, ed. S. Edwards (London: Open University Press, 1999), p. 282.

71 J. Trescott, "Exhibiting a New Enthusiasm Across US, Museum Construction, Attendance, Are on the Rise," *Washington Post* (June 21, 1998), pp. A1, A16.

72 Hooper-Greenhill (ed.), *Cultural Diversity: Developing Museum Audiences in Britain*; S. Macdonald and G. Fyfe, *Theorizing Museums* (Oxford: Blackwell, 1996).

73 U. Beck, Anthony Giddens, and S. Lash, *Reflexive Modernization: Politics, Tradition and Aesthetics in the Modern Social Order* (Cambridge: Polity, 1994).

74 N. Merriman, "The Peopling of London Project," in *Cultural Diversity*, ed. E. Hooper-Greenhill (London: Leicester University Press, 1997); S. Hemming, "Audience Participation: Working with Local People at the Geffrye Museum, London," in *Cultural Diversity*, ed. E. Hooper-Greenhill (London: Leicester University Press, 1997).

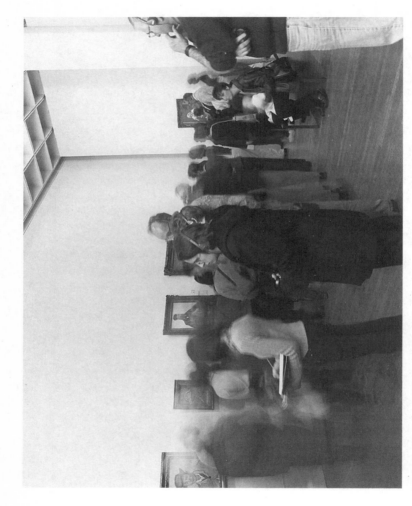

Plate 4 Visitors contemplating portraits by Van Gogh at the Philadelphia Museum of Art, 2000. Photo: Philadelphia Museum of Art.

3

Museums:
Theory, Practice, and Illusion

Danielle Rice

Many different narratives propose to represent the art museum as an institution and to characterize "the museum experience." However, although the past two decades have seen a substantial increase in museological theory, the relationship between theory and practice is irrelevant to most theorists who see museums primarily as ideological symbols of the power relationships in today's culture. On the other hand, while it is not entirely ignorant of theory, most museum practice continues to be too deeply rooted in the politics of competing interests to respond to the structural issues discussed in theoretical literature. This slippage between theory and practice results in an illusory museum, or a series of illusory museums. As scholarship evolves, so does the illusion. However, in practice, the museum is also an evolving institution, so that it is never quite in the same spot on the intellectual landscape that theorists create. As a museum professional, I am primarily interested in whether a useful middle-ground can be found between theory and experience, resulting at once in a more nuanced theory and a more thoughtful practice.

Museums as collecting and displaying institutions have been "academified" within the discipline of art history for well over two decades.[1] Thus the theory of museums has been a regular part of many young art historians' training. When these young theoreticians enter the world of actual practice in museums they inevitably experience a kind of culture shock. Indeed the academic world describes a museum that most people entering practice fail to find. Here is how one art history graduate student characterized her actual experience in practice and the relationship of this

to the theoretical introduction to museums she had previously received in her academic setting:

> After this past summer at the PMA [the Philadelphia Museum of Art], I was entirely convinced that I wanted to work in a museum. Academia is very appealing to me, and I love teaching, but I love the various aspects of museum work even more. It was so great to be a part of all the processes behind museum exhibitions: the research, the installations, etc. Even data-basing was a blast. And inventory? I can't even explain how thrilling it was to poke around in the storage room upstairs.... In short, I really love the objects and I love the processes that go behind presenting those objects to the public.... In my idealistic undergraduate way of thinking, I'm pretty devoted to the relationship that exists between the public and its museums. I'm forever hearing about the evil political side of museums. Of course, there's no way to avoid that, but working in conjunction with a curatorial department and an external affairs department renewed if not fine-tuned my faith in museums.[2]

"The evil political side of museums," is the way that this student understood, no doubt a bit naively, how museums are represented in the current academic discourse of museum theory. What happened to this student during the course of the summer in the museum is well under-stood at Disney World and other amusement parks, that is that if some-one's expectations of an experience are low and the experience exceeds their expectations, the person defines this as a high quality experience.[3] In the same way, by indoctrinating students into all the negative aspects of museums, museum critics are inadvertently creating students, like the summer intern, who have powerful conversion experiences when they enter museum work. Persuaded to believe that museums are symbols of unequal power relationships and exclusive enclaves of privileged, hege-monic culture, young art historians entering the actual world of museum work have a direct experience with that disconnection between theory and practice.

The image of the museum as a monolithic representative of elite taste and institutional power is obviously incomplete and difficult to reconcile with current practice and with the goals and mission statements of most museums. The process whereby museums enter and shape the conversa-tion that is called contemporary culture is more complex than much existing critical literature would have us believe. That is because museums stand at a crossroads between history, high culture and popular culture,

and a single discipline, such as art history, is often inadequately narrow for defining this hybrid.[4]

Among the many narratives that have come to shape the way that art museums are represented in contemporary thought are those created by artists, theorists, museum workers, journalists, movies, and even ordinary people, those who frequent museums and those who do not. These narratives, while they occasionally overlap, don't always inform one another, and can seldom fit within a method that cross-examines them together. Perhaps, instead of thinking of museums as static objects and trying to represent them as such, we should describe instead what scientists call an event horizon.[5] In analyzing museums, we would study the intersections between everyday life as represented by the experiences of actual visitors and professionals, and the more abstract world of theoretical literature. The event horizon of museums would include the many voices that propose to represent it before their multiplicity becomes a confusing mass of noise. That intersection, where theory and practice would meet before falling into the black hole of incomprehension, would be the event horizon for museum studies. Undoubtedly that threshold would be a complex and fluctuating one, full of enigma and paradox, but through that very essence, it would approximate the complexity of lived experience more vividly. In what follows I would like to offer a series of observations that complicate the prevalent stereotype of the museum by revealing the diversity and contingency of visitor responses, both real and imagined. Instead of the ossified and elitist institution posited by recent critical theory, I hope to suggest that museums are dynamic, complex social institutions that are constantly reinventing themselves in response to self-scrutiny and external stimulus.

It may perhaps be unfair to consider the ways that museums are caricatured in movies and other forms of popular culture as a valid form of representation. However, ironically, movies often make explicit, in a somewhat humorous ways, sentiments that are also expressed in more thoughtful critiques. Consider the implications of the following scene from the movie, *Rocky III*:

A crowd is gathered at the top of the Philadelphia Museum steps. A band is playing. The band stops and the mayor of the city steps up to the podium and speaks: "Thank you, thank you one and all. Every once in a while, a person comes along who defies the odds... who defies logic, and fulfills and incredible dream. On behalf of all the citizens of Philadelphia and

the many who have been touched by your accomplishments, and your untiring participation in the city's many charity functions, it is with tremendous honor that we present this memorial which will stand always as a celebration to the indomitable spirit of man. Philadelphia salutes its favorite son, Rocky Balboa!" As the black drape falls, unveiling a statue of Rocky, the crowd cheers. Rocky looks stunned. Adrienne looks at Rocky and says: "It's beautiful!" (Scene from *Rocky III*, United Artists, 1982)

Ironically, the one-dimensional representation of art museums in the movies often parallels the monolithic characterization of museums in much critical theory and artistic practice. For example, the Philadelphia Museum of Art plays a prominent role as a backdrop in the famous series of movies about the boxer Rocky Balboa, played by Sylvester Stallone. The myth of the *Rocky* films is the wish-fulfillment fantasy of the hometown boy who achieves success through perseverance and hard work, but maintains his humility despite a number of challenges and temptations. In *Rocky I*, Rocky's rigorous training includes a symbolic run from the bowels of South Philadelphia, a neighborhood inhabited largely by a mixture of working-class Italian, African and Asian Americans, down the imposing Benjamin Franklin Parkway. The run climaxes at the top of the Museum steps, that ultimate monument to ascendant, owning-class culture.[6] In *Rocky III*, the city unveils a statue to the boxer who has by now become a hero in gratitude for the honor that he has brought to Philadelphia. The statue, not surprisingly, is placed at the top of the Museum steps, at the culmination of the Benjamin Franklin Parkway, with its back to the Museum, looking down at and on axis with monuments of George Washington and William Penn. Thus to some degree, in upstaging the Museum, Rocky also upstages dominant culture. In this context the Museum can also be seen as embodying "the state" against which the individual triumphs, a common narrative in popular culture films and novels.

To some twentieth-century artists, the museum has appeared in much the same ways as it did to the fictive boxer from South Philly, as a temple to high culture forever inaccessible to their aspirations. The definition-challenging antics of Marcel Duchamp in the first quarter of the twentieth-century, posited the museum as mausoleum.[7] Duchamp's seminal role in making issues of inclusion and exclusion, production and reproduction and the role of the viewer in art, the very subject of art practice is not to be underestimated as necessary role model. But a more consistent art practice

that was specifically and intentionally critical of museums dates to the early 1970s. Frenchman Daniel Buren and German-born US artist Hans Haacke were among the first to begin deconstructing the museum's relationship to power. Daniel Buren installed his characteristic stripes in museums such as the Wadsworth Atheneum, drawing attention to how museum installations privilege certain works and certain types of words. By focusing on the walls of the museum, Buren pointed out that the "sacred" setting for art, deemed to be neutral and transparent, was far from being so. Hans Haacke, on the other hand, brought to light connections between museum governance and corporate interests, challenging the traditional notion that museums were apolitical, neutral contexts for art.[8]

In the 1980s, artists began adding to the list of museum-related phenomena under their scrutiny. In addition to collection, installation and fundraising strategies, artists began criticizing interpretive practices such as exhibitions, programs, and tours. Performance artist Andrea Fraser took on the persona of a "typical" museum docent, Jane Castleton. Her tour of the Philadelphia Museum of Art in 1989 included all the rooms of the museum, including the ones that are so clearly differentiated from galleries containing art. "Our tour today is a collection tour – its called Museum Highlights – and we'll be focusing on some of the rooms in the museum today, uh, the museum's famed period rooms; dining rooms, coat rooms, etcetera, rest rooms, uh – can everyone hear me? If you can't hear me, don't feel shy; just tell me to speak up. That's right. As I was saying, we'll also be talking about the visitor reception areas, and various service and support spaces, as well as this building, uh, this building, in which they are housed. And the museum itself, the museum itself, the 'itself' itself being so compelling."[9]

Waxing poetic over the design features of a water fountain, exploding into admiring superlatives in the "cafeteria, Fraser's narrative humorously presents all of the museum, the itself itself." She calls into question the purity of this temple to high art with its period rooms, bathrooms, coatrooms, and cafeterias. The language she uses in her tour is mostly borrowed from a broad range of publications, including the Museum's own Bulletins, dating back to the 1890s, fund-raising brochures and annual reports. Fraser intertwines these writings with excerpts taken from other nineteenth-century publications about public culture and institutions of containment such as asylums and prisons. Her vision of art museums, inspired by the critical theory of French theorist Michel Foucault, and currently popular with both artists and scholars, identifies

them as authoritative symbols of dominant culture that are anything but a neutral context for art.

It is interesting to note that after "performances" of tours in several different museums, Andrea Fraser decided to retire Jane Castleton. One of the reasons she cited for this withdrawal was the fact that she became uncomfortable with the relationship between the insiders and outsiders on her "tour." In other words, at any performance, the audience was generally composed in part of knowledgeable contemporary art followers, who had come to see a performance, and general museum visitors who thought they were taking a guided tour. While all participants could rapidly sense that this was no ordinary tour, Fraser could not be sure that she was not creating a situation where the insiders were laughing at the outsiders for their gullibility.[10] In this case, the very real museum visitors bore witness, at least for the very sensitive artist if not all her fans, to a practical disconnection between the reality of the museum environment and the illusion created by the artist's performance.

African-American artist Fred Wilson critiqued the exclusionary practices of standard museum exhibitions. Wilson's breakthrough installation at the Maryland Historical Society, juxtaposed iron shackles with silver tea pots, Ku Klux Clan hoods with baby carriages, and African-American heroes with busts of George Washington and Thomas Jefferson, in a jarring display aimed at reminding viewers that the African-American perspective is chronically left out of the definition of culture engendered by museums. Walking through the exhibition with a young African-American woman friend, however, I was struck by how Wilson's installation was clearly addressed to art world insiders. My young friend was baffled that a museum would display something that seemed so obviously critical of its own practices. Like many novice viewers, she came with the expectation that museums uphold standards of culturally defined "truth" and "beauty," rather than choose to challenge them. While the caricatures of museums as seen in the movies, and the critiques of these institutions by contemporary artists may seem at first glance to have little in common, they both use a model of the institution as bully. This model is often at odds with the way the museum is perceived by ordinary visitors.

The oppositional practices of avant-garde artists like Buren, Haacke, Fraser and Wilson, far from taking the museum "as muse," as the 1999 MoMA exhibition by that title implies,[11] take the museum on as adversary. In this sense, much of contemporary art practice engaged with museums parallels and reinforces the critique of museums in theoretical literature,

insisting in effect that museums are either not democratic enough, or quite the opposite, that they are too democratic, as in the case of large blockbuster exhibitions that replace high-minded mission with low-brow entertainment. Like some of the artists cited above, many museum critics focus on the nature and production of meaning in museums. A key early piece, for example, is the groundbreaking essay by Carol Duncan and Alan Wallach, "The Universal Survey Museum."[12] Duncan and Wallach focused on the beliefs and values that museums communicate, describing the museum as a ceremonial, ritual place whose primary function is ideological, meant to impress upon those who use or pass through it society's most revered beliefs and values. Duncan and Wallach interpret the symbolic messages imbedded in architecture, likening museums to Roman displays of war trophies, permanent triumphal processions, testifying to western supremacy and world domination. While the authors do not say that museum visitors actually acknowledge their experience as a ritual process, they imply that visitors, by "performing the ritual of walking through the museum, [are] prompted to enact and thereby to internalize the values and beliefs written into the architectural script."[13] The implication of this thesis is that the museum is a value-laden narrative that communicates its message effectively to all visitors, whether they know it or not. This characterization of visitors implies that visitors are mindless dupes of the powerful institutions that manipulate them.

Following the example set by Duncan and Wallach, much museum theory critiques the production of knowledge without any significant analysis of the reception of that knowledge. And, while it sets out to break down totalities, theory often creates new totalities of its own, presenting museums as monolithic institutions. The influence of Michel Foucault is deeply felt in works such as Eilean Hooper-Greenhill's *Museums and the Shaping of Knowledge*,[14] and the collection of essays edited by Daniel Sherman and Irit Rogoff, *Museum Culture: History, Discourses, Spectacles*.[15] Hooper-Greenhill takes her cue from Foucault's *The Order of Things*. She sets out to interrogate how the museum's ways of classifying and displaying objects exclude some ways of knowing while presenting others as "common sensical." Hooper-Greenhill celebrates that aspect of Foucault's work that shows how the origin of what we take to be rational, "the bearer of truth, is rooted in domination and subjugation, and is constituted by relationship of forces and powers."[16] Like Hooper-Greenhill, the authors contributing essays to Sherman and Rogoff's anthology also seek to unmask the "structures, rituals, and procedures

by which the relations between objects, bodies of knowledge, and processes of ideological persuasion are enacted."[17] Sherman and Rogoff offer a collective critique of the materials and strategies museums employ to naturalize the concreteness of the social and historical processes in which they participate.

These kinds of analyses posit the museum not only as a monolithic "bad guy," an instrument of so-called dominant culture, but also a "bad guy" who hides his tracks by obfuscating the nature of the practices in which he engages. According to the critical literature, by making their displays look seamless and "natural", museums force their own concepts of knowledge on an innocent and receptive public. But is the public really that receptive? And to what degree is it relevant in characterizing "the museum" to consider the actual reception of art within its walls?

> It gave me a chance to think. As soon as I walked in, I went with my family, but everything was solemn and quiet. And you walk up to something you can, you know, just take your time. There was [sic] not many people, you know, around you, and you had time to think. You can walk up to something and say, 'Wow! This is a good artist. I would like to meet him in person.'[18]

The statement above is from a middle-aged African-American woman who participated in a Focus Group experiment at the Philadelphia Museum of Art in 1988. She had never been to any art museum before in her life and she came because, after agreeing to participate in the Focus Group study, she was required to do so. Like many of her companions in the project, she waxed poetic over her first experience. She found the museum a refreshing oasis, a place to think, to connect with the past, to see "good" art. The experience was both restorative and recreational. If there had been an institutional agenda, an exclusionary ritual of power being played out within the walls of the museum, this first-time visitor, having broken the barrier and breached the entrance into the hallowed halls, was certainly unaware of it.

Now here was exactly the kind of person museums all over the country have been working so hard to attract. Indeed, this was why the focus group study was conceived, to examine the barriers to visitation and begin to remove them. Unfortunately, the focus groups were not terribly useful in this respect. The studies were structured to include two similar groups, one composed of museum visitors – people who had visited at least once

in the past few years – and non-visitors. The groups, which met separately, were closely matched in the makeup of their respective participants so that there was parity in earning levels and race. Visitors and non-visitors were invited to discuss why they either chose to come or not to come to the museum. Ironically, some of the same reasons were cited both in support of visiting and for not visiting. Visitors, for example, gave children as a primary reason for going to museums, explaining that it was important to imbue their young ones with art appreciation. Non-visitors also cited children, but, in their case, the children were perceived as the obstacle to a museum visit, posing too great a threat of misbehavior or simply not being interested in a museum visit.

Unlike many other cities, Philadelphia has a highly visible, prominent landmark for a museum. Visitors and non-visitors alike were well aware of the museum's presence and they knew exactly what it was and where it was. Non-visitors acknowledged passing the building frequently, or seeing exhibitions advertised, and yet never making that leap from mild curiosity to actual visit. When asked directly what the museum could do to make itself more attractive to them, many people took the blame onto themselves, remarking that they thought it was a good idea to visit, but they simply had never done it. Perhaps the caricatured image of the museum that is so prominent in movies such as the Rocky series continues to carry a strong hold on the perceptions of non-visitors, reinforcing their sense of disenfranchisement. Education and class issues are also ones that continue to haunt the debate about why people do not chose to go to museums.

Although the challenge of attracting new audiences to the museum continues to haunt museum professionals, the focus groups confirmed that when non-visitors become first time visitors they respond with a freshness and enthusiasm that holds hope for the future. This was fully confirmed by the focus group study. As I monitored the reactions of first time visitors I was surprised and somewhat confused by their overwhelmingly positive response. A young truck driver, who had looked bored and angry in the session preceding the museum visit, came back singing the praises of seventeenth-century Dutch landscape painting. Another middle-aged African-American woman who expected to find lots of big abstract paintings that she wouldn't understand, confessed to actually enjoying the galleries of modern art. Perhaps, as in the case of the museum intern who was pleasantly surprised that real museums were a lot more fun and more public-minded than museum theory led her to believe, these first-time visitors may have been so readily converted by the force of their

own very low expectations. Or, was this a case of the cultural script "art is good for you" having a powerful subliminal effect?

The burgeoning field of visitor studies characterizes museums as places that provide their visitors with a "leisure-time experience."[19] Visitor studies analyze who comes and how often. In addition to demographics, more market-oriented studies analyze how much money visitors spend in an effort to characterize the economic impact of museums on their communities. These efforts of course serve the institution both directly and indirectly by helping museums to justify their existence to granting agencies and private and public funders of all sorts. The success of most public art museums in the United States today is measured in numbers. Over the years a few studies have tried to understand why people visit museums, what they get out of the experience, and most importantly, what are the barriers to museum visitation. As critics are quick to point out, "The simple fact that museums draw large numbers of visitors, especially since the Second World War, should not be taken uncritically as an indicator of substantial democratization.... those who frequent art museums tend to be better educated, better off, and older and are more likely to be professionals than those who visit history, science, or other museums."[20]

The 1985 Survey of Public Participation in the Arts (SPPA) based on data collected in over 13,000 interviews indicated that 22 percent of the adult American population reported visiting an art museum or art gallery in the previous year.[21] Museum-goers generally have middle to higher incomes and higher levels of education. Women are slightly more likely to visit museums than men and whites are twice as likely to visit than African Americans. While this rate may have gone up a little in the last fifteen years since the Survey was taken, it is clear that museums are quite far from reaching everyone.

Much harder to study and characterize are the reasons that people don't come to museums. Unlike the demographic surveys sponsored by individual museums, participation studies such as the SPPA, and focus group projects such as the one sponsored by the Getty in 1989, try to understand the "psychographics" of non-visitors. US studies shy away from discussions of class, focusing instead on education as the primary indicator of museum going versus non-going practices. But education is clearly just another indicator of class distinctions. In his classic study Pierre Bourdieu analyzed the relationship between social class and the taste for art and art museums. He introduced the concept of "cultural capital" – the idea that

people visit museums in order to differentiate themselves from people who do not, thereby reinforcing and enhancing the economic distinctions of class.[22] While a number of scholars have challenged Bourdieu's findings, they have not come up with more believable accounts why some people seem to find museums inviting and some do not.

Museum professionals, on the other hand, took research such as Bourdieu's in France and the Surveys for Public Participation in the United States as road maps for self-transformation. In France, the Centre Pompidou, the Musée d'Orsay and the newly expanded Louvre, stand, each in their own way, as monuments to the conscious popularization of museums. In the United States, even the most conservative art museums offer information-filled websites, audio tours, and social evenings in an attempt to attract increasing and increasingly diverse audiences. Literature aimed at museum professionals celebrates the concept of museums as town squares as opposed to temples. The civically engaged, socially conscious, ethically moral museum is the discursive norm of the American Association of Museums main publication, *Museum News*.[23]

Often absorbed in the self-criticism that comes from an awareness of museum theory, and challenged by the democratic imperative of their institution, museum professionals are more critical of themselves, their institutions and their practices, than their visitors are. Furthermore, because museum professionals often represent an intellectual class, their definitions of art tend to be more progressive than the definitions of laypersons. Progressive scholarship in the history of art challenges the notion of artistic genius and focuses instead on the process, content and social/political contexts of works of art. Traditional art history, on the other hand, holds a transcendent view of artistic virtuosity and extols art works as apolitical and universal. While some museum professionals undoubtedly still practice this kind of art history, they are few and far between. But among museum visitors, this notion of art is very prevalent. In this sense, museum-going publics are often more conservative in their definition of art and their expectations of the messages that museums should communicate than are the professionals who work within the institution.

Furthermore, the notion of the visitor as "dupe" of the institutional "script" implied in much critical literature simply does not hold water. Experience with museum visitors, and the growing body of literature on visitor experience suggests that this is hardly the case. In fact, visitors often come with heavily loaded agendas of their own, and blissfully construct

their own narratives in museums.[24] This sometimes dismays museum professionals who seriously want to communicate certain messages. An example of this, to name just one, was the exhibition, "The West as America" held at the National Museum of American Art in Washington, D.C. in 1991. This politically correct, heavily didactic show presented a radical deconstruction of one of the central myths of American identity, the idea of the virtuous frontier. But those visitors who did not read the labels, completely missed the show's message, and some who did, disagreed, indeed quite vocally, with the exhibition's agenda.[25]

Visitor comments from the comment books in "The West as America" exhibition reveal that visitors can be quite scathing in their opposition to the perceived institutional agenda, and, in fact, with anything that they perceive as an attempt by the museum to brainwash them. "What a crock of shit!" intoned one visitor, "Don't force your p.c. views down my independently thinking throat." Or, more rationally: "[A] serious flaw in the exhibit: railroading one polemical line over all the art at hand. Not unlike what the commentators themselves are accusing others of." [26]

While visitors may feel fully empowered to disagree with a museum's political agenda, they have, on the whole responded quite positively to the new trend in museums to contextualize art and to challenge the traditional canon of high art by including a broader diversity of objects. While museums have increased their experimentation with this kind of exhibition and have seen positive results from the public, art critics have often been scathing in their disdain for such practices:

> Today's museums are under attack from art-theory ideology on one side and commerce on the other. In their exhibition programs, at least, they often behave less and less like museums – that is, places where the goal is the visual, largely private experience of art objects. More and more they are in danger of becoming places where larger social and historical patterns are either consciously played out, where people of all ages are given cursory lessons in history and morality, or where consumer desire is stoked by merchandise orchestrated into artful displays that may or may not be sponsored by the maker of that merchandise[27]

Roberta Smith's objections to this trend took as a case in point the exhibition *Made in California*, on view at the Los Angeles County Museum of Art in the fall of 2000. This exhibition took an inclusive approach to the definition of art, combining a variety of media and non-canonical objects, and emphasized cultural and historical context

over aesthetic innovation. Audiences flocked to the show in record numbers, while critics took the museum to task for pandering to the lowest common denominator.[28]

Art critics are often more traditional in their expectations of museum exhibitions than either curators or museum visitors. Their critiques often wax nostalgic for times when museums were quiet places devoted to the contemplation of beauty. And they often take museums to task either for being too innovative, or for being too commercial. The critical voice purports to speak on behalf of the public while at the same time it often seems disdainful of it. Needless to say the difficulty of satisfying multiple constituencies at the same time greatly complicates museum practice.

In their relentless pursuit of audiences, museums have found that telling a good story helps. While the revisionist approach to art and art history occasionally backfires when there is a strong political agenda, as in *The West as America* exhibition, the inclusion of context and narrative have become increasingly evident in art museums. These approaches are proving to be good strategies for winning public approval and are coming to be used increasingly even in the more traditional setting of the permanent collections. At the Newark Museum, the reinstallation of the American collection, which opened in May 2001, did so to both public and critical acclaim. Entitled "Picturing America," the heavily thematic installation tells a politically correct story of diversity and multiplicity, class posturing and oppression. Each gallery is introduced by a large text that stands on a platform blocking the entrance, suggesting that the text is a necessary preamble to the viewing of art. Wands equipped with recorded messages give visitors a choice of voices and interpretations that they can listen to, while homey photo albums discuss the personalities of different periods. Labels try to anticipate visitors' questions and answer them directly and with a minimum of jargon.

Populist approaches to installations and exhibitions abound and are often encouraged and subsidized by foundations such as The Pew Charitable Trusts and the Lila Wallace-Reader's Digest Foundation. The latter financed an ambitious five-year exhibition and community-project initiative at the Museum of Fine Arts in Houston. Entitled "A Place for All People," the initiative, launched in 1993, was the product of an ambitious collaboration of museum staff, artists, high school students, teachers, city councilmen, community volunteers, and even the rector of a nearby church. Each participant interpreted the museum's collections from their

own experience, created artworks, and organized exhibitions in the museum as well as in the community.[29]

A careful, empirical examination of today's museums reveals that they encompass many different cultures and conflicting interests.[30] The interests of the museum curators and educators who make up the professional class in museums not only vary considerably from those of museum visitors, but also from those of the governing bodies, or trustees. Museums' preservation and research agendas are often pitted against exhibition and public access issues.[31] While a certain number of museum workers may continue to identify with the goals and values of high culture, the way that museums actually function in the public, corporate, and political spheres that help shape them makes them as much a part of popular cultures as movies and theme parks. This is not to say that they are the same as movies or theme parks, or that museum audiences do not know and appreciate that difference. But in order to understand how art museums function within popular culture we need also to rethink how popular culture is defined.

For the most part, the same critics that have given us an understanding of the power relations that define elite cultures, notably Foucault, Althuser and Baudrillard, see mass culture as a large undifferentiated mass. Critics of these writers have pointed out that culture does not have one center or no centers, but rather a series of multiple, simultaneous centers. "Within decentered cultures, no Zeitgeist can emerge as dominant; nor can any one institution – whether the university, [the museum] or prime-time television – be considered the sole 'official' culture responsible for establishing aesthetic ideological standards for entire societies."[32] Thus we need to understand that popular culture is not composed of undifferentiated masses dominated by a powerful corporate state. Instead, within a diverse and heterogeneous popular culture of the kind found in the United States, conflicting agendas are not only possible but also probable.

> It is not clear that, in a 'postmodern' world, in which aesthetic relativism seems to obviate 'standards,' it is still valid to think that there is only one elite culture. The Art museum, after all is no stranger to the avant-gardes that have tried to overthrow traditional boundaries between formerly hiearchicalized genres of fine art and low art, academic styles and commercial designs, or to promote the coexistence of art styles and unconventional forms. If there seems to be an 'anything goes' ethos in the world of fine art, however, this does not mean that the taste cultures of all social status groups are valued equally.[33]

In the art museum, the illusion of high culture continues to be maintained not by a governance that is disdainful of the masses, for in fact, that very governance is putting pressures on museums to be run more like effective and productive attractions in the entertainment industry. Instead, if a sense of high culture still exists within museums, and it surely does, it exists in the more traditional definition of good art that is still operative today. The "Q" word, quality, is still the great separator between professional and popular interests. Many museums – and they are strongly supported in this by most art critics as well – boldly defend the autonomous character of the "free" arts, which often means valuing more highly art that is recognized by the small number of art world insiders, as opposed to art that is popular.[34] By this definition, contemporary art can only be good if it resists commodification, and stresses its own autonomous character, usually by resisting codes comprehensible to any but a select few. But as we have seen, this rigidity is slipping away as revisionist scholarship, the interests of sponsors, and museums' own audience-building agendas, broaden the definition of what is acceptable within the institution.

One ironic side-note in this professional pursuit of the public interest among museum-workers, is the subtle reversal that has transpired in the past decade between the roles taken on by curators and educators. In the practice of the 1970s and 1980s, curators generally took the more elitist approach to art eschewing the use of didactic labels in favor of "letting the art speak for itself," and educators fought for written, verbal, and recorded information of all kinds. In the past decade these roles have somewhat reversed. The profusion of contextual exhibition and installations such as *Picturing America* and *Made in California* turns curators into prolific label writers, audio-tour commentators and even video producers. At the same time, an anti-information movement has grown among museum educators, founded in research and fueled by a frustration with the perceived inadequacy of information to help visitors decode and derive meaning from works of art. Inspired by a program entitled Visual Thinking Strategies (VTS), this movement, initiated by the research of cognitive psychologist Abigail Housen and fueled by the articulate passion of Philip Yenawine, former Director of Education at the Museum of Modern Art in New York, has taken a strong hold on several large art museum education departments.[35]

The VTS program entails guiding viewers to make their own meanings from art objects through a series of open-ended questions: "What is going

on here? What do you see that makes you say that? What more do you see?" The museum educator acts as facilitator, often repeating and rephrasing visitor responses, but refrains from adding their own interpretive remarks into the mix. Supporters of this method point out that the addition of art historical or contextual information will not only inhibit visitor responses, but also invalidate some responses completely. Thus information about art is strongly discouraged. Ironically, while some curators are depending more and more on information to reach out to museum visitors, some educators are turning their back on information in their pursuit of audience empowerment.

Perhaps this relatively recent and quite paradoxical reversal illustrates more than any other factor the complexity of museums and the difficulty in characterizing them. Understanding that the institution serves both a symbolic function and a more practical one may help scholars to see that event horizon discussed earlier as the place where symbolism, perception and object intertwine. As symbols, museums are best characterized as temples, indeed many museum buildings such as the Philadelphia Museum of Art prominently placed on a hill overlooking a grand parkway, concretely embody that symbolism. In standard contemporary practice, it is the idea of forum or Town Square that predominates the professional literature, while museums strive to be more inclusive and more diverse. As Anne d'Harnoncourt puts it: "there's nothing that's going to make the Philadelphia Museum of Art shed its stones. We just have to get the town square inside..."[36] The critical literature does little to bridge the gap between the symbolic messages that museums project and how these messages are received and interpreted by museum visitors in the richly diverse, visual, popular cultures that characterize today's contemporary life. The competing interests of museum workers and trustees further complicate the situation within museums.

Just as cultural historians and anthropologists have made clear distinctions between cultures and Culture, we need to distinguish between museums and the Museum. We need a critical literature that in addition to analyzing how museums construct meaning and project an ideal viewer in the abstract, will also give us a theory of the viewer that emphasizes individual responses to both complex interior impulses and conflicting external messages. Finally, we need a practice informed by a broad range of theoretical approaches in art history, criticism, anthropology, cultural and visual studies, as well as visitor studies and aesthetic development. From

this rich combination of diverse voices, may emerge a new museum presence.

In the aftermath of the terrorist attacks of September 11, 2001, what role can museums hope to play in the world? For me there is one direction that seems more urgent than any of the others: museums stand as monuments to relentless idealism in the pursuit of what Simone de Beauvoir called an "ethics of ambiguity."[37] Only through this pursuit can we hope to affect the black and white terrorism of fanatical practice. If museums seem complex, it is because they are. And it is that very complexity and their ability to change according to shifting social needs that insures their status as symbols of democratic civilization.

Notes

1 I borrow the word "academified" from Mark H. C. Bessire, "Facts and Fictions: The Histories of Museum Display and Installation in Cultural History," *Art Journal*, Summer 2001, pp. 107–9

2 Philadelphia Museum of Art 1998 summer intern Jen Song, in an e-mail correspondence to the internship coordinator Glennis Pagano.

3 This is why amusement parks purposely and explicitly overestimate the stated waiting times that visitors see displayed when waiting in line. It goes to follow that if someone expects to wait twenty minutes and they arrive at their destination in less than ten they feel very pleasantly surprised. "Six Flags Debuts Queue Management," in *Amusement Business*, April 5, 2001, on-line version.

4 Nicholas Mirzoeff argues that the study of museums might be better understood as part of a newly conceived discipline of Visual Culture. *An Introduction to Visual Culture* (London and New York: Routledge, 1999), p. 12.

5 In the study of black holes an event horizon is the "point beyond which nothing, not even light, can escape the black hole's powerful gravity." James Glanz, "Evidence Points to Black Hole at Center of the Milky Way," *New York Times*, on-line version, September 6, 2001.

6 It is interesting to note that the museum is never identified as such, but since the setting is explicitly Philadelphia where the museum is such a well-known visible landmark, it really does function as a museum (or temple) up on a hill. Placing the statue of Rocky on the steps of the museum eliminates all necessity for going inside. The art stays outside, as does the crowd. See my essay "The 'Rocky Dilemma': Museums, Monuments and Popular Culture in the Post-Modern Era" in *Critical Issues in Public Art*, edited by Harriet Senie and Sally Webster (New York: Harper/Collins, 1992).

7 "I think a painting dies, you understand. After forty or fifty years a picture dies, because its freshness disappears.... Afterward it's called the history of art.... For me, the history of art is what remains of an epoch in a museum..." Marcel Duchamp as quoted in Pierre Cabanne, *Dialogues with Marcel Duchamp.* Translation by Ron Padgett (New York: Viking Press, 1971), pp. 67, 70–1. First published as *Entretiens avec Marcel Duchamp* (Paris: Editions Pierre Belfond, 1967).

8 For a survey of artists' engagements with museums in the 1970s, see, *Museums by Artists,* edited by A. A. Bronson and Peggy Gale (Toronto: Art Metropole, 1983).

9 "Museum Highlights: A Gallery Talk." Performed at the Philadelphia Museum of Art in 1989, published in *October,* vol. 57, Summer 1991, pp. 105–22. It is interesting to note that Fraser meticulously scripted the "uh's" and "uhm's" so characteristic of the inherent insecurity of museum volunteer docents, who often feel that they represent the institution's authority but are painfully aware of their marginal status within it.

10 Author's conversation with Andrea Fraser, March 1999.

11 Kynaston McShine, *The Museum as Muse: Artists Reflect* (New York: Museum of Modern Art, 1999). In his introduction to the catalogue, McShine argues that he seeks to present a variety of ways in which artists have used the museum as a subject for art. Thus the exhibition and catalogue presented both artists critical of the museum and those who approached the institution in a variety of other ways.

12 *Art History,* vol. 3, no. 4, December 1980, pp. 448–69.

13 Ibid., pp. 450–1.

14 London: Routledge, 1992.

15 Minneapolis: University of Minnesota Press, 1994.

16 Hooper-Greenhill, *Museums and the Shaping of Knowledge,* p. 5.

17 Sherman and Rogoff, *Museum Culture: History, Discourses, Spectacles,* p. x

18 From a videotape of the Focus Group made by the Philadelphia Museum of Art of the first-time visitors discussing their experiences (Philadelphia Museum of Art, 1989). Part of a project sponsored by The Getty Center for Education in the Arts and The J. Paul Getty Museum.

19 John Falk and Lynn D. Dierking, *The Museum Experience* (Washington, D.C.: Whalesback Books, 1992), pp. 11–24.

20 Vera L. Zolberg "Barrier or Leveler? The Case of the Art Museum," in *Cultivating Differences: Symbolic Boundaries and the Making of Inequality,* ed. Michel Lamont and Marcel Fournier (Chicago and London: The University of Chicago Press, 1992), p. 190.

21 J. Mark Davidson Schuster, *The Audience for American Art Museums, Research Division Report # 23, National Endowment for the Arts* (Washington, D.C.: Seven Locks Press), p. 4.

22 Pierre Bourdieu, *Distinction: A Social Critique of the Judgement of Taste* (Cambridge, MA: Harvard University Press 1984).

23 David Thelen, "Learning Community: Lessons in Co-Creating the Civic Museum," in *Museum News* (May/June 2001) pp. 54–9, 68–73, 93–5; David

Carr, "Balancing Act: Ethics, Mission, and the Public Trust," *Museum News* (September/October 2001), pp. 28–32, 71–81.

24 Lisa Roberts, *From Knowledge to Narrative: Educators and the Changing Museum* (Smithsonian Institution Press, 1997).

25 Ibid., pp. 115–16; see also Steven C. Dubin, *Displays of Power: Controversy in the American Museum from the Enola Gay to Sensation* (New York and London: NYU Press, 1999), ch. 5, pp. 152–85.

26 As quoted in Dubin, *Displays of Power*, pp. 169–70

27 Roberta Smith, "Memo to Art Museums: Don't Give Up on Art," *The New York Times*, on-line version, December 3, 2000.

28 Ibid., pp. 2–3

29 Lila Wallace-Reader's Digest Fund, *Engaging the Entire Community: A New Role for Permanent Collections* (New York, 1999), pp. 13–20.

30 See my article, "Modern Art: Making People Mad," in *Museum News*, vol. 76, no. 3, May/June 1997, pp. 53–8.

31 V. Zolberg, "'An Elite Experience for Everyone': Art museums, the Public and Cultural Literacy," in Sherman and Rogoff, pp. 49–65

32 Jim Collins, *Uncommon Cultures: Popular Culture and Post-Modernism* (New York and London: Routledge, 1989), p. 141.

33 Vera L. Zolberg, "Barrier or Leveler? The Case of the Art Museum," p. 204.

34 Jan Vaessen, "The Inflation or the New: Art museums on their Way to the 21st Century," in T. Gubbels and A. van Hemel, eds., *Art Museums and the Price of Success* (Amsterdam: Boekman Foundation, 1993), p. 119.

35 Housen and Yenawine started an organization called VUE (Visual Understanding in Education). The website at *www.vue.org* has a description of the VTS curriculum, a k-5 sequential curriculum intended for classroom use. Projects with museums are also described.

36 *Curating Now: Imaginative Practice, Public Responsibility*, proceedings of a symposium organized by Paula Marincola and Robert Storr (Philadelphia: Philadelphia Exhibitions Initiative, 2001), p. 87.

37 Simone de Beauvoir, *Pour une morale de l'ambiguïté* (Paris: Editions Gallimard, 1974).

Plate 5 Visitors at the *Norman Rockwell* Exhibition, on tour 2001.

4

Norman Rockwell at the Guggenheim

Alan Wallach

... as for what has until today passed for a capitalist culture – a specifically capitalist "high culture," that is – it can also be identified as the way in which a bourgeoisie imitated and aped the traditions of its aristocratic feudal predecessors, tending to be eclipsed along with their memory and to give way, along with the older classical bourgeois class-consciousness itself, to mass culture – indeed to a specifically American mass culture at that.

Frederic Jameson (1994)[1]

Probably no institution is more identified with the achievements of modernism at its historical highpoint than New York's Solomon R. Guggenheim Museum. Founded in 1939 as the Museum of Non-Objective Art, the Guggenheim initially focused on Wassily Kandinsky and other German expressionists but quickly broadened its scope to include artists ranging from Cézanne and Picasso to de Kooning, Rothko, and Pollock.[2] Today, the museum's extraordinary permanent collection remains centered on the period 1890 to 1970. It is, according to the museum's website, meant to "represent the breadth of Modernism."[3] Yet while the Guggenheim is still identified with modernism's greatest achievements, it nonetheless appears to be breaking with its own modernist past. Three recent exhibitions signal new forces at work. In 1998, *The Art of the Motorcycle*, sponsored by BMW, presented motorcycles as objets d'art.[4] *1900: Art at the Crossroads*, the museum's millennium offering, surveyed a wide range of *fin-de-siècle* artistic production, including paintings by such nineteenth-century *pompiers* as Carolus-Duran and

William-Adolphe Bouguereau as well as works by such familiar modernist masters as Matisse and Mondrian.[5] Less than a year later, the museum mounted *Giorgio Armani*, a retrospective of the Milanese fashion designer's oeuvre that was in large measure underwritten by the subject of the exhibition himself.[6]

Yet when it comes to undermining the museum's modernist heritage, these three exhibitions pale by comparison with *Norman Rockwell: Pictures for the American People*, a blockbuster exhibition featuring seventy of the artist's best-known oil paintings and all 322 of his *Saturday Evening Post* covers. Sponsored by the Ford Motor Company with additional funding support from Fidelity Investments and the Luce Foundation, *Norman Rockwell* reached the Guggenheim in November, 2001, after stops at the High Museum in Atlanta, the Corcoran Gallery in Washington, D.C., the Chicago Historical Society, the San Diego Museum of Art, the Phoenix Art Museum, and the Norman Rockwell Museum in Stockbridge, Massachusetts. *Rockwell* at the Guggenheim was a deliberate provocation, an opportunity, no doubt gleefully seized upon by director Thomas Krens and curator Robert Rosenblum, to defy the Guggenheim's own modernist past and, in the most flamboyant manner imaginable, to outrage and entice critics and the public.[7] From a high modernist perspective, nothing could have been more incongruous than the paintings Rockwell executed for reproduction on the cover of the *Saturday Evening Post* gracing the walls of Frank Lloyd Wright's ethereal spiral. As a popular illustrator as opposed to a fine artist, Rockwell represented everything modernism abhorred. Here was a painter, admired by millions, whose work, which had more than a passing resemblance to Russian Socialist Realism, was almost entirely devoted to bland patriotic myths of American goodness and innocence. In 1948, Clement Greenberg penned a spirited defense of modernist abstraction in which he confessed his resignation to the idea that the "millions [who] prefer Norman Rockwell to Courbet" would never be persuaded "to comprehend the standards that make Courbet the one to be preferred."[8] The worm has chewed more than half a century since Greenberg wrote. It is therefore worth asking what Rockwell was doing at the Guggenheim in 2001. "The millions" had not converted to Greenbergian formalism. Had the guardians of high culture capitulated to the blandishments of popular art?

Answers to these questions might be sought in an examination of the Guggenheim's recent history beginning with the museum's decision in 1996 to hire Robert Rosenblum as its curator of twentieth-century art.[9]

A professor of art history at New York University since 1967 and a scholar with wide-ranging interests in European and American art of the nineteenth and twentieth centuries, Rosenblum has long been fascinated with areas of art history ignored by more traditional art historians. A pioneering student of nineteenth-century European academic painting, he has also displayed an unalloyed enthusiasm for the work of Walt Disney and for art that has often been derided as kitsch.[10] Rosenblum has not been shy about proclaiming his "loathing" for theory – i.e., anything that might prompt critical awareness of his own institutional and historical role. Thus the Rockwell show simply exemplifies his belief in a curatorial policy of what he calls "variety."[11] It is noteworthy that in the discourse surrounding the current Rockwell revival, much of it the work of writers of a conservative-populist bent, modernism is often tagged as exclusionary and "elitist" – the antithesis of Rockwell's "pictures for the American people." In Rosenblum's view, bringing *Rockwell* to the Guggenheim provided an occasion for "the surprise of being forced to reconsider an artist so totally scorned by earlier generations of elite modernists."[12] Rosenblum can be taken at his word, but set against the history of American art museums in the latter half of the twentieth century, his views appear to be as much effect as cause. For what is at issue is not simply the immediate circumstances surrounding the decision to bring the Rockwell exhibition to the Guggenheim, but the bald fact that in the late 1990s such a decision could become possible in the first place.

In this essay I am concerned with the question of how American museum culture reached the point where a Norman Rockwell blockbuster could make it to what was, until recently, a modernist bastion. My analysis proceeds in stages. I first outline what I take to be the three preconditions for *Rockwell* at the Guggenheim. As will be seen, these preconditions are interrelated and can be understood as aspects of the same phenomenon, sometimes called "postmodernism": (1) the erosion of a traditional bourgeois culture which had based itself upon aristocratic models; (2) the waning of what Pierre Bourdieu has called "distinction" – an ideological development in which a taste for high art functioned as a marker of superior social status; (3) modernism's decline and along with it the devolution of the category "high art." These preconditions provide a framework for an analysis of the history of American art museums in the twentieth century leading up to the triumph of corporatization: how museums have in their operations and in their approach to the public increasingly come to resemble the corporations that, for the most part,

now support them. In my conclusion, I argue that given the historical forces at work, the Rockwell show also marked a new stage in the ongoing amalgamation of mass culture and the traditional high culture of the museum.

Preconditions

In *The Origins of Postmodernity* (1998), Perry Anderson argues that modernism arose in a Europe where the bourgeoisie still struggled for self-definition and cultural authority against its feudal-aristocratic other.[13] In the process, the bourgeoisie appropriated the cultural trappings of aristocracy as part of its effort to consolidate its power. American robber barons such as J. P. Morgan and Henry Clay Frick exemplify the way in which the late nineteenth-century American ruling class, perhaps even more desperate for cultural legitimacy than its European counterparts, bought for itself an aristocratic heritage.[14] Anderson observes how the appropriation of aristocratic culture helped to sustain the bourgeoisie as "a social force with its own sense of collective identity, characteristic moral codes and cultural *habitus*."[15] Yet by the end of World War II "aristocratic tradition had received its quietus across continental Europe" and thus, "by and large, the bourgeoisie as Baudelaire or Marx, Ibsen or Rimbaud, Grosz or Brecht – or even Sartre or O'Hara – knew it, [had become] a thing of the past."[16] As in Europe, so in the United States the "democratization of manners and disinhibition of mores" did their work. By the 1990s, the pseudo-leveling of class differences and the abandonment of traditional cultural norms resulted in what Anderson describes as "a general *enca-naillement* of the possessing classes" – the transformation of a once staid and seemingly self-confident ruling class into a "rabble" of oil company executives, CEOs, Wall Street operators, media moguls, shyster politicians, and millionaire celebrities.[17]

"Distinction," as Bourdieu defines it, was a key prop of the older bourgeois identity. Not everyone could claim the ability to appreciate high art; indeed, only a chosen few could possess the necessary "aesthetic disposition."[18] This "gift" resulted from class background and education but, via a pervasive mystification, appeared to be inborn. That the "gift" almost invariably belonged to members of the upper-middle class was taken not as a demonstration of the workings of social privilege, but as a result of an inherited superiority of taste. For Bourdieu,

It is as if those who speak of culture, for themselves and for others, in other words cultivated people, could not think of cultural salvation in terms other than of the logic of predestination, as if their virtues would be devalued if they had been acquired, and as if all their representation of culture was aimed at authorizing them to convince themselves that, in the words of one highly cultivated elderly person, "education is innate."[19]

In retrospect it is not hard to understand the role "distinction" played in strengthening a traditional bourgeoisie's claims to cultural authority. In effect, "distinction" in the Bourdieusian sense supplanted the distinction associated with aristocratic blood lines. The paradigmatic figure here is the gentleman-connoisseur, a social type that flourished in the nineteenth and first half of the twentieth centuries but had by the end of the twentieth century all but disappeared. By then, the bourgeoisie, no longer having any real need to claim cultural superiority, could simply be itself – an entirely practical self unencumbered by aristocratic pretensions and no longer ashamed of its taste for among other things popular culture. In other words, "distinction" is becoming obsolete – a development that holds profound consequences for museums. Museums may remain engines of inclusion and exclusion, but without the older forms of mystification, the connections between taste, education, and *habitus* become clearer every day. Moreover, since the exhibition of works of art is at some level less and less motivated by the need to vindicate a rarefied taste, artifacts that once failed to qualify as high art – motorcycles, *pompier* extravaganzas, Armani suits, canvases by Norman Rockwell – can with impunity be introduced into the museum's most sacred spaces.[20]

The loss of cultural self-definition I have been describing coincides with modernism's demise. For as T. J. Clark has observed, with the decline of a traditional bourgeois-aristocratic culture, modernism had

> no adversary. Its endless riffs and deformations of the aristocratic legacy –
> the very legacy the bourgeoisie was struggling at the same time to turn to its
> own purposes – came to mean nothing, to have less and less critical force,
> because the bourgeoisie had abandoned the struggle, and finally settled (as
> it always wanted to) for purely instrumental reason.[21]

Modernism has become a thing of the past. Indeed, at major art museums it has taken on the dimensions post facto of an *art officiel*. Artists who fifty or sixty years ago engendered controversy or stood beyond the pale of respectable opinion – Van Gogh, Picasso, Matisse, Kandinsky, Pollock –

have attained old master status. Museums vie for their work, which also forms the core attraction of such institutions as New York's Museum of Modern Art and the Guggenheim. Indeed, it is the Guggenheim's collection of modernist art that is being "leveraged" throughout its burgeoning museum empire.[22]

Yet if modernism is now triumphant as high art, its triumph coincides with the erosion of the category itself. Beginning in the 1960s, the lines separating high and popular art began to blur. Modernism had always flirted with "primitive" and popular art, appropriating it for its own ends, its resort to "bad" taste a deliberate affront to bourgeois aesthetic propriety. Beginning in the 1960s artists took over the forms of mass art not only as a way of ironizing popular taste but also of ironizing bourgeois culture. For it had not escaped the notice of artists as different as Andy Warhol, Roy Lichtenstein, and Jeff Koons that a taste for high art was becoming less and less distinguishable from a taste for the products of popular culture.

Rockwell at the Guggenheim can thus be seen as an almost inevitable outcome of these developments. Indeed, it was perhaps only a matter of time before an enterprising museum decided to make explicit what had for the last decade or so been implicit in the culture. Hence the *Rockwell* tour culminating in the exhibition's arrival at the Guggenheim. Frederic Jameson writing in 1994 can be taken as a prophet of Rockwell's current apotheosis. For here we have, precisely, evidence of the way in which capitalist high culture is giving way "to mass culture – indeed to a specifically American mass culture at that."

Two Phases of the American Art Museum

The history of the American art museum in the twentieth century can be divided into two phases – Robber Baron and Blockbuster. This division, as shall become evident, is not arbitrary. The Robber Baron phase represents the period in which high art reigned supreme in the museum. The Blockbuster phase witnessed the transformation of the meanings associated with the category high art. That transformation set the stage for the arrival of *Rockwell* at the Guggenheim.

The Robber Baron Phase began shortly after 1900 and lasted until the 1960s. At the beginning of this period financial magnates possessing undreamt of wealth took over the boards of trustees at New York's Metropolitan Museum and at other big city museums. At the Metropol-

itan, J. P. Morgan and Henry Clay Frick took the place of such half-forgotten figures as William T. Blodgett, John Taylor Johnston, and Henry Marquand. The museum now became a site for conspicuous display. Roman-revival-style buildings proclaimed imperial aspirations. Far less focused on their educational mission than they had been in an earlier period, major museums featured dazzling arrays of original works bought in Europe. This shift marked the disappearance of cast collections and the other replicas that had filled the halls of the post-Civil War art museum.[23] Henry James, writing in 1907 in *The American Scene*, produced an extraordinary analysis of the new order that was at that very moment taking hold at the Metropolitan:

> There was money in the air, ever so much money – that was, grossly expressed, the sense of the whole intimation. And the money was to be all for the most exquisite things – for *all* the most exquisite except creation, which was to be off the scene altogether; for art, selection, criticism, for knowledge, piety, taste. The intimation, – which was somehow, after all, so pointed – would have been detestable if interests other, and smaller, than these had been in question. The Education, however, was to be exclusively that of the sense of beauty; this defined, romantically for my evoked drama, the central situation.[24]

Other observers, far less ironic than James, also focused on beauty, proclaiming a new museological doctrine of art for art's sake, of the efficacy of formal appreciation, which made superfluous earlier efforts to educate masses of immigrant visitors. Matthew Prichard, assistant director of the Boston Museum of Fine Arts in the early years of the century, argued strenuously against retaining casts and replicas in the museum's new Beaux-Arts building, and for a new approach to originals.[25] A genuine *fin-de-siècle* aesthete, his thinking often shading into something resembling religious mysticism, Prichard put forth rationales for the aesthetic value of original works of art that remained current throughout the period (and still retain some influence today). According to Prichard, original art exhibited in the museum had no purpose other than to give pleasure:

> The Museum is for the public and not for any caste or section of it, whether student, teacher, artist or artisan, but is dedicated chiefly to those who come, not to be educated, but to make its treasures their friends for life and their standards of beauty. Joy, not knowledge, is the aim of contemplating a

painting by Turner or Dupré's *On the Cliff,* nor need we look at a statue or a coin for aught else than inspiration and the pleasure of exercising our faculties of perception. It is in this sense, furthermore, that they are accepted by those who visit our galleries, in accordance with the teaching of Aristotle, who recognized that the direct aim of art is the pleasure derived from a contemplation of the perfect.[26]

Here we discover the origins of the idea – still sometimes encountered in the museum and academic worlds – that works of art have the power to speak for themselves and that interpretation in the form of wall texts or educational efforts only places barriers between the viewer and authentic aesthetic experience. According to this theory, what counts is the work's formal qualities, its "significant form," as Prichard's contemporary Clive Bell maintained, and consequently a viewer could derive unqualified aesthetic pleasure from the productions of diverse cultures and different historical periods.[27] Thus a Flemish altarpiece, a Chinese porcelain, a Persian miniature, an African mask, or a Renaissance bronze would provide, in more or less equal measure, an occasion for inspired looking.

But it was entirely unlikely that an untutored public would find its way to such rarefied delights. Today we readily see the elitist logic underlying such thinking. Yet during the period under consideration formalist notions deeply influenced the direction American art museums took. Of course museums never abandoned entirely the idea of an educational or civilizing mission, but with millionaire trustees firmly in control, such institutions as the Metropolitan and the Boston Museum of Fine Arts more and more resembled elite preserves. These institutions may have felt obliged to open their doors to visitors of whatever stripe or background, but they did not believe they were duty-bound to make such visitors feel particularly welcome. The museum was accessible mainly to those who felt a sufficient level of comfort in the face of intimidating displays of cultural wealth, who knew what they were looking at, or for, in the ever-expanding collections, and who identified with an upper-class culture or lifestyle that may have been more fiction than fact but which nevertheless set a standard relatively few could attain. The museum became for many a forbidding or bewildering place. I am old enough to remember the undisguised snobbery that surrounded museum culture in New York in the late 1950s and early 1960s, that was indeed almost tangibly present in such institutions as the Frick Collection and the Morgan Library, and how often the galleries of major art museums were all but deserted. As late as 1965 one could

study Cézanne's *View of Mont St.-Victoire* at the Metropolitan without fear of distraction or serious interruption, or spend an hour or two in the Museum of Modern Art's permanent collection scrutinizing Matisse's *Red Studio* with only an occasional strolling tourist breaking the silence of the nearly empty galleries.

The Blockbuster Age

The Blockbuster phase of our history dates to the beginning of the 1960s and continues today. The 1960s mark the rise of a new type of museum audience and at the same time the reorganization and expansion of major art museums along modern corporate lines.

The new public that began to appear at art museums in the 1960s was attracted by that new phenomenon, the blockbuster exhibition. The Metropolitan Museum kicked off the age of the blockbuster in 1963 with an exhibition of the *Mona Lisa*, a "momentous and controversial event," as Calvin Tomkins has observed, that in the space of a month drew more than a million visitors to the museum.[28] The appearance of this new audience coincided with the sudden, rapid expansion of American higher education beginning in the late 1950s, and along with it the spread of standardized introductory art history courses. The first printing of H. W. Janson's *History of Art*, by far the most widely used art history textbook of the 1960s, dates to 1959. The new audience consisted almost entirely of students and professionals – men and women with at least a year or two of college and, minimally, a smattering of art history.

At this point museum directors and trustees became aware of new possibilities. Probably the most symptomatic figure of the period was the flamboyant Thomas Hoving, an upper-class renegade with undisguised populist ambitions who became the Metropolitan Museum's director in 1966. Hoving, who had an extraordinary flair for publicity, aimed to transform the Metropolitan into the city's leading cultural attraction, and during the ten chaotic years he ran the museum, he oversaw a host of large-scale exhibitions including *Harlem on My Mind*, which plunged the Metropolitan into endless controversy and a series of blockbusters marking the museum's centennial.[29]

Hoving's reign resulted in a new scale of operations at the Metropolitan. To serve an enlarged public the museum needed new resources, and it increasingly turned to corporations and the government for support.

Earlier, moguls and financiers put their stamp on museums by donating their collections, often setting up enclaves or what might be called "family chapels" within the institution. The museum was, in this sense, a monument to the powerful individuals who ran and supported it. It is, in this respect, instructive to spend a few minutes in the Washington National Gallery's Donors' Room with its portraits of Mellons, Wideners, and Kresses. Beginning in the 1960s, corporate wealth began to supplant individual donations. Of course wealthy individuals continued to patronize art museums. Yet today most large-scale funding now comes directly from corporations and indirectly from the government in the form of tax breaks. Or to put the matter somewhat differently: corporate funding and the blockbuster – the defining innovation of the period – go hand-in-hand. Today, no major exhibition is conceivable without some form of corporate underwriting. Pick up almost any catalogue and inevitably you encounter something like the following from the catalogue for the big Thomas Moran exhibition held at the National Gallery in 1997: "The National Gallery of Art wishes to thank the Boeing Company, in particular its chief executive officer Philip M. Condit, for its generous sponsorship of the exhibition and the catalogue."[30]

Corporate influence became pervasive. Not only did corporations take on the role of museum patron, which brought them dividends in the form of "image" and good will, they also provided models for expansion and reorganization. With boards of trustees that increasingly included corporate officers, museums rationalized and enlarged operations, offering the public a host of new services. The museum became a hotbed of marketing strategies and public relations techniques. Specialists were hired to raise money, augment membership, run sales operations, direct production of museum publications, and oversee food services. Curatorial and education departments were professionalized. Advanced degrees became de rigueur. By the 1980s, the days of genteel museum amateurism were all but over.

Museum architecture – the wings and extensions that were added to traditional buildings as well as the new museums that were begun from scratch – also registered corporate influence. Such structures as I. M. Pei's East Wing of the National Gallery and Kevin Roche's additions to the Metropolitan Museum recapitulated, in a fittingly ceremonial form, corporate ideals of rationality, efficiency, functionality, impassivity and, in complicated ways, individualism. While earlier museum buildings symbolized ideals of education, republican virtue, imperial dominance, the

glories of western civilization, and artistic genius, museum architecture of the 1960s, 1970s, 1980s, and 1990s signaled the museum's alignment with the dominant corporate culture.

Remnants of the earlier elitism persist. Still, over the last forty years the museum has steadily become more user-friendly. Visitors are no longer put off by what might be called institutional condescension. A lack of art historical knowledge is no real barrier to spending an hour in an exhibition devoted to Olmec sculpture or the paintings of Jan Steen. The museum is, if anything, eager to accommodate visitors with handouts, brochures, introductory videos, docent tours, special lectures, touchscreens, and computer mini-galleries. Visitors are encouraged to rent an "acoustiguide" at the entrance to a blockbuster exhibition, or to sign up for a docent tour. Indeed, at the museum, visitors simply put themselves in the hands of professionals and experts who furnish them with information and insight. In this respect, they are not very different from corporate clients in need of specialized services.

American art museums are today far more democratic than they were in the past, at least for the class of people who in increasing numbers now visit them.[31] Structurally, a visit to a major art museum is not very different from a trip to a mall or to Disneyland or Colonial Williamsburg. Visitors choose from a variety of possible activities and experiences: visiting the permanent collection or a special exhibition, shopping for souvenirs, reproductions and books, eating a meal in a cafeteria or more upscale museum restaurant. A decade ago, Hans Haacke argued that art museums are part of the consciousness industry.[32] In late capitalist society the consciousness industry is nothing other than the news and entertainment industries – the staging of politics and current events, history, drama, fantasy, and the arts for mass audiences. Having abandoned some of their elitist pretensions, museums now occupy a more central place in American culture. The Metropolitan Museum of Art, New York's premier tourist attraction, draws an astonishing 4.6 million visitors per year – more than the combined yearly attendance at the city's sports stadiums. And as the barriers between high and popular culture are lowered or disappear, it is not surprising that the moguls of the entertainment industry have taken an increasing interest in the arts by supporting museums and other cultural institutions. Not for nothing, then, the caricature of Michael Eisner as a modern Medici that in the fall of 1998 appeared on the front page of the *New York Times* Sunday Arts and Leisure section.[33]

The New Cult of the Original

The robber baron phase of this history – the period in which museums acquired fabulous collections of old master paintings and other rarefied works – marked the abandonment of casts and simulacra and the rise of what I call the "cult of the original." The ideal museum visitor was now no longer a man steeped in classical learning but the gentleman art lover, an amateur, a man of aristocratic taste, perhaps even a connoisseur who took pleasure in his unique ability to discern aesthetic quality. As we have seen, taste conferred upon the gentleman amateur his superior status. More generally, it served as a cornerstone of elite or upper-class culture, distinguishing it from all that was commonplace and ordinary. Those who identified with upper-class taste might share a sense of cultural and, by implication, social superiority. But because it excluded those who knew little or nothing about art, it effectively limited access to museum culture – and hence to the museum.

In "The Work of Art in the Age of Mechanical Reproduction," Walter Benjamin maintained that in the museum the art object lost the aura or sense of psychic distance derived from its religious or cult value, only to gain a new aura based upon what Benjamin called its "exhibition value," its uniqueness and authenticity, the way it offered proof of artistic genius.[34] In the period extending from the 1960s to the present, the emphasis upon the work of art as authentic and unique has intensified. Far from diminishing its aura, mechanical reproduction has only served to enhance its power and attractiveness, especially since improvements in printing technology have made quality color reproductions readily available while, at the same time, museum culture has been publicized as never before with such programs as "Civilization," "Shock of the New," and "Sister Wendy." As John Berger pointed out in *Ways of Seeing*, visitors now come to the museum to view the original of the reproduction.[35] Although the museum may still be home to an elite culture personified by the amateur art lover or gentleman of taste, today more often than not the gentleman of taste is impersonated only by the museum director with his quaint, self-consciously upper-class accent and his unyielding insistence upon the importance of artistic quality (Carter Brown, until recently director of the National Gallery in Washington, D.C., and Philippe de Montebello, director of the Metropolitan Museum of Art, immediately come to mind). Museum visitors are for the most part

content to leave questions of taste, quality, and connoisseurship to the museum's experts. Drawn to blockbuster exhibitions – which predictably vindicate genius, originality, and authenticity – to the permanent collection, and perhaps to more specialized attractions, they have little reason to feel inferior or put off because they lack the abilities that once distinguished the upper-class amateur.

And yet, while the upper-class amateur viewed the work of art as an aesthetic object–an object that demanded a refined appreciation of its formal traits—today's museum audience, with its apparently insatiable appetite for blockbusters, is increasingly prompted to admire works of art on other terms. The original now not only projects an aura of authenticity and genius but is also often an object of nostalgia for the high culture and bourgeois lifestyles of an earlier era. Thus, for example, Impressionism summons up the imagery of gracious holiday leisure à la Masterpiece Theater, while the work of Van Gogh or Picasso recalls the bravery and defiance of the avant garde and its early supporters. In other words, blockbusters present works of art as components of popular historical narratives. In this respect, blockbusters are not very different from the "themed" entertainments associated with corporate culture (e.g., Disneyland). As such, they exemplify, as nothing else in the art world, the converging trajectories of high and popular culture. What might be called the "blockbuster mentality" transforms such figures as Monet, Van Gogh, Picasso, and Vermeer into the art-historical equivalents of media stars. Little wonder then that critics promoting the Norman Rockwell blockbuster got into the habit of calling Rockwell the "Vermeer" of American art.[36]

Legitimation

Rockwell at the Guggenheim can be taken as a measure of the extent to which museum culture has evolved since the 1960s. Indeed, the successful promotion of Rockwell's art over the last two decades strikingly contrasts with earlier efforts to elevate it to high art status. In the early 1970s, Thomas Buechner, director of the Brooklyn Museum of Art, collaborated with Rockwell's New York gallery to organize a touring exhibition of Rockwell canvases that was seen at nine museums including the Brooklyn Museum, the Corcoran Gallery in Washington, D.C., and the De Young Museum in San Francisco. Critics recoiled in horror. John Canaday,

chief art critic for the *New York Times*, dubbed Rockwell "The Rembrandt of Punkin Crick."[37] The exhibition, although publicly proclaimed a success, was in the end accounted a failure. As Eric Segal has noted, despite "press accounts claiming the traveling exhibition a great success, internal memos of the Brooklyn Museum indicate that the director and staff members were disappointed in both attendance and sales of the book" that accompanied the exhibition.[38] Rockwell's art may have drawn a fair-sized audience, but given the strength of critical resistance this early attempt to promote his work could only end in failure.

Today the situation has changed dramatically, due in part to a concerted, thirty-year campaign to elevate Rockwell's paintings to the level of high art. This campaign, which from the viewpoint of earlier museum practices could be read as a parody of traditional forms of high art legitimation, began in 1969 with the founding of the Norman Rockwell Museum in Stockbridge, Massachusetts. The museum, which was supported by Rockwell himself, soon outgrew its original building, and in 1993 moved to its present quarters on a thirty-six-acre estate two miles west of the center of town.[39] With moral support from Ronald Reagan, who agreed to serve as its honorary president, the "Campaign for Norman Rockwell," as it was called, raised $5.4 million for a museum building "designed in the tradition of the New England meeting house."[40] This themed structure was the work of Robert A. M. Stern, an architect long associated with the Walt Disney Corporation, who wanted to create a museum that would, in his words, "resonate deeply with what we feel about Stockbridge and other New England towns, about our colonial experience, and about ourselves as Americans."[41] Named the Steven Spielberg/Time Warner Communications Building after two major donors, the museum houses a permanent display of Rockwell's art along with temporary exhibitions of work by Rockwell and other artists and illustrators of his era. The museum sees itself as a "repository of Rockwell's own collection of work, his archives and his studio [sic] [and] as a center of scholarship on Norman Rockwell and his life's work."[42] With its new building, its powerful individual and corporate backers, and its ever-expanding collection of Rockwelliana, the museum makes a claim for the importance of Rockwell's art that cannot easily be ignored.

Yet, as the museum could not have failed to recognize, without scholarly respectability, the campaign for legitimation would have foundered. Consequently, in addition to providing facilities for research and study, in 1986 the museum published director Laurie Norton Moffatt's "definitive

catalogue" of Rockwell's work.[43] With a museum dedicated to Rockwell and a massive catalogue raisonné providing a scholarly basis for the study of Rockwell's oeuvre, collectors began to compete for examples of Rockwell's work. In 1971, Richard Reeves reported that the highest price ever paid for a Rockwell was $27,000.[44] By the 1990s, prices had risen dramatically. In 1995, *After the Prom*, painted in 1957, sold for $800,000. Between 1996 and 1999, Sotheby's New York auctioned twenty Rockwells for prices ranging from $90,000 to $937,500 with the majority in the $200,000 to $300,000 range.[45] Prices of this magnitude, although nowhere near the tens of millions paid for the work of such blue-chip modernists as Picasso and Pollock, suggest the extent to which dealers and collectors now have a crucial financial as well as ideological stake in the success of the Rockwell revival.

Critical validation accompanied these developments. By the mid-1990s, in a changed cultural climate, well-known literary and art world figures – Arthur Danto, Dave Hickey, Thomas Hoving, Paul Johnson, Karal Ann Marling, John Updike, and Tom Wolfe – began to champion Rockwell. These writers produced often extravagant claims on the artist's behalf – claims echoed in the catalogue and publicity surrounding the Rockwell exhibition. That Rockwell was the "Vermeer" of American art put him in a league with the old masters – or at least in a league with such earlier American masters as Thomas Eakins and Winslow Homer. Indeed, in November, 1999, in a move timed to coincide with the opening of the Rockwell show at the High Museum, PBS broadcast an hour-and-a-half program about Rockwell in its "American Masters" series, which featured testimonials by, among others, Thomas Buechner, Arthur Danto ("like Vermeer"), Dave Hickey, Karal Ann Marling, Robert Rosenblum, and Steven Spielberg.[46] Soon thereafter, the Rockwell Museum was crowing that with the exhibition's success, the critical tide had turned and that now "the time [was] right to add Rockwell to the canon of American art."[47]

That was the point of the whole campaign of course. Although some critics and art historians remained skeptical or were confirmed in their opposition, Rockwell's art-historical reputation received an enormous boost.[48] Speaking on National Public Radio's "Talk of the Nation" on 24 November 2000, Professor Wanda Corn, a respected scholar of twentieth-century American art and a Rockwell partisan, could not restrain her enthusiasm for what she took to be a new cultural dispensation: "Isn't it wonderful, we're in an age where we can love Pollock and Rockwell?"[49] With an extraordinarily popular Jackson Pollock blockbuster at the

Museum of Modern Art a recent memory and a major Hollywood film about the artist on the verge of commercial release, her remark addressed not only the historical moment but also the ongoing convergence of high and popular culture.[50]

The campaign to "add Rockwell to the canon of American art" had thus had its effect, but it would never have succeeded to the extent that it did had it not been for the changes in the wider culture. *Rockwell* at the Guggenheim signaled not only the art-historical triumph of an artist the art world had once derided as a banal, popular illustrator but also the historical triumph of a corporatized museum culture. For what "Rockwell" at the Guggenheim finally demonstrated was a new stage in the breakdown of the polarity between high and popular art – a polarity that had once seemed immutable and absolute. In the space of less than half a century, the American art museum had been transformed. The ideologies that made high art a viable social and cultural category were once its raison d'être. But no more! At the Guggenheim, the paintings of Norman Rockwell were acquiring something of the cachet of high art at the very moment when high art was losing the exclusivity it had for so long enjoyed.

Notes

My thanks to Rodney Olsen, Phyllis Rosenzweig, and William Truettner for their critical readings of the manuscript of this essay.

1 Frederic Jameson, "The Antinomies of Postmodernity," in *The Cultural Turn: Selected Writings on the Postmodern, 1983–1998* (London: Verso, 1998), p. 67. The essay was originally published in 1994.
2 See Nathaniel Burt, *Palaces for the People* (Boston: Little, Brown and Company, 1977), 340–7, for an account of the Guggenheim's early history. See also Neil Levine, *The Architecture of Frank Lloyd Wright* (Princeton: Princeton University Press, 1996).
3 http://www.guggenheim.org/exhibitions/perm_coll/index.html (as of August 2001).
4 See Thomas Krens and Matthew Drutt, eds., *The Art of the Motorcycle* (New York: The Guggenheim Museum, 1998); see also Michael Kimmelman, "Machines As Art, And Art As Machine," *New York Times* (June 26, 1998).
5 See Robert Rosenblum, Mary Anne Stevens, and Ann Dumas, *1900, Art at the Crossroads* (New York: H. N. Abrams, 2000).

6 See Germano Celant and Harold Koda, eds., *Giorgio Armani* (New York: The Guggenheim Museum, 2000). In response to the *Armani* exhibition, critics upbraided the museum for turning Frank Lloyd Wright's pristine temple of art into a showroom for high-priced commodities. See Roberta Smith, "Memo to Art Museums: Don't give up on art," *New York Times* (December 3, 2000).

7 On National Public Radio's "Talk of the Nation," Rosenblum anticipated

> a great deal of heat, which I think is fine. I mean, I would be very bored with keeping the status quo, and I think that one of my duties and the duties of most serious art critics or curators is to stir things up a bit, just to attack the prevailing prejudices, that kind of knee-jerk reflex that says "This has to be good and this has to be bad." So I expect there'll be a lot of flak, and I wouldn't want it otherwise, because to have a show that produced no flak probably would be a bit boring.

See transcript, "Talk of the Nation" (November 24, 1999), n. p.

8 Clement Greenberg, "Review of an Exhibition of Mordecai Ardon-Bronstein and a Discussion of the Reaction in America to Abstract Art," in *The Collected Essays and Criticism*, ed. John O'Brian, vol. 2 (Chicago: The University of Chicago Press, 1986), p. 219.

9 See "New Curators at the Guggenheim," *The New York Times* (July 10, 1996).

10 See, for examples, Robert Rosenblum, *Modern Painting and the Romantic Tradition* (New York: Harper and Row, 1975), passim and pp. 130–2, 141; *Paintings in the Musée D'Orsay* (New York: Stewart, Tabori and Chang, 1989); *On Modern American Art: Selected Essays* (New York: Harry N. Abrams, Inc., 1999), passim and pp. 294–304; and Robert Rosenblum and H. W. Janson, *19th-Century Art* (New York: Harry N. Abrams, 1984).

11 Robert Rosenblum, cited in "High Anxiety? Revisiting the Bad Art Issue," *Art Papers Magazine* (March–April 2000), 25.

12 Ibid.

13 See Perry Anderson, *The Origins of Postmodernity* (London and New York: Verso, 1998), pp. 84–6. My account also owes something to T. J. Clark, "Origins of the Present Crisis," *New Left Review* 2, ser. 2 (March–April 2000), pp. 87–8.

14 See Matthew Josephson, *The Robber Barons* (1934; rpt New York: Harvest Books, 1962).

15 Anderson, p. 85.

16 Ibid., pp. 84–5.

17 Ibid., p. 86.

18 See Pierre Bourdieu, *Distinction: A Social Critique of the Judgment of Taste*, trans. Richard Nice (Cambridge: Harvard University Press, 1984); see also Pierre Bourdieu and Alain Darbel, *The Love of Art: European Art Museums and Their Public*, trans. Caroline Beattie and Nick Merriman (Stanford: Stanford University Press, 1990).

19 Bourdieu and Darbel, *The Love of Art*, p. 4.

20 I would draw a distinction here between the Museum of Modern Art's exhibitions in which objects such as motorcycles, sports cars, kitchen fixtures, etc. are presented as exemplars of good design, and the Guggenheim's *Art of the Motorcycle*. At the Modern, design has been treated as a consequence of, but also secondary to, the development of modernist painting and sculpture, and in this respect, it tends to retain its traditional associations with applied as opposed to fine art. The museum inscribes this relation between modern design and modern painting and sculpture in the organization of its galleries, and thus visitors to the museum are in no doubt about which is more important. By contrast, by occupying the Guggenheim's spectacular main gallery, *The Art of the Motorcycle* claimed fine art status for the objects displayed.

21 Clark, "Origins of the present crisis," p. 87.

22 For an account of the Guggenheim empire, see Mark Rectanus, "New York–Bilbao–Berlin and Back: The Global Museum and Cultural Politics," *The European Studies Journal* 17, no. 1 (2000), 41–66.

23 See Alan Wallach, "The American Cast Museum: An Episode in the History of the Institutional Definition of Taste," *Exhibiting Contradiction* (Amherst: University of Massachusetts Press, 1998), pp. 38–56. I have drawn upon this text in what follows.

24 Henry James, *The American Scene* (1907; rpt. New York: St. Martin's, 1987), p. 138.

25 For Prichard, see Wallach, "The American Cast Museum," pp. 45–56, and David Sox, *Bachelors of Art: Edward Perry Warren & the Lewes House Brotherhood* (London: Fourth Estate, 1991), pp. 167–208.

26 In Walter Muir Whitehill, *Museum of Fine Arts Boston, A Centennial History*, vol. 1 (Cambridge, MA: Harvard University Press, 1970), pp. 201–2.

27 See Clive Bell, *Art* (New York: Capricorn Books, 1958; orig. publ. 1914).

28 See Calvin Tomkins, *Merchants and Masterpieces: The History of the Metropolitan Museum of Art*, rev. ed. (New York: Henry Holt and Company, 1989), pp. 340–2.

29 See Tomkins, pp. 340–73.

30 Earl A. Powell III, "Preface," in Nancy K. Anderson, ed., *Thomas Moran* (Washington, D.C.: National Gallery of Art; New Haven: Yale University Press, 1998), p. 9.

31 The demographics of museum visitors have probably not substantially changed over the last twenty or so years, it is rather the frequency with which about 20 percent of the population visits art museums that accounts for the increase. See Alan Wallach, "Class Rites in the Age of the Blockbuster: Distinction *à l'Américan*, or the Art Museum in American Culture," *Harvard Design Magazine* no. 11 (Summer 2000): 48–54.

32 See Hans Haacke, "Museums, Managers of Consciousness," *Art in America* 72, no. 2 (Feb. 1984), 9–17.

33 See Peter Applebome, "The Medici Behind Disney's High Art," *New York Times* (4 October 1998).

34 See Walter Benjamin, "The Work of Art in the Age of Mechanical Reproduction," in *Illuminations*, trans. Harry Zohn (London: Collins/Fontana, 1973), pp. 219–53.

35 See John Berger, *Ways of Seeing* (London: British Broadcasting Company; Harmondsworth and New York: Penguin Books, 1972), p. 21.

36 See, for example, Dave Hickey, "America's Vermeer," *Vanity Fair* no. 471 (November 1999), 172–80.

37 John Canaday, "Rockwell Retrospective in Brooklyn," *New York Times* (March 23, 1972).

38 E-mail communication with the author, October 3, 2000.

39 For this discussion of the Norman Rockwell Museum, I have drawn upon Alan Wallach, "The Norman Rockwell Museum and the Representation of Social Conflict" in Patricia Johnston, ed., *Between High and Low: Representing Social Conflict in American Visual Culture* (Berkeley: University of California Press, forthcoming).

40 James McCabe and Stuart Murray, *Norman Rockwell's Four Freedoms: Images That Inspire a Nation* (Stockbridge, MA: Berkshire House and the Norman Rockwell Museum, 1993), p. 97.

41 Robert Stern, "The Architect Reflects," in *The Norman Rockwell Museum at Stockbridge* (Stockbridge, MA: The Norman Rockwell Museum, 1993), n.p.

42 http://www.nrm.org/info.html (as of September 2, 2000).

43 Laurie Norton Moffatt, *Norman Rockwell, A Definitive Catalogue* (Stockbridge, MA: Norman Rockwell Museum at Stockbridge; Hanover, NH: University Press of New England, 1986).

44 Richard Reeves, "Norman Rockwell is Exactly Like a Norman Rockwell," *New York Times Magazine* (February 28, 1971), 27.

45 See Edgar Allen Beem, "Norman's Invasion," *The Boston Globe Magazine* (16 January 2000), 34, 37.

46 The program was broadcast on 24 November 1999. *Norman Rockwell* opened at the High Museum on 6 November. Thanksgiving seems to be a key date in the Rockwell calendar, probably because of its associations with Rockwell's *Freedom from Want*, the artist's most famous image. Not surprisingly, then, both the 1999 "American Masters" program and the edition of National Public Radio's "Talk of the Nation" devoted to Rockwell (see below) were aired the day before Thanksgiving.

47 *The Portfolio* 17, no. 4 (Winter 2000), 8–9. This journal is published by the Norman Rockwell Museum.

48 Perhaps the most skeptical consideration was Charles Rosen and Henri Zerner, "Scenes from the American Dream," *The New York Review of Books* 47, no. 13 (August 10, 2000), 16–20. I would add that I agree with many of the points that Rosen and Zerner raise in the course of their review.

49 See transcript, "Talk of the Nation" (November 24, 1999), n. p.

50 "Pollock" was at the Museum of Modern Art from October 28, 1998 to February 2, 1999. It was later seen at the Tate Gallery in London. The film "Pollock" was shown at the New York Film Festival in September 2000 and put into commercial release in mid-December. See Stephen Holden, "Splashed Across Life's Canvas, Dripping," *The New York Times* (September 30, 2000) and Holden, "A Dynamic Force, Hurling Life's Passion onto the Screen," *The New York Times* (December 15, 2000).

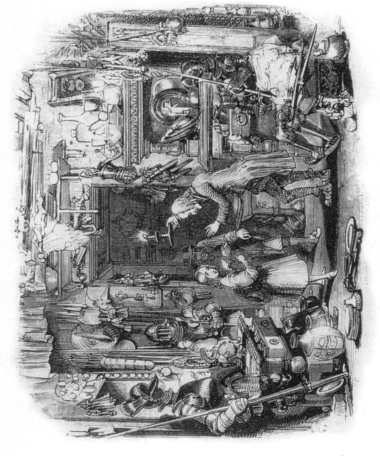

THE CHILD'S RETURN.

Plate 6 *The Child's Return* from Charles Dickens, *The Old Curiosity Shop*, London, 1841.

The Return to Curiosity:
Shifting Paradigms in Contemporary Museum Display

Stephen Bann

It has become a commonplace to repeat, in recent years, that the origins of the pervasive museum culture of the present day lie in the Renaissance and seventeenth-century development of the "Cabinet of Curiosities." Even my daily newspaper, on the day before I drafted the original version of this paper, contained a double-page spread celebrating what were entitled "Modern cabinets of curiosities," for the instruction of younger readers. These were told that: "The first museums grew from 'cabinets of curiosity'. The rejuvenation of museums in recent years recognises that being delighted and amazed is an important part of learning" (*Guardian*, 1998). In effect, much of this article, following in the track of the "interactive and user-friendly" techniques used to stimulate "delight" and "amazement," focused on the development of Science and Natural History museums within the British context. But the particularly adventurous child was advised to step across the road, emboldened by the attraction of free admission charges for those under eighteen, and view the artistic treasures of the Victoria & Albert. (Not a word was said about the significantly high proportion of these treasures that were, at that very moment, taking a transatlantic holiday in the Museum of Fine Arts, Boston!)

I want to use the opportunity offered by this new collection of essays on museological themes to pursue the question of the present-day relevance of "curiosity" to artistic culture. My argument is that we

are now experiencing a kind of historical *ricorso* to curiosity whose effects are often perceptible just where we might least expect them: that is, in the conception and display of immediately contemporary works of art. However I am not going to claim that the newspaper by-line tells the whole truth. Museums did not "grow" from cabinets of curiosity. On the contrary, paradigms of knowledge themselves shifted, over the period between the Renaissance and the late nineteenth century, in such a way as to ensure that collections of objects acquired a new epistemological status, while being simultaneously adapted to new forms of institutional display. Even if we accept (as we surely must) that particular objects and classes of objects were transferred wholesale from the Renaissance cabinet into the nineteenth-century museum, we need to appreciate when seeing them in the new context how completely different the earlier situation must have been.

In fact there has been a general tendency, over the last few years, to rehabilitate the cabinet as a mode of display, and so provide an instructive contrast to the conventional hang of the Beaux-Arts museum. This has usually taken the form of a temporary exhibition, as with the remarkable unearthing of the Amerbach Cabinet in the Kunstmuseum of Basel, which took place in 1991. Visitors who were already well enough acquainted with the famous Holbeins in this collection could also inspect the numerous curiosities on a much smaller scale – such as a hazelnut shell containing a tiny carved crucifixion – and see the spectacular wooden cabinet in which many of them were originally housed (Landolt and Ackerman, 1991). Arthur Wheelock's *A Collector's Cabinet*, presented at the National Gallery of Art, Washington, in 1998, was a more daring enterprise, in the sense that it did not recreate a specific collection but tried to evoke "the spirit underlying Dutch and Flemish encyclopedic collections." This was done through a judicious selection of loan material from other American museums, featuring such curiosities as a snail, with a miniature rider, carved out of a Nautilus shell. What came across effectively in this presentation was the point that small-scale Dutch and Flemish paintings from the seventeenth century not only featured in their subject matter, but also customarily shared an exhibition space with, such ingeniously adapted *naturalia* – marvellous objects deriving from the natural world (Wheelock, 1998, pp.13–63).

Besides such adventurous temporary exhibitions, it has become more and more common for museums that derive, directly or indirectly, from collections formed in the early modern period to signal their provenance in a well advertised separate space where certain objects of curiosity are placed on view. Thus the Ashmolean Museum in Oxford has a small

enclosed area with backlit vitrines in which items from Ashmole's original benefaction (such as the feathered cloak of the Indian chief's daughter Pocahontas) are put on permanent display. The Museum of Medieval Art in Bologna, itself a recent foundation occupying an immense baroque palace, has devoted one of its opening rooms to a selection of small objects and curiosities drawn from the extensive early collections of the University. Clearly this kind of parenthetic placing can do relatively little to bring out the strangeness and individuality of such surviving collections. It is hardly feasible to adjust the scale of the display to the intricate and singular character of the objects, and it is not easy to retain the attention of the visitor, who will probably be impatient to launch out into the main rooms, stocked with more substantial masterpieces.

So a collection of this type, however integral to the early development of a particular museum, cannot easily be reinvested with its founding importance and its original powers of attraction. Nonetheless, the attempt is occasionally being made. Current plans for the rebuilding of the Musée Calvet, Avignon, acknowledge the magnitude of the task by siting a full display of the founder Calvet's eighteenth-century collection of curiosities in a central, specifically planned part of the museum. This may not, however, resolve the problem that the main collections are of paintings, furniture and sculpture, and the traditional Beaux-Arts style of hanging along a wall, by century and school, is inimical to the habit of close attention and almost philosophical reverie which we may imagine to have been induced, at an earlier period, by the precious rarity.

In the present state of things, it is likely to be a more rewarding experience to eavesdrop on an early collection which has been retained, often by pure chance, as part of the display of a scientific institution, and where there is no historical sequence of paintings to set the tone. This can be done, for example, in the delightful "Muséum" of La Rochelle, where an entire eighteenth-century collection in its specially designed rococo showcases shares a classical building with an array of stuffed birds and a heroic giraffe, which finished up here thanks to the taxidermist, having survived the march from Marseilles to Versailles as a gift from the Egyptian pasha to the French royal menagerie. It is also possible with the French national collection of precious stones and other mineral curiosities originally created in 1626 as the "Droguier du Jardin du Roy," and reorganized in the eighteenth century by Buffon as the "Cabinet Royal d'Histoire Naturelle." This can be seen in present-day Paris as a section of the "Muséum National d'Histoire Naturelle" in the Jardin des plantes (Schubnel and Chiappero, 1993).

However my concern here is not simply to comment on the current interest in the display of what were formerly known as "curiosities," but to take the phenomenon as symptomatic of what is to be my central theme: what I have called the *ricorso*, or running back in time, which is exemplified in the display of such historic objects and artefacts, but at the same time occurs in the conception and presentation of certain works of art that are being made at the moment. What is at stake here, no doubt, is the long-term effect of the weakening of the paradigm of historicism, which has for at least two centuries dominated the classification and display of the visual arts in the West. It can now be seen clearly that the rise of Modernism, so far from challenging the historicist paradigm entrenched in the museum as a result of the twofold impact of the Enlightenment and the Romantic movement, actually succeeded in reinforcing them. The Museum of Modern Art, in its original form and until quite recently, simply enshrined the pantheon of great modern artists and their works in due, historical succession. Only in the last decade of the twentieth century, and with mixed results, has it become tempting to subvert this triumphalist chronology in favour of a more punctual, thematic, and often (it must be admitted) haphazard association of ideas.

This new desire to contest chronology does not, of itself, amount to a return to "curiosity." It would be absurd to use the concept as a catch-all for the many diverse new strategies of the postmodern age. But it may well be that curiosity has a specially important and indicative role, as well as being merely symptomatic of what it is that returns when the historicist mode of presentation no longer retains unquestioned authority. Curiosity has the valuable role of signalling to us that the object on display is invariably a nexus of interrelated meanings – which may be quite discordant – rather than a staging post on a well trodden route through history.

Here there is probably a useful lesson to be drawn from the very exhibition that prompted this paper in the first place. The magnificent exhibition of selected works from the Victoria & Albert Museum, assembled under the title *A Grand Design*, was intended to present a faithful picture of the growth and development of the collections held there from the mid-nineteenth century onwards. Yet, to the extent that the different phases of the history of the museum itself reflected quite different conceptions of what mission it should perform, the different sections (and the individual objects within them) carried similarly diverse messages for the visitor. It was a poignant experience to see this exhibition first of all at the Baltimore Museum of Art, where the grand neoclassical façade seemed

to promise what Charles Saumarez Smith has termed in another context: "the message of an organization of knowledge and its subordination to a universal system of classification, which was essentially an Enlightenment ideal" (Saumarez Smith, 1995). Within this grandiloquent space, the display brought together works of art so physically and conceptually diverse as a late Gothic German limewood angel, an antique marble Narcissus probably recut during the Renaissance (and believed to be by Michelangelo in the early years of the museum), and a Victorian oil painting of Donatello profiled against a simulated mosaic ground. Each of these objects spoke not only for itself, but for the irretrievably contradictory identity of the Victoria & Albert as a collection initially devoted to useful (and commercially profitable) instruction, which subsequently became a repository of artistic treasures. The object inevitably became the point of intersection for a number of competing discourses, each attributing to it a certain identity, status and value: yet at the same time, in its insistent materiality, it succeeded in deconstructing these discourses.

In relation to the early history of the Victoria & Albert, it is worth noting that, for the Victorian period, "curiosity" still had the force of a subversive paradigm whose potency threatened the benevolent ideal of useful instruction, and the progressive onward march of modern history. When Charles Dickens published *The Old Curiosity Shop* in 1841, he vividly characterized the scene of curiosity as a chaotic, regressive domain half hidden from "the public eye," and metonymically identified with an aged occupant who also happens to be a compulsive gambler:

> The place... was one of those receptacles for old and curious things which seem to crouch in odd corners of this town, and to hide their musty treasures from the public eye in jealousy and distrust. There were suits of mail standing like ghosts in armour, here and there; fantastic carvings brought from monkish cloisters; rusty weapons of various kinds; distorted figures in china, and wood, and iron, and ivory; tapestry, and strange furniture that might have been designed in dreams. The haggard aspect of the little old man was wonderfully suited to the place; he might have groped among old churches, and tombs, and deserted houses, and gathered all the spoils with his own hands. There was nothing in the whole collection but was in keeping with himself; nothing that looked older or more worn than he. (Dickens, 1951, pp. 4–5)

In so far as he is a gambler, the old man in Dickens's novel allows "true" value to slip through his hands like water. In the place of the gold that he

has wasted, he has built up this meaningless combination of obdurate and ill assorted materials – "china, and wood, and iron, and ivory." Nietzsche saw the necessity, in his essay on the "Use and Abuse of History," of making a tri-partite distinction between fundamentally different attitudes to history: the "monumental", the "antiquarian" and the "critical." Amongst these, the figure of the "antiquarian" who "breathes a mouldy air" seems like a close cousin to the guardian of the "Old Curiosity Shop" (Bann, 1995, pp. 63–6). But Dickens's artful narrative conveys more vividly than Nietzsche's treatise the subversive attraction of these "fantastic carvings" and "distorted figures," which crowd out the antiquarian environment, challenging the imagination in a fashion which is at odds with the cheerful morality that guides his tale to its conclusion.

Dickens is faithful to the general tendency of his age in subsuming under the label of curiosity the class of objects also broadly described as "antiquities." And indeed his fictional collector in *The Old Curiosity Shop* shares many of the characteristics of the "antiquarian," so frequently invoked for satirical purposes in the Romantic period. All that is needed, you might say, to transform a mouldy old antiquarian into a pioneer museum director is fully summed up in the career of the French collector Alexandre du Sommerard, pictured in 1826 as an "antiquaire" entertaining a visitor to his collection by the painter Charles-Caïus Renoux. In this little scene of instruction, the assembly of objects seems only marginally less chaotic than the marvellous clutter devised by Dickens's illustrator. The collector has to secure his visitor's attention by fixing him with his beady eye. Yet within the following decade Du Sommerard has succeeded in rearranging his antiquarian collections in an orderly fashion on the first floor of the medieval Hôtel de Cluny, near to the Sorbonne (Bann, 1995, pp. 145–50). Distinct rooms, such as the "Chambre François 1er," have gained an overaching unity through connecting the objects in a single theme or plan. Once again, "historicism" is the general paradigm through which such heterogeneous objects deriving from the distant past can be reconciled in a spatial order under the sign of their common pastness. In the 1830s, it is being offered by Du Sommerard as a novel, indeed an almost experimental possibility. By the end of the century, however, it will have been normalized in the ubiquitous museum practice of the "period room."

That the concept of "curiosity" was, by the nineteenth century, virtually conflated with the broad category of "antiquity" says little, however, about its original usage, which was well established by the middle of the seven-

teenth century. This is exemplified by the clear division of categories within the seventeenth-century collection that I have had the opportunity to study closely: the "cabinet of curiosities" assembled by Dr John Bargrave, mainly between the mid-1640s and the early 1660s, which still forms part of the Archive of Canterbury cathedral. It is through a four-fold division into "medals, antiquities, rareties [sic], and coynes" that Bargrave chooses to classify his objects when he composes a written catalogue for them in the years immediately prior to his death in 1680 (Bargrave, 1867, p. 114). One may conclude from this division that, though there must be antique objects in the collection that are also esteemed rare, there are also rarities that are in no way antique. All these categories, however, fall under the general rubric of "curiosity."

Here it is worth making a general point about the basic contrast between the development of a "historicizing" museum practice in the nineteenth century and the widespread cult of "curiosity" in collecting which had flourished two centuries before. This will prove a link to our own contemporary situation. Historicism, whether in the victory over antiquarian eccentricity expressed through the normalizing strategy of the period room, or through its more common normalization of space through the chronological hang and the notion of the national school, seems to aspire to the Utopia of a display without an author. In other words, authority is vested in the objectivity of History itself. Curiosity, by contrast, invariably presumes an authored display, or a display as a subjective act of enunciation. Bargrave's written catalogue, which tells the story of each major acquisition in the process of describing it, is (like his whole collection) a rare survival from the period. But this lack of similar records should not blind us to the fact that these assemblages of small-scale objects must have required considerable narrative exposition, with the bizarre or humdrum circumstances of the collector's life intruding on the task of scrupulous description. The little tale attached to a piece of crystal in Bargrave's collection is a case in point. He describes it as a "chrystall... something longer than my middle finger, 4 or 5 inches compass, sexangular, inaequilateral, cylindrical, pyramidal." He then adds: "This I met with amongst the Rhaetian Alps... I remember the Montecolian man that sold it to me told me that he ventured his life to clamber the rocks to gett it" (Bargrave, 1867, pp. 123–4).

Indeed it is the existential and participatory aspect integral to the cabinet of curiosities that seems at first sight to be more or less lacking in the present-day museum. The general prohibition on touching the

objects in a modern display is particularly at odds with a practice which must have depended on the passing of small items from hand to hand (a gesture that we can still see represented in the *Antiquaire* painting of Renoux). Although it is excellent to see early collections of curiosities annexed to the conventional display of large-scale works of art, as in the Museum of Medieval Art at Bologna, or the Ashmolean at Oxford, such a restriction to the regime of the glass display case has its cost, if we wish to regain in any degree the sense of their original function.

Tantalized myself by the difficulty of adequately displaying the Bargrave collection, I organized a study day in 1998 in the Cathedral Archive at Canterbury at which around 25 invited scholars were able to see virtually all the objects, together with the wooden cabinets where they were originally stored – and even such survivals as the small paper labels inscribed by Bargrave himself – in the context of a group of papers discussing the collection and its author. One of the many small dividends of this occasion was the recognition by one expert on classical figurines that the examples in this collection still had the small bases that had been fitted to them in the seventeenth century, and have long parted company in the case of most statuettes from the same period.

Yet the inevitable outcome of such an event was the realization that the very authenticity of the Bargrave collection militated against any form of continuing display that would even recreate the conditions of its original use. The study day certainly galvanized several people (including myself) to do new work on aspects of this extraordinary relic from a vanished age of collecting. But it also resulted in a general perception that the best way of simulating the original strategies might be, quite simply, to put the whole collection on the computer in hypertext, and perhaps ultimately make it available on the Internet. In this way, through the use of the hypertext connections, the collection might at least recover some of its original flexibility of use, and its relationship to diverse areas of knowledge, as had been the case in Bargrave's own time.

Such a project would not only extend the didactic value of the collection beyond the restricted circle of people that have access to it at present. It might also convey the essential point that "curiosity" takes for granted a world of ordered discourses that underlie the physical presence of the individual object. This would, in its way, be a more satisfactory representation of the purpose of such a collection than some of the tantalizing visual records that remain from the seventeenth century, such as Johann-Georg Hainz's "Treasure Cabinet" (*Kleinodien-Schrank*, 1696, Hamburger

Kunsthalle). A painting of this type seduces the viewer with a dazzling array of rare and wonderful objects, but will not enable us to fetch them out of their little compartments, turn them around in the hand, and experience their roughness or smoothness of texture. It reminds us, all the same, that a cabinet from this period would probably have been festooned with hanging objects, and so in a sense perpetually on show. In the case of Bargrave's collection, the manuscript catalogue contains the direction that his own small "picture upon copper" is "To hang upon my cabinet," presumably depending from one of the wooden knobs (Bargrave, 1867, p. 139).

Yet it would be wrong to wax nostalgic about the opportunities now denied by the imperatives of conservation. It may simply be a matter of turning our attention to another type of artefact. The analogy to the earlier experience now barred to us might not be a visit to a museum, or a normal commercial art gallery, but perhaps a place like Harry Ruhé's Galerie A in Amsterdam, which specialises in "Artist's Books and records / Multiples and Graphics." Here everything may be taken down from the shelf and read or handled. Here you are unlikely to discover a Nautilus shell, but the overbrimming shelves of enticing objects might well include a felt postcard from a multiple edition by Joseph Beuys.

Here we return to the broad comparison between the contemporary arts and the paradigm of curiosity that is the guiding theme of this essay. It does not advance us very far, perhaps, to suggest that a locus of curiosity simply migrates to institutions which elude the regime of the unique object, with their inevitable hierarchies of value, and favors such places of convergence between the multiple object and the artist's book. But it can certainly be said that curiosity always takes for granted a kind of secondary revision of value, with the object being tied to something immaterial like a story or a personal association, as well as asserting its own materiality in animal, vegetable or mineral terms.

Also common to the contemporary felt postcard and the early modern curiosity is what might be called the typological exuberance achieved by juxtaposing different categories of material and placing the emphasis on agency and interaction, as opposed to confinement within a normalised, chronological order. Walter Benjamin reveals himself here as an authentic heir of the collectors of curiosities when, in his own campaign against nineteenth-century historicism, he indicates a preference (in Adorno's words) "for small and shabby objects like dust and plush... everything that has slipped through the conventional conceptual net or... [has] been

esteemed too trivial by the prevailing spirit for it to have left any traces other than those of hasty judgement" (Adorno, 1967, p. 240). In case the "small and shabby object" seems too far removed from Bargrave's hexagonal crystal (if not from Beuys's felt card) we can discover – again with Adorno – that "Small glass balls containing a landscape upon which snow fell when shook were among [Benjamin's] favourite objects' (p. 233).

I want to conclude this contribution to *Art and its Publics* with a review of some of the possibilities emerging from the less idiosyncratic aspects of "curiosity" in contemporary museum display. Certainly the "return to curiosity" is a concept that applies on a number of different levels to the development of museums and their publics in the present period. For example, it is relevant in so far as it enables a historically significant parallel to be drawn between the contemporary evolution of museums of science and certain museums of art. I alluded at the start to the way in which cabinets of curiosity were being invoked by curators of Science and Natural History museums not only to provide a genealogy for their collecting practices, but also to explain and justify their current strategies of communication. A more recent daily newspaper provides me with an even more categorical statement of this approach. The present Curator of the Contemporary Arts and Cultures Programme at the British Museum, James Putnam, who recently installed an installation from the "Museum of Jurassic Technology," Los Angeles, in the Petrie Museum of Egyptian Archaeology, University College London, is quoted as saying about this exhibition: "It's about curiosity and personal obsessions – they are what really underpin all museums and their collections" (Buck, 2001, p. 47).

For all its apparent throwaway character, this remark uncovers a significant fact. The degree to which "curiosity and personal obsessions" lie behind all forms of collecting (and hence all museums) is inevitably underplayed in all those museums of art that faithfully follow the historicist paradigm. Such motivations need to be swept under the table precisely in those canonical Museums of Modern Art whose role was conceived as one of giving historical and objective validity to the masters of the Modern Movement. All this goes to show that the contemporary art museum, by contrast, can claim to be heir to a more eclectic programme. Curiosity returns, just where the character of the objects exhibited has as much, or more, in common with the highly diverse collections of a museum of archaeology or natural history, than with a white cube inhabited by the abstract paintings of Mondrian. Another way of putting this would be

to say that curiosity is potentially at play when the ideology of Modernism falters: in this sense what we inadequately term "post-modernism" is not simply the state of being cut off from history, but the return of an "other" history.

This recognition of a surreptitious kinship between aspects of contemporary sensibility and the "curiosity" of the early modern period also has the advantage of challenging other, less convincing ways of accounting for such shifts in the dynamics of creativity. In Summer 2001, the Musée d'art contemporain at Bordeaux mounted an ambitious exhibition under the title "+ vrai que nature," which took as its epigraph Oscar Wilde's dictum that nature imitates art, rather than the reverse: in French, "C'est la nature qui imite l'art – ou du moins la perception que nous en avons." This idea espoused by the curators recalls the persuasive thesis that we see the world through the spectacles of art: Whistler's paintings, for example, enable us to perceive the London fog in a novel and aesthetically pleasing fashion.

Yet such a conceit hardly does justice to the intricate and extraordinary creations of one of the major French artists represented in the show. Hubert Duprat exhibits three works in all: *Corail*, consisting of a tree-like structure of coral fragments, sutured by pellets of bread; *Nord*, an oval form composed of glued pieces of amber gathered on the shores of the Baltic; and finally *Untitled* (2000), a bulky object in the shape of a torus, with shining quartz crystals dotted thickly upon a smooth ground of white paraffin wax. Wilde's dictum simply highlights a paradox in the process of representation. Nature can be seen to imitate art, but only because it is refracted through the medium of our perceptions. But in Duprat's case, it is not a question of representation at all. There is nothing to which the rare and exquisite materials refer except themselves. They are prodigies of nature to which a very little artifice has given extra pungency. Much more relevant to their impact would be early modern conceits like the coral and silver drinking vessel in the form of Daphne metamorphosing into a tree, created by Abraham Jamnitzer at the end of the sixteenth century and now in the "Grünes Gewölbe" Treasury at Dresden. Or indeed, in the case of the astonishing quartz piece, the comment of Bargrave on the acquisition of his much more modest hexagonal crystal: "One would wonder that nature should so counterfett art. There is no man but [that] seeth it but would veryly believe that by tools and art it had binn put into that figure" (Bargrave, 1867, p. 123). In all these cases, it is not that the representation overdetermines our perception of nature.

On the contrary, the "wonder" arises precisely from the difficulty of separating out the agency of the artist from the pure spectacular potentiality of the natural world.

Duprat's most audacious demonstration of this principle can be found in an ongoing series of works that he has produced through harnessing the constructive tendencies of the humble caddis-fly, which takes up stray pieces of gold and tiny jewels to form its chrysallis, before eventually deserting the shell and leaving it behind in the form of a microscopic jewelled casing. Here we are almost entirely in the realm of natural history. But the object on view is not the life-cycle of the insect as such: it is the long-term product of the systematic coiling of precious fragments around its vulnerable larval body. Only in one public display area, that of the Château d'Oiron in Poitou, do we get the chance to see, in every summer season, the stock of jewelled cases being patiently increased by the new batch of caddis-fly larvae. Otherwise the tiny objects remain (a little like the mummified chameleon brought back by Bargrave from Tunis in 1662) enigmatically detached from their animating narrative.

Oiron is the best point at which to end this conspectus of the "return to curiosity," since it is certainly the institution at which such a programme has been most imaginatively and literally carried through. Originally the family seat of the Gouffier family, powerful magnates at the French court in the Renaissance period, the imposing monument of the château has many surviving vestiges of the pictorial and decorative schemes carried out between 1500 and 1700, including frescoes tracing the story of Virgil's *Aeneid* by a painter of the School of Fontainebleau, and exceptional sequences of emblems comprising images and mottoes. Its current status is however the result of a unique agreement between the French authorities concerned with the conservation of ancient buildings, and those of the *Délégation aux arts plastiques* at the Ministry of Culture. As a result of this, the original curator Jean-Hubert Martin was able to carry out a programme of installations and specially commissioned installation works that would complement the very strong and historically authentic features of the restored building. In certain cases, a work not originally planned for Oiron has found its home there. A good case in point is Ian Hamilton Finlay's *Battle of Midway,* an emblematic installation involving stone beehives, living rose bushes and a soundtrack simulating both the buzzing of bees evoked in the garden setting, and (metaphorically) the sound of fighter planes involved in the battle between the Japanese and the American navies. This contemporary emblem found its place very appropriately

a few minutes away from the original seventeenth-century emblems, which are also concerned in their different ways with expressing political strategy through natural imagery.

A central participant in the planning of new features for Oiron was the Swiss artist, Daniel Spoerri, whose original table-top compositions per-petuating the debris of meal settings in upright form were associated with the Dadaist tradition. Spoerri's contribution to the magnificent "salle d'armes" of the château is a series of wall-hung works which similarly derive from collage and assemblage procedures, but in this case using spectacular elements like suits of armour and trumpets that link with the martial nature of the setting. But the contribution by Spoerri that most directly invokes curiosity is his installation of what may possibly be one of the last of such collections to be formed: a sequence of 39 framed objects occupying one of the rooms in the private apartments of Louis XIV's mistress, Madame de Montespan. The collection of curiosities – credited to "Mama W.," otherwise identified as a Saxon lady called Von Wendelstadt – assuages the visitor's credulity with the sheer improbability and diversity of the objects on display: stones brought back from the ruins of Carthage in 1871, a small piece of the first German flag that flew over the Cathedral of Strasbourg in the same fateful year, as a result of the Franco-Prussian war, and a morsel of the laurel wreath that was laid on the coffin of the ill-starred Emperor of Mexico, when his repatriated body lay in state in Vienna in 1876. The mode through which these abject little objects are presented is frankly anachronistic – the small wooden frames were supposedly made up by a peasant from the Bernese Oberland. But the contiguity of this display to those features of the building dating back to the original period of "curiosity" reinforces our feeling that Mama W. might *almost* have established a continuity between the early modern period, and the contem-porary return of curiosity. Blank though her biography remains, her collection becomes the emblem of an almost subterranean connection that rises to view if the history of modernism is elided.

Of course the Château d'Oiron does not and cannot eliminate that history. It merely invites us, by its recursive strategy, to place that history in suspension. What remains an open question is whether the powerful alliance between curatorial practices in the science-based museums, and those being accentuated in contemporary art displays like Oiron, will reinforce the attraction of "curiosity" as a mode of engagement for the general viewer. The fact that "curiosity" itself has such a long history seems to make this more, rather than less likely.

Bibliography

Adorno, T. (1967). *Prisms.* Translated by Samuel and Sherry Weber (London: Neville Spearman).

Bann, S. (1995). *Romanticism and the Rise of History* (New York: Twayne).

Bargrave, J. (1867). In James Craigie Robertson, ed., *Pope Alexander the Seventh and the College of Cardinals... With A catalogue of Dr. Bargrave's Museum* (London: Camden Society).

Buck, L. (2001). "Maverick at the Museum," *Evening Standard,* August 13, 47.

Dickens, C. (1951). *The Old Curiosity Shop* (Oxford: Oxford University Press).

Guardian Education Supplement (1998), 14 April.

Landolt, E., and F. Ackerman (1991). *Das Amerbach-Kabinett: Die Objekte im Historischen Museum Basel* (Basel: Historisches Museum Basel).

Schubnel, H-J. and P. J. Chiappero (1993). *Trésor du Museum: Cristaux précieux, gemmes et objets d'art. Revue de gemmologie, numéro special,* September.

Saumarez Smith, C. (1995). "Architecture and the museum," *Journal of Design History* 8, 4, 243–56.

Wheelock, A. (1998). *A Collector's Cabinet* (Washington, D.C.: National Gallery of Art).

Further Reading:

Bann, S. (1994). *Under the Sign: John Bargrave as Collector, Traveler and Witness* (Ann Arbor: University of Michigan Press).

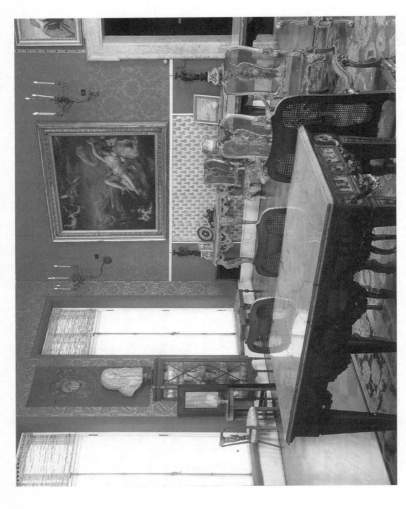

Plate 7 View toward Titian's *Europa*, The Titian Room, Isabella Stewart Gardner Museum, Boston. Photograph by David Bohl. © Isabella Stewart Gardner Museum, Boston.

Museum Sight

Anne Higonnet

There hangs the masterpiece. On a wall of the *Titian Room* on the third floor of the Isabella Stewart Gardner Museum in Boston, Massachusetts, hangs Titian's 1554–62 *Rape of Europa*. Titian's *Europa* ranks among the great paintings in the history of western art. What if I told you the "there" is as great, in a museum mode, as the "it" is, in a painting mode? For we are seeing one those rare instances in which an object's extraordinary beauty is matched by its history. The content of the history is exceptionally rich. But it is the form of the history that really matches the painting. The form is visual. The history is in the installation, at the Gardner for us to see. There history compounds the painting.

If the installation of Titian's *Europa* attracts our attention at all, it is because collecting has become a legitimate subject of study. Over the last fifteen years collecting has grown into an entire field of study, as books and articles on every aspect of collecting proliferate. By and large, these studies can be sorted into two camps, one concentrating on the psychic causes of collecting, and the other concentrating on the social effects of collecting. Studies of collecting using the methods of psychoanalysis have confirmed how deeply rooted collecting is in all human beings, by revealing how the most eccentric collectors are governed by the same psychological rules.[1] Spurred by an interdisciplinary interest in cultural institutions, theory has likewise rethought the museum. By examining national or municipal art museums, ethnographic museums, and history museums, a rapidly expanding literature has securely established the museum as one of the most important modern cultural institutions.[2] Understandably, these museum studies have concentrated on the collective issues of modern,

national, and racial identities as they demonstrate how effectively museums build "imagined communities."

Meanwhile, art about collecting has become as big a studio field as scholarship on collecting has become an academic field.[3] While these works of art address all basic issues of collecting, most of them focus on the institution of the art museum. Artists apparently feel their careers depend all too much on art museums. By turning a visually analytical eye on the actual contents, forms, and spaces of museums, art about museums urges us to do likewise. In so doing, art about museums makes us realize how comparatively un-visual academic studies about museums tend to be. Museum exhibition being by definition visual, you would think it would be ideal to understand its visual methods. Yet almost all studies of exhibitions, even those attentive to the semiotics of display, are limited in their ability to be visual.[4] The exhibitions they study simply no longer exist. Before the age of cinema and video, it was only possible to record the sight of exhibitions very partially through prints or photographs. Even when means were available, few exhibition installations were ever recorded. Before an interest in museums as cultural institutions, only the objects in museum collections seemed worthy of study. Swinging to the opposite extreme, most museum studies consider objects only as pretexts for, or superficial signs of, inner psychic impulses or social agendas. And then there is the problem of text versus image. While, hypothetically, texts can be abundantly illustrated, this volume of essays is only one (albeit extreme) example of publishers' reluctance to combine textual analysis and visual evidence. In the publishing world, scholarship is one thing, and coffee table books are another.

Despite these polarizing forces, the Gardner Museum demands an integrated analysis. Or perhaps it would be better to say that the case of the Gardner Museum, and especially of the Gardner Museum's *Rape of Europa* installation, suggests an integrated analysis might be possible. Studies of collecting divide into studies of psychic causes and studies of social effects because collections divide the same way. Institutions temper individuality. Private collectors may respect social standards, and individuals may staff museums, but on the whole private collections express individual impulses, while public museums express cultural values. The Gardner Museum, however, belongs to a museum type that bridges those differences. I call this type the private museum. It flourished between about 1890 and 1940, preserving intact art collections begun around 1848. It's most spectacular examples are: the Musée Condé in the Château

Chantilly near Paris, the Wallace Collection in London, the Isabella Stewart Gardner Museum in Boston, the Huntington Art Collection in Pasadena, the Frick Collection in New York City, and Dumbarton Oaks in Washington, D.C.[5] I would say that all collecting is at once psychological, individual, and social. While most collections privilege one of those levels over the others, private museums manage to be about equally psychological, individual, and social. At the psychological level, all private museums are alike, all of them mausoleums. As enshrined private collections, they provide paradigmatic examples of the primal impulse to create, and adore, a perfect version of oneself. The collection stands for but idealizes the self of the founder, all the more so because as a permanent institution it defies death. Yet the self of the private museum is also many different individual selves. Unlike large museums, or any museum more professional in origins, private museums display personality. Like individual people, private museums are alternately charming, fallible, seductive, pompous, pathetic, heroic, and occasionally quite funny. Pushing onward to the third, social, level of collecting, which could also be called historical, all the temperaments displayed in private museums were governed by factors, including, but hardly limited to, class, gender, nationality, and race. Only social or historical factors can finish explaining what kinds of things private museum founders collected, or even why they would collect things called art and put them in a place called a museum. And because every social factor interacts with every individual factor to produce a seemingly infinite number of permutations, private museums appear extremely different from each other at the social level.

What all museums like the Gardner put on display, therefore, is at once public and private. Consequently, the visitor to such a museum is always interpellated at once as a public visitor and as a private person. At worst, the effect can be narcissistic, selfish, and shallow. At best, a place like the Gardner confronts its audience with complex relationships between private experience and public history. Perhaps such relationships are all too often denied in more public museums. An entirely public museum, an institution designed to appeal to something called a public, may cultivate its own kind of passive superficiality. Without any sense of personal engagement, a visitor can glide through a public museum, paying close attention to nothing.

Private museums were designed to engage viewers with art on a personal level. This is why private museums were installed by their founders in what appear to be private homes. The appearance is deceiving. With

virtually no exceptions, collections like the Gardner were conceived from the start as public institutions, and the houses designed for them are not so much real homes as calculated effects of domesticity. When Gardner bought Titian's *Europa* in the summer of 1896, for instance, she had not yet built the building now called the Isabella Stewart Gardner Museum. As she described the painting's arrival in her collection, however, she moved straight from the personal, rhetorically physical, pleasure it gave her – "too excited to talk … breathless … drinking my self drunk with *Europa*" to her anticipation of a public pleasure, capitalizing the word museum and then taking the distance of a foreign language: "I think I shall call my Museum the Borgo Allegro. The very thought of it is such a joy."[6]

Private museum's domestic effects were created by installing master-piece art objects like Titian's *Europa* among a domestic array of things: tapestries, iron-work, plaster casts of hands, furniture of all kinds, lace, miniatures, rugs, lamps, model ships, porcelains, screens, enamels, china, crystal, closets full of clothes, letters from friends, entire bathrooms or kitchens complete with utensils, medals, flags, tiles, armor, weapons, drawings, etc. Sometimes the items are sorted according to category by gallery, but more often not, as in the case of the Gardner. Titian's *Europa* hangs against figured red fabric, between chandeliers, above white trim, figured green silk, a chair, and two eighteenth-century Venetian tables laden with precious bibelots. Elsewhere in the same room, the *Titian Room*, are more paintings, furniture, fabrics, and bibelots, plus a rather fine and rather gigantic mid-sixteenth-century Persian carpet. Contrary to national or municipal museums' visual exhortation to concentrated con-templation of isolated works of art, the private museum gallery forces a perception of its diverse objects in relation to each other, to their space, and to audience members designated as private individuals.

Private museums are installations, installations with authors. The founders of private museums always played a very active, if not compul-sively controlling, part in the arrangement of their collections. The found-ers are certainly, therefore, the creators of their museums. Had private museum founders not considered their museums as their personal cre-ations – at whatever level of consciousness – they would not have pro-tected their integrity as fiercely as they did in their wills. In the case of the Gardner, for instance, her installations must remain as she designed them, or else the entire collection gets dispersed at auction. (And Harvard University, rather than any other museum, gets the proceeds.) When a number of objects were stolen from the Gardner in 1990, therefore, it was

decided to leave their places blank, except for a small card declaring the fact of the theft.

One useful way to define private museums is as giant museum-works of installation art. Of course private museums are older than what we think of as installation art. In fact they are surviving the vicissitudes of time better than most installation art because they are protected by wills, as well as by the institutional apparatus of a public museum. So it might be more accurate to say that private museums are enormous three-dimensional artifacts from the past. If you put those two ways of thinking together, private museums become visual and spatial historical evidence in the form of museum installations. As such, they are susceptible to the same critical analysis as contemporary installation art, beginning with the kind of investigation installation work about the museum itself conducts. The Gardner Museum has actively promoted such analysis by encouraging work about itself. The Museum runs an artist-in-residence program, which over the years has produced probing observations of its host. The Gardner, moreover, has been the subject of an independent project, Sophie Calle's 1991 *Last Seen*.[7] Reading a lot about these works with no illustration of them would be tedious. Two lessons, however, warrant relying on verbal description because they pertain so directly to *Europa*'s installation.

In Calle's *Last Seen*, photographs of the wall spaces where stolen works of art once hung are juxtaposed with framed texts. The texts are Calle's collections of memories of the stolen works. By framing memory texts as if they were figural works of art, Calle suggests that our perception of any work of art is always partly a question of memories and associations. The original work of art, furthermore, in Calle's analysis, is lost (*Last Seen*). Calle's own figural work – the photograph of the place where the work of art once was – replaces a lost work, but only by acknowledging the loss. We might as well recognize, Calle implies, that we perpetually collect and display something new to compensate for loss and supplement memory. The supposedly "original" work of art was, fundamentally, itself a replacement. Here we are led back to the psychoanalytic explanation of collecting as compensation for psychic lack.

Another work about the Gardner shows how we might integrate Calle's psychoanalytic archival textuality into the sight of *Europa*'s installation. In a 1998 photograph titled *Europa Dimly Lit, Gardner Museum*, Abelardo Morell stages *Europa* in a dramatically different way than Gardner did. Taking advantage of the temporary hanging of Titian's painting in a

conventionally empty museum gallery, Morell creates an image that seems to isolate *Europa,* as we expect to see a masterpiece, only to resituate it in another context, hanging above the glare of a bare light bulb – the bare mechanical minimum of the modern gallery, but a context nonetheless. Furthermore, while we perceive the space represented by the photograph three-dimensionally, the photograph itself creates a two-dimensional installation of *Europa* uncannily like Gardner's. The painting is centered above a decorative stripe (the gallery baseboard), itself above the light bulb. Wherever we see *Europa,* Morell reminds us, we see it somewhere. Visual analogy to Calle's textual juxtaposition, Morell's light bulb is how we see *Europa,* literally in the light of, metaphorically in light of, its installation. Together Calle and Morell insist that an installation is always at once figural and textual, at once just what we see – there it is – and according to conditions: a chain of replacements, associations, and memories.

But we need to be careful. What justifies examining one museum and not another? Within a museum one installation and not another? What justification do we have for defining where the subject of inquiry begins and ends? There must be several convincing answers to those questions, and the answers must reinforce each other.

In the case of *Europa*'s installation, a first answer is the exceptional value of the painting itself. Writing to Isabella Stewart Gardner, Bernhard (later Bernard) Berenson described it as: "the finest Italian picture ever again to be sold,"[8] and "peerless."[9] Of course he was hoping to sell it to her and earn a commission. Berenson remains, however, one of the great art historians of his time. Berenson convinced Gardner. Let us return to Gardner's own reaction to *Europa*'s arrival in her collection. Expert acknowledgement of *Europa*'s greatness by Boston Museum of Fine Arts collectors and trustees, as well as professional artists, linked Gardner's private pleasure to her anticipation of a public Museum future.

> I am breathless about the *Europa,* even yet! I am back here tonight (when I found your letter) after a two day's orgy. The orgy was drinking myself drunk with *Europa* and then sitting for hours in my Italian Garden in Brookline, thinking and dreaming about her. Every inch of paint in the picture seems full of joy. Mr. Shaw, Mr. Hooper, Dr. Bigelow, and many painters have dropped before her. Many came with "grave doubts"; many came to scoff; but all wallowed at her feet!!! One painter, a general sceptic, couldn't speak for the tears! all of joy!!! I think I shall call my Museum the Borgo Allegro. The very thought of it is such a joy.[10]

Gardner would no doubt be pleased that this opinion has stood the test of time. In the Museum's most recent guidebook, published in 1995, *Europa* is still called "the treasure of her collection and the greatest Venetian painting in the United States."[11] *Europa*'s rank alone would explain why Gardner would have cared deeply about its installation.

Even before she installed *Europa*, Gardner felt an intense joy (her word) in her possession of the painting. The possible reasons are many. Let me begin with the most public, since Gardner was so elated at the prospect of *Europa*'s Museum status (her capitalization). A museum was an institution whose public status Gardner, like all her peers, associated with American democracy. As the United States gained global financial and political power at the end of the nineteenth century, it sought a corresponding cultural power. United States art collectors, we all know, avidly bought European art. S. N. Behrman, in his absolutely hilarious and somewhat unreliable account of the premier art dealer of the period, Joseph Duveen, pithily summed up the situation: "Duveen...noticed that Europe had plenty of art and America had plenty of money, and his astonishing career was the product of that simple observation."[12] The observation, however, was rather less simple than it seemed. Americans had money, and they also had motivation. The motivation was the Museum. Here is the logic. The Museum justified America's possession of the world's cultural heritage. Indeed, the Museum transformed a right into an obligation. The United States was inheriting Europe's world domination because its political and economic system was ethically superior. The American system was superior because it gave equal opportunity to all its citizens. Equal opportunity to art was public access to the institution of the Museum. In a letter to Gardner, Elsie de Wolfe, the pioneering interior decorator (and sometime expatriate) expressed the idealism as well as the pretensions of Gardner's vision: "You have accomplished a great and beautiful thing which will bear fruit in the great *artistic advancement* of our waiting people" (emphasis in original.)[13]

No single painting could have better symbolized the *ancien régime*, Old World power of Europe than *Europa*. Its title alone did a good job. But the painting was also notoriously royal. It had been commissioned by the archetypal absolute monarch, King Philip II of Spain, and first hung in his palace the Prado for his privileged viewing. Moreover, the theme of the painting celebrated the power of the Old World over the New. In the words of a scholar of Baroque art and curator of the Gardner: "Soaring with Europa over the sea, Jove, a glorious and virile bull, travels over the

Mediterranean, giving Europa's name to a new continent. The political parallels to Philip II and the modern Europe carried over to a new land are obvious."[14] Gardner reversed the power relationship. She, or rather her Museum, was the New World conquering the Old. By buying *Europa*, Gardner was symbolically gaining control over the simultaneously political and artistic power of Europe and handing it over to the Museum, symbol of American public democracy.

Europa was all about power. Think back on Gardner's language as she described the art experts: "dropped before her... wallowed at her feet... couldn't speak for the tears." In an earlier letter, Gardner used similar language, and brought out another dimension to the power at stake: "She has adorers fairly on their old knees – men of course."[15] Gardner's ownership of *Europa* reversed a sexual power relationship as surely as it did a political and economic one. For if I have been shortening the title of the painting for convenience, I have also been avoiding the sexual power in which it revels. The subject of the painting is rape, *The Rape of Europa*. Whatever the symbolic, political, and mythological connotations of the scene, what we are actually seeing is a bull carrying away a woman to force sexual intercourse on her against her will. The story being shown, as it was told in Ovid's *Metamorphoses*, is of a male figure, albeit divine, who takes the form of a bull in order to pursue his sexual goal of rape. Jove possessed Europa. He took her. Then Gardner took both of them. In her description of possession, she, Gardner, is at first physically taken by the painting: "I am breathless.... The orgy was drinking myself drunk... sitting for hours... thinking and dreaming about her.... Every inch of paint in the picture seems full of joy." But then the painting gives her its power, and subjugates masculine authority. Through her destination of the painting for the public sphere of the Museum, Gardner finally becomes the authority herself, and the subject of the story. The passage in Gardner's letter concludes: "Mr. Hooper [a BMFA trustee] long ago, pleased me greatly by saying I was the Boston end of the Arabian Nights. And now he only adds 'I told you so.'"

Installing *Europa* in the *Titian Room* in a museum called the Isabella Stewart Gardner Museum confirmed Gardner's authority over the painting and what it stood for. It was to be expected, given what the painting stood for, that the authority of the installation would be as personal as it would be public, or, more precisely, that it would be about trading private power for public power. The rest of Gardner's Museum raises the same expectation. As Carolyn Heilbrun has pointed out in

a brilliant lecture, Gardner scattered images of feminine force throughout her Museum. At the literal heart of the Museum, for instance, in the center of the inner courtyard, Gardner placed a second-century Roman mosaic head of Medusa. And the last figure one would have seen when leaving the Museum in Gardner's own lifetime was the proud woman dancer of John Singer Sargent's 1882 *El Jaleo*. None of these feminine images, however, was more clearly installed to magnify its power than Sargent's portrait of Gardner, painted in 1888.[16] Gardner repeatedly created installations that expressed an authority she thereby claimed as her own.

Gardner installed *Europa* above a piece of figured green silk. The fabric is impossible to miss because its height pushes the painting remarkably high on the wall. Natural light from a window shines equally on both painting and fabric. Rarely if ever did Gardner center a painting so decidedly above one piece of fabric. The fabric echoes the painting in its rectangularity, all the more so because its green color contrasts with the red around it, and it is framed, in a way, by the white decorative strips above and beside it, along with the white baseboard below it. The fabric therefore occupies the kind of position occupied by the framed texts in Calle's *Last Seen* and the light bulb Morell's *Europa Dimly Lit*. Like the light bulb, it is what underlies the painting. And it is, if we pursue its memories the way Calle pursued memories in *Last Seen*, what illuminates the painting. The fabric had once been a skirt. The skirt was part of a dress designed by Charles Frederic Worth for Gardner. Underneath the painting is what remains of a work of decorative art. Worth was to clothing design what Titian was to painting, and what Berenson was to art history. Before Gardner collected painting masterpieces, she collected clothing master-pieces. She began as a collector of skirts and moved upward in prestige and authority to become an art collector in the 1890s. After she became an art collector she moved outward to become a Museum founder, beginning in 1899. The installation of her Museum subsumes both phases of her career, reunites them, and makes them public. The installation of *Europa* sum-marizes Gardner's trajectory.[17]

Europa's installation layers Gardner's identity. The progress installed by Gardner – from decorative art collecting to fine art collecting to museum founding – seems to contrast with Gardner's many overt inscriptions of her self within the Museum. No portraits here, no representation of Gardner's person. It would seem to be the contrary: a description of Gardner's escape from a collecting confined to personal adornment into an activity

transcending her person, time, and place in two successive steps: the collecting of great art, and the creation of a public institution.

Yet this may actually be the most intensely personal of Gardner's installations, the one that represents an identity beneath the surface appearances recorded in portraits. Because this is not a random skirt, just as *Europa* is neither a random painting nor a random subject. Gardner understood that identity is always staged, and so she very rarely allowed herself to be photographed. Not for her a casual surrender of her image to the camera. But wearing this green silk, while it was still a Worth gown, she did allow herself to be photographed. This silk, in other words, had already been used to stage her self before it was used again for the same purpose but in a much more complex way. This was fabric with which Gardner identified.

As a skirt, the fabric had been an emblem of femininity. (Even now the schematic sign of woman is still a stick figure with a skirt.) At one point in Gardner's life, a skirt was a sufficient sign of self. Gardner's feminine self could at that point in her life be represented by a skirt. Her gender was a clothed femininity, a sex adorned and masked by skirts. It was a femininity that signified on the material surfaces of things, as objects like skirts. The Gardner who collected great art is also represented by a thing, a painting, but a painting seen by everyone as a body, a gorgeously, seductively, sexual body. A body had come out from under a skirt. A self that could identify with *Europa* was a self no longer in a skirt. It was not as simple an emergence as from social repression to sexual freedom. *Europa* was powerful not simply because she was sexual, but because she was a beautiful work of art, a Titian, a masterpiece of Venetian painting, an enormously valuable treasure of Western culture. *Europa*'s power, as Gardner described it – the power she first succumbed to and then harnessed – was gendered, and sexual, but it withheld or gave access to cultural power. The stakes were doubly high. What Gardner sought, and attained, through *Europa* – through what *Europa* stood for – was a self whose power was constituted by the mutual reinforcement of gender and culture. She arrived at that power with her Museum, and it is as an installation in her Museum that her power is represented. In her installation, the skirt is flattened out. The green silk no longer takes the shape of a body, represents the feminine body. It carries the memories of what had been. The fabric acknowledges a past self, but it no longer represents. It has become the base on which self-representation has been raised. Gardner had risen above femininity. What she had risen to is terribly double-edged. While triumph is there, in the power and the value of the work of art, the scene remains of a woman's

total submission to man, to myth, and to the laws of culture. Like the Freudian figure of the psychoanalyst-archeologist who unearths the layers of identity, Gardner has unflinchingly represented her self as its analysis. Analysis in material visual form.

Gardner summoned an audience to contemplate her *Europa* installation. At several key points in her Museum, Gardner provided a seat in front of an object, inviting us to pause and look carefully. (Needless to say, for conservation reasons no Museum visitor can actually sit on the chairs any longer, but the sight of the invitations remains.) We are initially, and obviously, urged to look at a small precious painting on the table to which the chair is pulled up. But all it takes, in every case, is to raise that engaged gaze to encounter something else: a larger painting behind the table, which is thus singled out from all the others hanging on the walls. In the *Raphael Room*, the attentive eye moves from a prized predella panel by Raphael to an even more prized portrait by Raphael. In the *Dutch Room*, the move is (or was until the 1990 theft) from a Vermeer to a Rembrandt. The third such observation post is set at a small painting of *Christ Bearing the Cross* that Gardner believed to be by Giorgione. Behind and above the Giorgione is *Europa*'s installation.

The Giorgione observation post is the most emotionally fraught of the three. Gardner coveted the "Giorgione," even though Berenson advised "it somehow is not the kind of thing I think of for you." Paintings attributed to Giorgione were among the most sought-after in Gardner's time, and Berenson not only assured her it was genuinely by Giorgione, he also tried to get the Boston Museum of Fine Arts to buy it as such, though he conceded "It is a sublime illustration rather than a great work of art. Moreover it is not in as good a condition as one might wish."[18] (Questions about Berenson's attribution arose immediately; the painting is now attributed to the school of Giorgione.) Gardner persisted through two years of difficulties over availability, heirs, prices, providing a copy, smuggling the original, cryptic cables, and local Italian scandals. The painting finally arrived in Boston late in 1898. Berenson wrote: "So you now are beyond question that unique creature, the owner of an unquestioned Giorgione."[19] Shortly after, Isabella's husband, Jack Gardner, suddenly died. In his memory, she placed a Norwegian silver cup filled with fresh violets in front of the painting. Their first trip to Europe had been to Norway, and she associated violets with him.[20] This association made by the silver cup and the violets between the mournful *Christ* and the memory of her husband was so important to Isabella Stewart Gardner

that her will decreed fresh violets would always be kept in the cup on the table by the painting. (One of the most exacting details in private museum will history.) The place from which Gardner has us contemplate her *Europa* installation, therefore, is the place of her mourning for her husband. Interpretations of her decision will differ. It could be argued that Gardner was perpetually paying tribute to her husband. It could also be argued that Gardner was relegating her husband to the realm of a dead past, from which she looked beyond to see what she had made of herself without him. In any case, Gardner was loading *Europa's* installation with significance.

It might be objected that the significance of Gardner's installation is secret. To understand the associations and resonance of the objects Gardner used certainly requires some research. No one who goes unprepared into the Gardner Museum to see *Europa's* installation could completely understand what it meant. Are the meanings of *Europa* more obviously significant, more immanent and evident? Art historians would once all have agreed they were. But how immanent are *Europa's* meanings, really? Without quite a bit of training in the history of art, who could identify its style or subject, know that the painting was by Titian, or even feel it was beautiful? As the values espoused by Gardner's contemporaries recede into a eurocentric past, as the history of art moves beyond a fixation on Italian and Baroque painting, and as feminism re-mystifies all female nudes, a twenty-first century audience might well find *Europa* rather less transparent than it once appeared. In comparison, the knowledge that one is looking at a picture of a woman being carried off against her will by an animal, hanging over a piece of fabric, in a museum founded by the woman the museum is named after, starts to seem pretty basic. Moreover the Gardner's audience sees *Europa's* installation as surely as it sees *Europa*. Installation and painting operate in the same mode, a primarily visual mode relayed and compounded by historical information.

Gardner's *Europa* installation is only an exceptionally dense example of what all museum installations do. Its density forcibly reminds us that all objects in museums are installed. The museum is an institution designed in theory to single out objects for display, but that in practice embeds objects into a new visual context. Museum studies over the last ten years have correctly insisted on the many cultural functions art museums serve. The ways in which museums have accomplished their tasks visually have all too often been irrecoverably lost, as exhibitions come and go without a trace. Thanks to the fossilization characteristic of the private museum

type, the Gardner Museum's installation reminds us not only that museums create visual meanings, but that those meanings have had a history. The history of museum installation could and should be a vital part of the public history of visual culture.

Notes

1 Among psychoanalytic studies of collecting: Jean Baudrillard, *Le système des objets*. (Paris: Gallimard, 1968); Werner Muensterberger, "Passion, or the Wellsprings of Collecting," "First Possessions," and "Of Toys and Treasures," in *Collecting: An Unruly Passion* (Princeton University Press, 1994); Susan Stewart, "*On Longing; Narratives of the Miniature, the Gigantic, the Souvenir, the Collection* (Durham and London: Duke University Press, 1993).

2 Among historical studies of the art museum, and addressing different aspects of the art museum's history: Tony Bennett, "The Exhibitionary Complex," in *Thinking About Exhibitions*, Ressa Greenberg et al., eds. (London and New York: Routledge), 1996); James Clifford, "On Collecting Art and Culture," in *The Visual Culture Reader*, Nicholas Mirzoeff, ed. (London: Routledge, 1998); Annie E. Coombes, *Reinventing Africa; Museums, Material Culture and Popular Imagination* (New Haven: Yale University Press, 1994); Douglas Crimp, *On the Museum's Ruins* (Cambridge, MA: MIT Press, 1993); Hans Haacke, "Museums, Managers of Consciousness," *Art In America*, 72, no. 2 (February 1984), pp. 9–17 (reprinted in Kynaston McShine, *The Museum as Muse: Artists Reflect* (New York: Museum of Modern Art, 1999); Eilean Hooper-Greenhill, *Museums and the Shaping of Knowledge* (Routledge, 1992); Andrew McClellan, *Inventing the Louvre* (Cambridge: Cambridge University Press, 1994); Donald Preziosi, "The Question of Art History," *Critical Inquiry* 18 (Winter 1991), pp. 363–86; Daniel Sherman, *Worthy Monuments; Art Museums and the Politics of Culture in Nineteenth-Century France* (Cambridge, MA: Harvard University Press, 1989).

3 Two books catalogue a wide variety of work on the subject of museums: Kynaston McShine, *The Museum as Muse: Artists Reflect*; James Putnam, *Art and Artifact: The Museum as Medium* (London: Thames & Hudson, 2001).

4 Among semiotic studies: Mieke Bal, "Telling Objects: A Narrative Perspective on Collecting," in John Elsner and Roger Cardinal, eds., *The Cultures of Collecting* (Cambridge, MA: Harvard University Press, 1994); Michael Baxandall, "Exhibiting Intentions: Some Preconditions of the Visual Display of Culturally Purposeful Objects," in *Exhibiting Cultures*, eds., Ivan Karp and Steven D. Lavine (Washington, D.C.: Smithsonian Institution Press, 1991); Ivan Karp and Fred Wilson, "Constructing the Spectacle of Culture in Museums," in *Thinking About Exhibitions*; Rosalind Krauss, "Postmodernism's Museum Without Walls," in *Thinking About Exhibitions*; Johanne Lamoureux, "The Museum Flat," in *Thinking About Exhibitions*; Jean-François Lyotard, "Les Immatériaux," in *Thinking About Exhibitions*.

5 Other examples include: Casa Bagatti Valsecchi (Milan); Barnes Foundation (Merion, PA); Benaki Museum (Athens); Bayou Bend (Houston, TX); Burrell Collection (Glasgow); Ca d'Oro (Venice); Goulandris Foundation (Athens); Peggy Guggenheim Museum (Venice); Hallwylska Museet (Stockholm); Hillstead Museum (Farmington, CT); Hillwood (Washington, D.C.); Musée Jacquemart André (Paris); Kröller-Müller Museum (Oterloo); Lenbachhaus (Munich); Maryhill Museum (Goldendale, WA); Musée Mayer van den Bergh (Antwerp); McNay Museum (San Antonio, TX); Morgan Library (NYC); Musée Nissim de Camondo (Paris); Museo Dolores Olmedo Patiño (Mexico City) Phillips Collection (Washington, D.C.); Museo Poldi Pezzoli (Milan); Ringling Museum (Sarasota, FL); Museo Stibbert (Florence); Taft Museum (Cincinnati, OH); Vizcaya (Miami, FL); Wheelwright Museum (Santa Fe, NM). On some examples of the private museum type, see Carol Duncan's chapter "Something Eternal; the Donor Memorial," in *Civilizing Rituals; Inside Public Art Museums* (New York: Routledge, 1995).

6 Isabella Stewart Gardner to Bernhard Berenson, September 19, 1896, in *The Letters of Bernard Berenson and Isabella Stewart Gardner 1887–1924*, ed. Rollin Van N. Hadley (Boston: Northeastern University Press, 1987), p. 65.

7 *Last Seen* has been published in its entirety in *Absence* (Rotterdam: Museum Boymans-van Beuningen, 1994).

8 Bernhard Berenson to Isabella Stewart Gardner, May 10, 1896 in Hadley, *Letters*, p. 55.

9 Berenson to Gardner, September 8, 1896 in Hadley, *Letters*, p. 65.

10 Gardner to Berenson, September 19, 1896, in Hadley, *Letters*, p. 66.

11 Hilliard T. Goldfarb, *The Isabella Stewart Gardner Museum; A Companion Guide and History* (Boston: Isabella Stewart Gardner Museum and New Haven: Yale University Press, 1995), p. 115.

12 S. N. Behrman. *Duveen* (New York: Random House, 1951), p. 3.

13 Elsie de Wolfe to Isabella Stewart Gardner, January 20, 1907, quoted in David Park Curry, "Never Complain, Never Explain: Elsie de Wolfe and the Art of Social Change," *Cultural Leadership in America: Art Matronage and Patronage. Fenway Court*, vol. 27, 1997, p. 57.

14 Hilliard T. Goldfarb, in Hilliard T. Goldfarb, David Freedberg, and Manuela B. Mena Marqués, *Titian and Rubens; Power, Politics, and Style* (Boston: Isabella Stewart Gardner Museum, 1998).

15 Gardner to Berenson, September 11, 1896, in Hadley, *Letters*, p. 65

16 Anne Higonnet, "Private Museums, Public Leadership: Isabella Stewart Gardner and the Art of Cultural Authority," in *Cultural Leadership in America*, pp. 83–4; Kathleen Weil-Garris Brandt, "Mrs. Gardner's Renaissance," *Fenway Court*, 1990–1, pp. 10–30.

17 On Gardner's biography, see: Morris Carter, *Isabella Stewart Gardner and Fenway Court*, 3rd edn. (Boston: Isabella Stewart Gardner Museum, 1972); Louise Hall Tharp, *Mrs. Jack; A Biography of Isabella Stewart Gardner* (New York: Congdon & Weed, 1965).
18 Hadley, *Letters*, p. 67.
19 Hadley, *Letters*, p. 114.
20 Tharp, *Mrs. Jack*, p. 211.

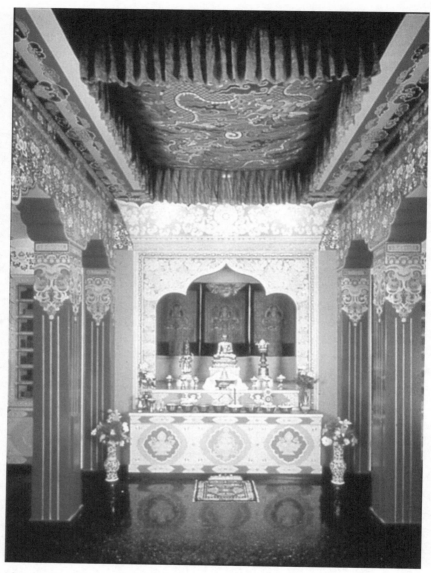

Plate 8 The Tibetan Altar, The Newark Museum. Photo © The Newark Museum.

Sacred to Profane and Back Again

Ivan Gaskell

When art historians consider the relationship between art and its publics they often appeal to non-aesthetic criteria – social or religious functions, for example – in order to account for the appearance and use of such objects. They are not invariably able to draw clear distinctions among the aesthetic qualities of objects and their other qualities as economic, social, and, where appropriate, religious artifacts. Objects considered as art allow a variety of modes of address. Their multivalency means that art objects can be viewed and used in various manners by various publics, some of which may be irreconcilable with one another, and none of which neces-sarily successfully claims exclusive legitimacy. The uses of art objects are shaped to an appreciable extent by the varied institutional contexts of these uses. The devotional significance of a Tibetan Buddha, or a Russian icon, or Native American dance regalia can predominate if each is in a temple, church, or at a dance site, whereas their characteristics as art objects for aesthetic contemplation or art-historical education are accen-tuated when they are displayed in an art museum. This observation should not prevent us from acknowledging the ambiguity that adheres to the perception and use of such objects whether in a sacred or a profane setting. When considered in relation to the sacred and the profane, art museums and places of worship are ambiguous in varying degrees. We can enter a church, shrine, or temple on one occasion to view its fabric and contents as art, and on another (depending on our beliefs) to take part in devotions. Yet the sacred spaces of churches, shrines, or temples and the secular spaces of art museums are not equally balanced alternatives to one another. Aesthetic qualities are often allied to the sacred, the former

reinforcing and even tending to confirm the latter, whereas those things we view aesthetically need not invariably be actively sacred in our perceptions. Once a sacred object has been removed to a secular space, its sacred qualities are often compromised. Indeed, in their emphasis on the aesthetic and the art-historical, art museums have proved to be very effective means of expunging the sacred qualities of objects.

The purpose of this chapter is to discover how art museums, concerned, among other things, with the ascription of aesthetic qualities to objects, can come to terms with the fact that in certain circumstances the sacred character of those same objects might predominate. Museums might do well to reassess the Enlightenment assumptions under which they operate that aesthetic and educational criteria alone justify the abstraction of sacred objects from their devotional or otherwise sacred contexts for deployment in an entirely secular domain. Should not certain objects be addressed in religious terms, even though they remain in museums? Should certain objects not remain in museums, but be returned to those who would treat them principally in religious terms? The exclusively aesthetic and scholarly uses of objects in museums does not exhaust the legitimate uses of those objects.

When a sacred object enters a museum we generally think of it as being desacralized, or, in devotees' eyes, desecrated. However, we should be aware that the sacred is not a uniform condition. In the western Christian tradition many objects can slip in and out of the sacred condition. Much depends on use and context. An artifact used in a sacred manner by some does not necessarily become sacred in the eyes of others. An object consecrated to devotional use one day, such as a Roman Catholic altarpiece, can be legitimately removed and sold into the purely secular realm the next, and not one scrap of its former sacred status need remain attached to it, other than by association and as a matter of its history. This is in sharp contradistinction to many other cultural traditions, for example, that of Orthodox Christianity. The Orthodox icon, as an object of devotion, is imbued with sacred status to the extent that properly executed copies of it partake of the power of the prototype. That sacred status is inalienable, rather like that of the authentic sacred relic in the western tradition. We must therefore distinguish between objects regarded by their community of users as inalienably sacred and objects which may be consecrated yet are fully amenable to deconsecration. There is plenty of room for equivocation and ambiguity in both sets of circumstances. None the less, objects, whether their sacred status is inalienable or not in the eyes

of their devotional users, usually make a one-way trip from the sacred realm of devotion to the profane realm of the museum. Is this inevitable? Three examples suggest that it is not.

Altar

On September 23, 1990, after a lengthy process involving lay and religious members of the New Jersey and New York Tibetan community, the fourteenth Dalai Lama consecrated a new Buddhist altar for the display of Tibetan sacred objects as part of a permanent exhibit, *Tibet, the Living Tradition*, at the Newark Museum. In the words of the then director, Samuel Miller, "the Trustees and staff of the Museum are gratified that, with the consecrated altar, the rare Tibetan religious objects under their care remain part of a living tradition."[1] How did this come about? The Newark Museum has an extensive, varied and important collection of Tibetan art. It owes its beginnings to the chance shipboard meeting in December, 1910 of a founding trustee, Edward Crane, with an American medical missionary to the troubled border region between China and Tibet, Dr. Albert Shelton. Shelton had acquired a considerable number of objects in the chaotic conditions then prevailing and was bringing them back to the United States. At Crane's behest they were exhibited in Newark between February and June, 1911. The director of the Library and Museum was John Cotton Dana, one of the most innovative museum professionals of the twentieth century. He investigated the worth of the collection and acquired it with the help of Crane's family when the latter suddenly died in the summer of that year. Dana thereafter encouraged Shelton to collect further Tibetan objects upon his return to China in 1913, and in consequence a second group of over 600 pieces entered the museum in 1920. Further missionary collections were added subsequently.[2]

Dana's interest in this material may have been prompted by chance, yet its emphasis on objects of practical domestic and religious use fitted perfectly with his promotion of the decorative arts and quotidian objects in contradistinction to the "fine" arts.[3] After Dana's death in 1929 the museum remained committed to Tibetan art under his successor, Beatrice Winser. In 1935 a group of American artists was commissioned under a Federal Emergency Relief program to design and build an altar in the Tibetan style for the display of Tibetan sacred art. There is nothing to

suggest that this altar was conceived as anything other than a device for giving the objects thus displayed a unifying context, for no Tibetans are known to have visited the museum prior to the members of the Tibetan Trade Delegation to America in 1948.

The continuing long-term openness of the museum to Tibetan culture was fostered by two people in particular: Eleanor Olson, who was in charge of the Asian collections between 1938 and 1970 (designated curator in 1950), and Helen Cutting, a trustee from 1943 until her death in 1961. After World War II a refugee Mongol Buddhist community settled in central New Jersey under the leadership of the first lama to come to America who had received full monastic training in Tibet, but the great change in local circumstances was the arrival of Tibetan refugees in the years following the flight of the Dalai Lama from Lhasa to India in 1959. Scholarly and public interest in Tibetan culture throughout North America and Europe soared with sympathy for Tibet's political fate, and the museum showed itself open to many constituents of the Tibetan diaspora.

Olson's successor as curator, Valrae Reynolds, has continued her predecessor's scholarly and public engagement with the Tibetan collections and the Tibetan community of New Jersey and New York. She was responsible for the exhibition of over 200 Tibetan objects which toured to several American cities between 1978 and 1980, returning to the Newark Museum in 1981.[4] There it was seen by the Dalai Lama who had first visited the museum two years previously with considerable publicity. The 1981 visit of the deposed head of state and spiritual leader of Tibetan Buddhism was described by the director, Samuel Miller, as the highlight event associated with the exhibition.[5]

Special consideration of Tibetan Buddhist concerns in relation to the museum's collection increased during the 1980s. When the museum planned an expansion and renovation in the mid-1980s, the curator reported that she "worked with lay and religious members of the Tibetan community, as well as with scholars of Tibetan religion, history and anthropology, to ensure the accurate selection and interpretation of objects from the Tibetan collection."[6] The most conspicuous result was the creation of a new altar, replacing that of 1935, but with a number of crucial differences. The altar designed and built between 1988 and 1990 was the work not of Americans, but of a Tibetan, Phuntsok Dorje, trained at a monastery in Sikkim. Most importantly, this altar was not conceived as a stage setting, but as a true religious structure. This was emphasized in the most authoritative manner possible, for the altar was consecrated by

the Dalai Lama himself.[7] The intermingling of well-meaning museum practice, religion and high politics on this occasion can be judged from the well-publicized attendance not only of local public figures, including the Mayor and the Roman Catholic Archbishop of Newark, but of the Anglican Archbishop of Capetown, Desmond Tutu.

The altar is a complex structure comprising a central shrine containing three sacred sculptures behind which hang *tankas* (scroll paintings) and before which are various objects including butter lamps and vessels containing offerings of saffron-colored water, barley, and rice. On each side are seven rows of three niches, each containing a volume of the *Kanjur*, a sacred text. The ceiling above the area before the central shrine and between the rows of columns is hung with a silk canopy. The woodwork of the entire altar is intricately decorated with symbolic motifs in pastiglia relief, polychrome, and gilding.

The central object on the altar is a gilded copper figure of Shakyamuni (Gautama) Buddha, seated in the lotus pose, his right hand touching the earth in witness of his overcoming temptation to return to his life of princely ease, and his left hand resting in his lap in the meditation position. This image represents the founder of Buddhism, Prince Siddhartha Gautama, at the instant of his attainment of Buddhahood, or ultimate enlightenment.[8] Such figures are used principally in visualization meditation, and, conforming precisely to codes of form, proportion and design, they instantiate an aspect of nirvana, thereby radiating the presence of what is represented with which the meditator seeks to identify. Therefore such images inherently partake of a real presence which is further enhanced by the insertion of sacred relics, mantras and texts into the cavity of the statue, and activated by the consecration ceremony in which a lama imagines and projects the spirit of the actual Buddha onto the object. The effects of such visualization, repeated in ritual meditations, are cumulative, and when the image is the sustained object of meditation by adepts its religious efficacy increases to the extent that it can grant blessings to supplicants. It is treated with the same respect as if the living Buddha were present.[9]

The figure of Shakyamuni Buddha on the Newark Museum altar, which entered the collection with the second group of objects acquired from Albert Shelton in 1920, was opened in 1928 and found to contain all the objects one might expect to have been placed ritually within it in the course of a special ceremony for the purpose, including the *srog-'sin* ("life-stick" or "soul pole"), eighty-five rolls of sacred texts each wrapped in silk, and

twenty clay votive images.[10] In her catalogue, Eleanor Olson notes that the removal of the base plate and withdrawal of the sacred contents was "contrary to usual museum policy."[11] One wonders if the efficacy of the figure has not been compromised in religious terms if the contents have not been restored. None the less, the ceremony performed by the Dalai Lama in 1990 invoking the Buddhas to enter the altar and remain there, was, on the museum's part, a demonstration of its willingness to act, in the curator's words, on its "newly self-conscious assessment of its obligations."[12] That sense of obligation derived from discussions with Tibetans who had helped research and add to the collection, and who saw the objects as invested with sacred power.[13] In consequence these objects are now activated spiritually in order to function in a more complex manner than might have been the case had they merely been activated by the museum in an aesthetic or art-historical manner. Even if the project is colored by deference, for the Tibetans concerned are described by the curator as "great lamas and descendents of Tibet's noble families,"[14] and also by political naïveté, for the lamaist cause is not unchallenged,[15] the Newark Museum acknowledges that objects displayed on the altar can be approached in terms that museums generally only present as a matter of history or ethnography.

Icon

The second example concerns one of the most celebrated objects in the State Tretyakov Gallery, Moscow: the icon generally known as the *Virgin of Vladimir*. It is an icon of twelfth-century Byzantine origin that assumed the status of palladium of the Russian people. It is of the type known in Greek as *Eleousa* (in Russian, *Umilenie*), meaning tender, for the *Panagia*, or Mother of God, inclines towards the child who caresses her while grasping her neck below her mantle or maphorion. It conventionally evokes maternal and filial love and a premonition of Christ's sacrifice. Its authority stems from its ostensible direct derivation from one of those icons believed to have been painted by the Evangelist Luke. While great religious efficacy can adhere to derivations from such a work, leading to its diffusion by copying, the greatest efficacy resides in the prototype.

The known history of the icon goes back to 1131 when it was sent as a diplomatic gift from Byzantium to Prince Mstislav of Kiev. Prince Andrei Bogoliubsky subsequently used it as a palladium in his war against the

Bulgars and in 1155 took it from Vishgorod, near Kiev, to the new political center of Vladimir. When Moscow, which became predominant in the fourteenth century, was threatened by Timur (known as Tamberlane) in 1395 the icon was moved there and Timur's retreat credited to its miraculous intercession. This and two further ostensibly miraculous deliveries of Muscovy from Tatar khans in 1480 and 1521 respectively, were the occasions for the three great feasts thereafter dedicated to the Vladimir icon, August 26, June 23, and May 21. These and other episodes in the sacred history of the icon became the subject of subsidiary scenes in further icons derived from the *Virgin of Vladimir* which partake of its power.

Between 1395 and 1918 the icon remained in the Cathedral of the Dormition in the Kremlin, behind the holy table within the sanctuary according to documentary sources. Following the October Revolution the icon was the subject of a thorough technical study that determined the complex strata of its several successive selective repaintings on four known occasions between the end of the thirteenth century and 1895–6. Only the faces themselves can be associated with its original Byzantine execution. Following this technical study the work was further conserved in 1918–19. Its elaborate gold and silver fifteenth-century *oklad* (literally shirt) and *korona* (crown) – the honorific covering that ornamented it but obscured much of the painted surface – were not reattached, and the icon entered the collections of the State Tretyakov Gallery.[16] From an object of unqualified religious devotion second to none in the Russian Empire, the *Virgin of Vladimir* became an object of dispassionate scientific enquiry, and then an object of desacralized aesthetic contemplation in an art museum. It remained literally naked, for its *oklad* and *korona* remained in the Kremlin collections.[17] This represented a purposeful expurgation of its religious potency and a symbolic transfer of the locus of its nationalistic protective power from the church to containment and implicit diminution by the state.

The dissolution of the USSR and the change of governmental system in 1991–3 led to changed circumstances once again, and here we enter deeply sensitive territory. I owe what follows to a colleague at the State Tretyakov Gallery who told me what happened during my visit there in 1999. My subsequent attempts to elicit further details and confirmation of my understanding of the story were reported to the director and my further efforts to make contact have met with silence.

To celebrate the 600th anniversary of the translation of the *Virgin of Vladimir* to Moscow, the State Tretyakov Gallery organized an exhibition

devoted to the icon in 1995. It was accompanied by a substantial cata-
logue, but no mention is made of the controversy concerning its owner-
ship and control.[18] This controversy arose as a consequence of the claim
by the Patriarchate of Moscow for what it regarded as the return of the
icon as ecclesiastical property. The newly resurgent Russian Orthodox
Church was attempting to reassert control over the single most potent
object once associated with it. It had not escaped anyone's notice that since
the twelfth century whoever has controlled the *Virgin of Vladimir* has
controlled Russia. It remains the palladium of the culture.

Such is the resurgent power of the Orthodox Church that, rather than
be provoked into adopting a legalistic refutation of the claim for restitu-
tion, the State Tretyakov Gallery achieved an amazing accommodation. It
was quite feasible to demonstrate that the icon had always been a royal and
state, rather than ecclesiastical, possession, so its disposition by the state
should continue. However, political prudence and expediency – and
perhaps a genuine desire for accommodation – suggested another, far
more complex, solution.

For many years a secularized church near the State Tretyakov Gallery
had been used for the storage of unexhibited, mainly twentieth-century,
works in the collection. It is connected to the Gallery by a tunnel. This
church was restored for religious use with objects and icons from the State
Tretyakov collections. During Gallery open hours it is only accessible
through the Gallery by means of the underground corridor, but at other
times can be entered from the street. The icon of the *Virgin of Vladimir*
remains in its vitrine, exhibited in the Gallery with the other icons, except
on occasions such as the three great feasts dedicated to its protective
powers. Then it is removed from its vitrine and brought to the church
for liturgical use and veneration. Although without its *oklad* and *korona*,
once more it becomes a fully sacred object. And to complete the arrange-
ments the Patriarch of Moscow has been accorded curatorial status within
the State Tretyakov Gallery. This extraordinary solution – an ingenious
compromise on both sides – allows for the use of the icon alternately
according to the aesthetic and art-historical criteria of the museum on the
one hand, and according to the sacred criteria of the Russian Orthodox
Church on the other.

Perhaps – and this can only be speculation – neither side to the
agreement can be entirely satisfied, for these alternating uses of the icon
imply that neither the one nor the other is fully and exclusively legitimate.
If an object is truly sacred that quality cannot be turned on and off for the

sake of convenience. Curators and priests have to turn a blind eye to one another's uses of the object and suppress the jealousy of exclusive claims inherent in either a religious or a museological conception of the proper use of objects. Each party has to allow another whose claims it considers inferior to its own to enjoy the use of and responsibility for an object that it would rather control exclusively. Ceding exclusive control may even mean vitiation in the eyes of critics of either sympathy, hence the need for extreme discretion in discussing the current arrangement regarding the *Virgin of Vladimir*. Were it to be opened up for discussion, its repeated movement from sacred to profane and back again may end up satisfying no-one, not even those who are immediate parties to the arrangement. These fears are indeed justified. A colleague who visited the State Tretyakov Gallery in the winter of 2001 reported witnessing Orthodox devotees entering the gallery and ostentatiously venerating the icon in its vitrine, even deliberately blocking the approach of visitors who wished to view it in a secular manner.

Dance Regalia

The third example of an against-the-grain passage from the profane to the sacred realm is, on the face of it, quite different from either that of the Newark Museum or the State Tretyakov Gallery. In November 1998 seventeen items of dance regalia were repatriated from the Peabody Museum of Archaeology and Ethnology at Harvard University to the Hoopa Valley Tribe of the Hoopa Valley Reservation, in north-west California.[19] These objects had been collected in the early years of the twentieth century and had entered the Peabody Museum from a variety of sources between 1904 and 1911. The objects were officially described as "a skirt or shoulder cape; a ringtail cat apron; a hookmen headdress; two sets of dance plumes; a wolf blinder headdress; three headdresses (head-nets); a roll for a headdress; two woodpecker headdresses; a red humming-bird headdress; two dance baskets; and a head ring." To these was added a "doctor's necklace."[20] Six of these objects had been on display in a vitrine dedicated to the sacred dances of the Klamath River area in the Hall of the North American Indian in the Peabody Museum.

Commenting on the repatriation of these objects, Tribal Chairman, Merv George stated, "This is a historic thing. It's a victory for not only the regalia itself – because we believe it is living and has a life and spirit of

its own – but for the people who created it. For the people today, it allows us to rekindle and share a part of our history here that I feel has been wrongly taken from this area."[21] Most of these objects are associated with one or other of two dance ceremonies that historically form the ceremonial core of Hupa life, the White Deerskin Dance and the Jump Dance. Both ceremonies, each of which lasts ten days, are concerned with what has been termed annual "world renewal": the purification and setting in balance of the world, contaminated by the existence and actions of the Hupa themselves. The White Deerskin Dance is performed to "repair the earth," or to "wipe out the devil brought into the world by members of the society who have broken taboos" (in the words of two ethnologists).[22] It takes place in August or September, the dancers moving from site to site according to a traditional route through the valley. Among the returned regalia employed are the ring-tail cat apron, such as is worn by principal singers, and the "hookmen headdress" embellished with sealion incisors. Such headdresses are worn by the two dancers who move up and down the line of performers holding rare obsidian blades before them.

The fall Jump Dance takes place ten days after the White Deerskin Dance and itself lasts ten days, but is not itinerant, taking place at the principal sacred site in the village of Takimildin. It is part of the world renewal rites and specifically addresses the prevention of disease, natural disasters, and the procuring of plentiful acorns, deer, and salmon, the age-old Hupa food staples. Among the returned Jump Dance regalia are the two dance baskets, held by the dancers above their heads in the first phase of the dance, and the scarlet headdress decorated with the scalps of pileated woodpeckers, a bird with complex spiritual associations.

There can be no doubt that all these objects were and remain highly spiritually charged. Trying to understand their status as property is no less difficult than trying to understand their allusive and symbolic significance in Hupa cosmology. Most of the regalia were traditionally made by men within the exclusively male *taikyuw*, or sweathouse of their clan or extended family, itself within one of the Hupa villages. The Hupa had a highly developed sense of chattel property, used in trade and the settlement of feuds by compensation. A man who commanded a considerable quantity of such property, notably the dentalium shells and pileated woodpecker scalps used in such transactions, enjoyed high status, commanding respect and power. The complex dance regalia, using these and other highly valued materials, was also a display of wealth, but wealth dedicated not exclusively to proclaiming the power of the user and his

lineage (for regalia was heritable), rather to a transcendent common purpose. In the context of the recent restitutions this ambiguity has been resolved in favor of the denial of any right of alienation on the part of individuals. The regalia can be thought of as being "spiritually entailed" property, expressed by the statement in the "Notice of Intent to Repatriate" that "Ownership rights to the ... cultural items rest with the Immortals and only secondarily to specific lineages."[23] The implication accepted by all parties to the repatriation is that the original transactions by which these objects were purchased from Hupa individuals were illegitimate.

The repatriation in November 1998 took place under the auspices of the Native American Graves Protection and Repatriation Act of 1990 (NAG-PRA). This Federal legislation has had and continues to have far-reaching consequences for relations between the 756 Federally recognized Native American tribes and Hawaiian organizations and the rest of the country, especially as represented by its museums. NAGPRA mandates mechanisms for inventorying and returning on request human remains, funerary and sacred objects, and objects of cultural patrimony. The Peabody Museum's collections are second only to those of the Smithsonian Institution in size, extent, and geographical diversity. In the fiscal years 2000 and 2001 the Peabody Museum budgeted approximately $1 million per annum and a staff of at least twenty full-time equivalents to NAGPRA compliance.[24] Items have been successfully claimed by various tribes, and some of those returned will inevitably by destroyed by the uses to which they are put. This will not be the case with the Hupa dance regalia: far from it. They are now kept in the Hoopa Tribal Museum.[25] Their role in the religious life of the tribe is compatible with museum care in a sense similar, though not identical, to the compatibility achieved between the museum and ecclesiastical care of the *Virgin of Vladimir* in the State Tretyakov Gallery and the demonstrated respect of the Newark Museum for the sacred character of its Tibetan religious holdings. The regalia will be brought to attend the dances, though not actually used in their performance, and at other times exhibited in the museum. The Tribal Chairman and elders have ultimate control of both institutions – the museum and the dances – so a western analogy closer to the Hupa case than the *Virgin of Vladimir* would be that of a Roman Catholic diocesan or church museum or treasury temporarily relinquishing for occasional liturgical use an object usually on public display. In both instances the sacred realm takes precedence and has ultimate first call on the object, whereas in the cases of the State Tretyakov

Gallery and the Newark Museum the profane realm of the museum takes precedence and retains ultimate control, however ambiguously presented.

All three cases – and others could be adduced – suggest that mechanisms of compromise, where culturally sustainable, that permit both the museo-logical and the sacred uses of objects are worth searching for. Exclusive claims upon objects in the interests of uses incompatible with others may well sometimes be unavoidable, yet when accommodations can be reached, with a little imagination and good will, an altogether richer, more varied and more challenging use of objects results than would be the case if they were at the disposal of one party alone.

If more than one group of people can use any given object or objects safely for a variety of seemingly incompatible purposes, the life of those objects, and of all who think about that variety of uses, is greatly enriched. Those who are responsible for museum collections might ask themselves how they should best meet their responsibilities towards objects in those collections in all their complexity, rather than solely in respect of their aesthetic, art-historical, and educational characters. The paradigm that holds the latter criteria as exclusive validation for museums' attention to objects is coming to the end of its cultural life, and we must develop means of meeting a far wider range of expectations regarding objects and their uses on the part of a variety of publics than has generally been the case in the past.

Notes

1 Samuel C. Miller, "Foreword" in Valrae Reynolds, *Tibetan Buddhist Altar* (Newark: The Newark Museum, 1991), p. 5. See also Valrae Reynolds, *From the Sacred Realm: Treasures of Tibetan Art from the Newark Museum*, exhibition catalogue, The Newark Museum, 1999–2000 (Munich, London and New York: Prestel, 1999), esp. pp. 19–21.

2 A brief history of the origins of the collection is given in Reynolds, *From the Sacred Realm*, pp. 11–21 recapitulating earlier museum publications.

3 Valrae Reynolds, "The Oriental Collections," in *The Dana Influence: The Newark Museum Collections* (*The Newark Museum Quarterly* 30, 4, 1979), p. 45.

4 Valrae Reynolds, *Tibet, a Lost World: The Newark Museum Collection of Tibetan Art and Ethnography*, exhibition catalogue, American Federation of Arts (New York: American Federation of Arts, 1978).

5 Samuel C. Miller, "Report of the Director," *1981 Annual Report* (*The Newark Museum Quarterly* 33, 1, 1982), p. 6.

6 Reynolds, *From the Sacred Realm*, p. 20.

7 Although there is no published mention of the 1935 altar ever having been consecrated, it was deconsecrated in a ceremony for the local Tibetan community by Ganden Tri Rimpoche in January, 1988 (Reynolds, *Tibetan Buddhist Altar*, p. 11; Reynolds, *From the Sacred Realm*, p. 20).

8 Eleanor Olson, *Catalogue of the Tibetan Collection and other Lamaist Material in The Newark Museum*, vol. 3 (Newark: The Newark Museum, 1971), pp. 5–6.

9 Janet Gyatso, "Image as Presence: The Place of Art in Tibetan Religious Thinking," in Valrae Reynolds et al., *Catalogue of The Newark Museum Tibetan Collection*, vol. 3, 2nd edn. (Newark: The Newark Museum, 1986), pp. 30–5; reprinted in Reynolds, *From the Sacred Realm*, pp. 171–6.

10 A complete descriptive list is given in Olson 1971, pp. 7–8, and illustrated in Reynolds et al. 1986, p. 57.

11 Olson, *Catalogue of the Tibetan Collection*, p. 5.

12 Reynolds, *Tibetan Buddhist Altar*, p. 11.

13 Reynolds, *From the Sacred Realm*, p. 20.

14 Ibid., p. 20.

15 For example, Robert Irwin, "An Endless Progression of Whirlwinds," *London Review of Books* 23, 12, 2001, pp. 32–3.

16 The literature on the *Virgin of Vladimir* is considerable. See E. K. Guseva et al., *Bogomater Vladimirskaya: k 600–letiyu Sreteniya ikony Bogomateri Vladimirskoy v Moskve 26 avgusta (8 sentyabrya) 1395 goda* (exhibition catalogue, State Tretyakov Gallery and State Historical–Cultural Museums Moscow Kremlin, Moscow, 1995), Moscow: Avangard, 1995 (with English summary and many further references).

17 A. V. Ryndina, "K istorii restavratsii okladov ikony 'Bogomater Vladimirskaya' v XV veke," *Drevie-russkoe iskusstvo*, 1997, pp. 136–46 (with English summary).

18 Guseva et al., 1995.

19 The contemporary tribal nation is known as the Hoopa and is constituted not only by descendents of the original Hupa tribe, but also of the Chilula, Chimanko, Whilkut and Yurok peoples who joined the Hupa from 1864 onwards in their Trinity Valley reservation, the Hupa ancestral homeland. Thus Hupa designates the historical tribe, and Hoopa the contemporary nation. See Dolan H. Eargle, Jr., *The Earth is Our Mother: A Guide to the Indians of California, their Locales and Historic Sites*, 4th edn. (San Francisco: Trees Company Press, 1993), p. 49.

20 "Notice of Intent to Repatriate," *Federal Register* 63, 191, October 2, 1998, pp. 53097–8

21 Jeannine Gendar, "Big Times/Little Times," *News from Native California* 12, 2, 1998/99, p. 36.

22 A. L. Kroeber and E. W. Gifford, *World Renewal: A Cult System of Native Northwest California* (Berkeley: University of California Press, 1949), p. 1. In addition to the works already cited, this necessarily brief account is derived from Pliny Earle Goddard, *Life and Culture of the Hupa* (*University of California Publications in American Archaeology and Ethnology* 1) (Berkeley: University of California Press,

1903); Walter R. Goldschmidt and Harold E. Driver, *The Hupa White Deerskin Dance* (*University of California Publications in American Archaeology and Ethnology* 35) (Los Angeles: University of California Press, 1940); Byron Nelson, *Our Home Forever: The Hupa Indians of Northern California*, 2nd edn. (Hoopa: Hoopa Tribe, 1994); Anne-Marie Victor-Howe, "Hupa World View" (unpublished MS). I am especially grateful to Anne-Marie Victor-Howe for making this paper available to me and for her inestimable help in introducing me to the Hupa/Hoopa world.

23 *Federal Register* 63, 191, October 2, 1998, p. 53098.

24 Lecture by Rubie Watson, director, delivered at the Peabody Museum, October 18, 2000.

25 Gendar 1998/99, p. 36

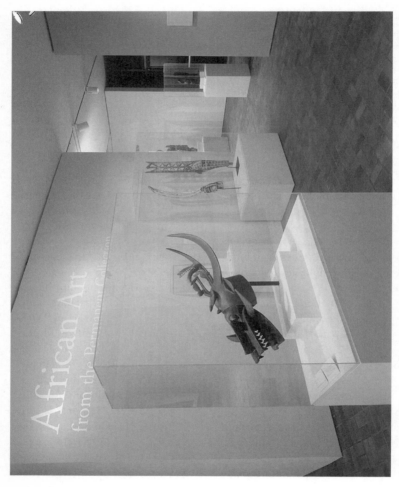

Plate 9 *African Art from the Permanent Collection*, Neuberger Museum of Art, Purchase College, State University of New York, 2001. Photo by Jim Frank.

From Theory to Practice:
Exhibiting African Art in the Twenty-First Century

Christa Clarke

A sculpted wooden headdress, mounted on a pedestal and placed inside a Plexiglas vitrine, sits at the entrance to the recently reinstalled permanent collection of African art at the Neuberger Museum of Art, on the campus of Purchase College, State University of New York. As the curator of African art for the Neuberger Museum, I have placed this work here deliberately, just outside the bounds of the wall leading to the museum's gallery. The headdress is a strong sculptural work, intended to visually arrest the casual viewer. Its placement in a freestanding vitrine allows the headdress to be admired from all sides. I picture a group of schoolchildren gathered around, excitedly identifying its complex animal imagery, which combines the features of an antelope, hornbill, crocodile, and chameleon. I imagine the headdress attracting the interest of a college student, who then wanders through the rest of the gallery, eager to learn more.

I am using form to visually engage a prospective visitor and, at the same time, employ various interpretative strategies to help that viewer "understand" the work of art. A label inside the case identifies the headdress as an example of the genre called *kponyugu* and attributes the work to a Senufo artist (whose name remains unknown) from Ivory Coast. Another label explains that this type of headdress is the most important mask genre used in the men's Poro society among the Senufo. Its animal imagery relates to the origins of the world, important legends, and the supernatural powers associated with animals. Such a powerful mask, the text continues, would be worn by a man who, concealed in a cloth costume, appears at critical

stages in funeral and initiation ceremonies. A larger text panel on the wall discusses more broadly the topic of "Masks and Masquerades," which is the unifying theme of the works on display in this room. Photographs on the walls show masks similar in style to the works on display in performance.

Although the information provided allows the museum-goer to have a greater understanding of the work, I am ultimately confronted with the fact that the viewer's experience of this headdress will be very different from that of its original maker or owner. In the museum case, the object is isolated and still, displayed as a final product of artistic creation. In its original setting, the headdress would be worn as an element of a costumed performance, appearing infrequently, and viewed only by a select group of individuals. The headdress, once seen as an active force in motion, is now an object of reverie and contemplation in an art museum context. "Almost nothing displayed in a museum was made to be seen in them," Susan Vogel has observed, adding that, "this evident fact lies at the very heart of museum work... and should be a preoccupation of all museum professionals though most museum visitors seem practically unaware of it."[1] The object's displacement from its cultural origins is obvious to me and perhaps to the viewer, but is its recontextualization within the framework of an art museum as apparent?

Museum professionals today, if not preoccupied by, are certainly cognizant of the ways in which meaning is made through curatorial practices. The exhibition of African art, in particular, has been the subject of much critical inquiry in recent years, as scholars address the ideological constructs underlying the selection and presentation of African artifacts in a western museum setting.[2] In response, many curators are striving to create permanent installations of African art that acknowledge the problematic issues surrounding the display of non-western art. A recent reinstallation of the Neuberger Museum's permanent collection of African art has afforded me an opportunity to reflect on these issues and consider how theoretical discussions have informed my own curatorial practice. From this personal perspective, I offer here an overview of the opportunities, challenges, and limitations posed by the collection and presentation of African objects in an art museum context as we move into the twenty-first century.[3]

Issues of selection and display have been central to discourse on western appreciation of African art since the beginning of the twentieth century,

when objects from Africa first attracted the attention of the avant-garde. Although African artifacts entered European collections as early as the fifteenth century, it was not until the first decades of the twentieth century that their artistic qualities came to be appreciated by westerners. The growing admiration for African art was led by artists, dealers and collectors, whose aesthetic preferences resulted in the development of distinctions between art and artifact. While ethnographic museums of the time displayed a wide range of African material culture, collectors preferred masks and statuary in wood and metal – genres and media most easily assimilated into the established categories of fine arts in the West. The objects sought during this period subsequently became validated as "African art," their formal qualities valued over their role as cultural artifacts.[4]

Along with the formation of private collections, temporary exhibitions in galleries and art museums also contributed to the aesthetic valorization of African art in the first half of the twentieth century. A number of influential exhibitions sought to validate African sculpture as an art form solely through its relationship to western modernism. For example, the first gallery exhibition devoted solely to African art, organized by photographer Alfred Stieglitz and caricaturist Marius de Zayas, was held in 1914 at Stieglitz's gallery 291 in New York City. Despite its racist premise, as indicated by the title, *Statuary in Wood by African Savages: The Roots of Modern Art*, the exhibition was notable not only for its subject, but also for its innovative strategy of display. A select grouping of eighteen African masks and statuary were presented as singular masterpieces, framed by rectangular panels of yellow, orange, and black paper that emphasized the planar elements of the objects.

The appreciation of African artifacts as art gained widespread acceptance in 1935 when the Museum of Modern Art in New York presented *African Negro Art*, curated by James Johnson Sweeney. This exhibition, the first in a major art museum, introduced objects from sub-Saharan Africa to a large museum-going public and, in the process, established a canon of African art. The nearly 600 works in the exhibition, primarily masks and figurative sculpture from west and central Africa, were selected entirely for their expressiveness as art forms. "It is not the tribal characteristics of Negro art nor its strangeness that are interesting," wrote Sweeney in the exhibition catalogue, "It is its plastic qualities. Picturesque or exotic features as well as historical and ethnographic considerations have a tendency to blind us to its true worth."[5]

The emphasis on pure form was reflected in the display, which featured African objects set against the spare, white walls of the museum and highlighted as isolated examples in vitrines. The selective presentation, in tandem with the dramatic installation, provoked critical attention. As one reviewer described, "Against a background of dead white these 600 objects, selected from the leading European and American art collections, are arranged with ample space around them, so that the idols and masks may be seen without conflicting with the glass display cases of smaller objects. So well assembled is the collection that on one of the upper floors an entire wall is given to a single head."[6] That the critic deemed worthy of comment the installation itself, which today seems unremarkable, suggests its innovation at the time. This selective representation of African artistry and decontextualized strategy of display would become the standard approach to the exhibition of African art for the large part of the twentieth century.

The period following World War II witnessed increasing interest on the part of western art museums in collecting and exhibiting African objects as art. With its opening to the public in 1957, the Museum of Primitive Art in New York became the first museum devoted to the collecting and display of objects from Africa, Oceania, and the Americas expressly for their aesthetic properties. The announcement, in 1969, that the Museum of Primitive Art's collection would be given to the Metropolitan Museum of Art, signaled a widespread shift in larger art museum community. Still, when the Metropolitan's Michael C. Rockefeller Memorial Wing opened in 1982, the selection and presentation of the African art collection was again validated through comparison to western traditions of fine art. Susan Vogel, the Metropolitan's first curator of African art, supervised the inaugural installation, which was constrained by the institutional parameters of the museum. "In the context of the Metropolitan, at least in the beginning, it had to be presented as art – pure art, high art, the equal of any in the building. This meant installation techniques used in natural history museums were out. No mannequins, no photo murals, no music."[7]

The exclusive emphasis on the formal properties of African art reached its apogee with the influential, and controversial exhibition, '*Primitivism*' *in Twentieth-Century Art: Affinity of the Tribal and Modern* held at the Museum of Modern Art in 1984. Juxtaposing non-western objects with western modernist masterpieces, the formal relationships between the two were presented as a matter of affinity, positing the presence

of universal aesthetic norms. The exhibition's premise prompted a flood of scholarly criticism that challenged modernism's search for "informing principles" that transcend culture, politics, and history.[8] In particular, critics addressed the cultural assumptions informing the formation and exhibition of institutional collections of non-western art, drawing attention to issues of power and cultural imperialism underlying appropriation.[9]

At the same time, curators began to explore these theoretical concerns through temporary exhibitions addressing the political and aesthetic implications of western collection and display of African art. In 1988, the groundbreaking exhibition *Art/Artifact* was presented at the Center for African Art in New York, curated by Susan Vogel, the institution's founder. Through varying strategies of display, from "curiosity room" to ethnographic museum to art gallery, Vogel demonstrated how the physical setting of an object may determine its identification as art or artifact.[10] A number of subsequent temporary exhibitions also have responded in innovative ways to contemporary debates regarding the way African art is collected and displayed. Many of these have been organized by the Center for African Art, now known as the Museum for African Art, whose leadership role stems from its focus on maintaining an active program of temporary exhibitions rather than developing a permanent collection.[11] As Susan Vogel observes, this allowed the institution to be "freed of the responsibility to teach the basics of African art, and of the obligation to be comprehensive.... It could present single styles, ideas, or collections in depth; it could explore the nuances and byways, the overarching concepts and the untested hypotheses, of African art and history."[12]

By contrast, museum installations of their permanent collections of African art do not have such freedom. Permanent exhibitions of African art are, by definition, drawn from the existing collection of the museum. This collection usually functions as an introduction to a broad subject – the art of an entire continent – to diverse audiences, which may include schoolchildren, college students, and adults with varying levels of knowledge. The installation must serve the needs of the education department while also responding to the concerns of the registrar and exhibition crew. Its design must take into consideration the nature of the space, not only the size of the gallery but also practical matters, including the heating and cooling system as well as security concerns.

Despite these institutional constraints, museums have begun to respond to theoretical issues raised by recent scholarship by rethinking the ways

in which their permanent collections of African art are displayed. The Neuberger Museum is only one of a growing number of museums in the United States and Europe that have either reinstalled or are currently planning reinstallations of their permanent collections of African art.[13] As a curator whose research interests focus on the history of western collecting and display of African art, I am exceedingly conscious of my role as mediator between objects and the public. How do museum collection policies reflect and/or contribute to defining African art? How do strategies of display shape a viewer's experience of art? How can theoretical concerns concerning the collection and display of non-western art be reconciled with museum practice today?

The Neuberger Museum of Art's stated mission includes a mandate to collect, preserve, present, and interpret African art. In practice, fulfilling this mandate is actually more complex than may be initially apparent. The terms themselves are broadly stated and offer no specific solutions. As curators we are faced with a host of open-ended decisions on how to interpret our mission. To begin with, there is the simple question of what exactly constitutes "African art"? Our postmodern age of reflexivity has made us keenly aware that what has come to be known as African art has largely been the product of western imagination. What, then, does a museum collect?

In recent years, there has been a shift in museum collection policy toward a broader geographic representation of African artistic traditions. Although most museum collections of African art remain heavily weighted toward masks and figural sculpture from west and central Africa, the canon is expanding. The restrictive definition of "African art" has, for a long time, excluded large portions of the continent. Historically, the arts of sub-Saharan Africa have been viewed as distinct from those of northern Africa, a division based on racial, cultural, and religious differences. Scholars have challenged this exclusion, arguing that these regions are linked historically by centuries of commercial, religious, and cultural contacts.[14] Though many museums continue to display these traditions separately, particularly with regard to Egyptian art, some are beginning to adopt a "whole continent" approach to Africa. The recent reinstallation of the Brooklyn Museum's African art collection, for example, now includes arts of ancient Nubia and Egypt as well as that of Islamic north Africa. Similarly, the National Museum of African Art in Washington, D.C. has a gallery devoted to the art of ancient Kerma.

The arts of southern and eastern Africa have also been neglected, though for different reasons. In these regions, artistic traditions center more on personal adornment and objects of everyday use, as opposed to the masks and figural sculptures more commonly found in west and central African cultures. As art historical scholarship increasingly challenges the boundaries between art and craft, African objects that appear overtly utilitarian have entered the realm of artistic appreciation. Carved headrests and basketry containers from east Africa, beaded garments and staffs from south Africa are all now routinely seen in western art museums. This inclusiveness of genre has extended to other regions, as ceramic vessels from central Africa are now included in museum collections alongside the more well-known reliquary guardian figures.

The broadening of the boundaries in which African art has been inscribed also contributes toward redressing the marginalization of women's artistic production in art museums. In sub-Saharan Africa, artistic production is traditionally dictated by gender: men typically sculpt wood and work in metal, while women create pots, weave baskets and beautify the body through scarification and body painting. A greater awareness of this disparity in terms of museum representation, where the overwhelming majority of works are made by men, has led curators to make more of an effort to include women's art. Yet although we can collect and display a Tutsi (Rwanda) basket or Chewa (Malawi) ceramic pot, we cannot convey the artistry of body beautification, a form of artistic production highly admired by men and women in African societies, except as represented on figural sculpture or in contextual photographs. Ultimately, the object-centered framework of the western art museum imposes limits on what can be collected.

From a practical standpoint, as well, curators must confront their institutional parameters for making acquisitions. Potential purchases and gifts must be presented for review to a museum's acquisition committee. An institution that defines itself as a "masterpiece" museum, for example, may limit the curator to collecting what has already been canonized, as opposed to what may broaden the canon. The overall focus of the museum may also impact what is and is not accepted. At the Neuberger, a university museum which collects and presents only modern and contemporary western art, in addition to African art, the openness of our committee to new and challenging ideas about artistic expression has allowed an expansiveness in the development of a collection. Thus, our recent purchase of a Yoruba (Nigeria) *egungun* masquerade, composed of

multiple layers of appliqué cloth panels that create a highly textured optical surface, elicited an enthusiastic response rather than puzzlement.

The museum's mission of preservation can also impose limits on what can be represented in an art museum context. The western emphasis on permanence leaves behind whole categories of artistic production that consist of ephemeral or fragile materials. For example, in various Bwa communities in Burkina Faso, men perform masquerades in honor of Do, who embodies the life-giving powers of nature. The masker is disguised in a costume of vines, grasses and leaves, enveloping his entire body. The organic materials, which symbolically evoke the cycle of regeneration, are key to its meaning and use, but ultimately do not permit the costume to be collected by an art museum. As we try to collect African art in a comprehensive manner, such dilemmas point out the difficulties of working within the framework of the western art museum.[15]

Collecting policies also reveal a broadening of what constitutes "traditional" as museums strive to present a portrait of African artistic practices as dynamic and evolving, rather than static and unchanging. Curators are more aware that, as John Picton reminds us, "we still come from a desire, whether overt or covert, to freeze-dry the cultures of sub-Saharan Africa within a safe, authentic, "traditional' context. Yet traditions are not static, and context is not a fixed property, neither in Africa nor elsewhere."[16] One solution is to acquire and display works that subvert accepted notions of "tradition." The Neuberger recently acquired a pair of Zulu earplugs, a form of women's personal decoration that developed in the 1930s. The colorful geometric patterns on the earplugs, derived from designs found in beadwork traditions, are formed from small pieces of imported vinyl asbestos (used for flooring).

An on-going challenge is how to present contemporary art from Africa, a subject made more vexing by the lack of a firm consensus on what exactly constitutes contemporary African art. Contemporary African art may take different forms, from studio canvasses and conceptual works by academically trained artists to urban popular painting to contemporary revivals of "traditional" art practices. The National Museum of African Art has been an innovator in this area, expanding their mandate to expressly include the collection and exhibition of contemporary African art. In most museums, however, curatorial responsibilities regarding the collecting of contemporary African art are not so clearly defined, and several different departments within the same museum may end up participating in the process. At the Metropolitan Museum of Art, for example, recent acquisi-

tions of contemporary African art span three different departments. A contemporary textile from Madagascar was acquired by the Department of the Arts of Africa, Oceania, and the Americas, a ceramic pot by Kenyan artist Magdalene Odundo entered the collection of the Twentieth Century Department, and a studio portrait by Malian artist Seydou Keita is now part of the Photograph Department's collection. All three works were made in Africa during roughly the same time period – 1990s – but have entered the Metropolitan's collection through very different ways.

For some curators, acquiring contemporary African art offers an opportunity to challenge the notion of African art as ahistorical and to demonstrate the vitality of African artistic expression today. At the University of Iowa Museum of Art, curator Victoria Rovine purchased a contemporary ceramic, entitled *Cè Djan (The Tall One)*, made by Malian artist Baba Wagué Diakité in 2000. The acquisition was specifically intended for Iowa's reinstallation of the permanent collection of African art, which opened in September 2001. Diakité's work is displayed next to an older Malian vessel, a terra-cotta bottle from the thirteenth century discovered at an archaeological site near Djenne. Though different in intent and technique, their pairing challenges the ahistorical way African art is presented by representing Africa's long artistic history as well as its contemporary responses.

The challenges and opportunities of a museum's mission to collect and preserve African art are matched and perhaps extended by the complexities inherent in a museum's presentation of African art. Beyond the responsibilities of forming a collection, the curatorial process often involves organizing that collection into a cohesive and coherent display. The installation of a permanent collection of African art involves a number of elements that all require certain decisions to be made. We need to take into account the layout of the galleries and arrangement of the collection, the mounting of the works of art, and the information supplied to visitors in the form of labels, wall texts, photographs, acoustiguides, videotape, and guidebooks. The process of developing an exhibition may be supervised by the curator, but often involves a number of other museum professionals, such as educators, conservators and exhibition designers, working together toward the final project.

In recent years, the most evident shift in museum display of African art is a greater desire to help the viewer understand the object's conditions of production and use. In the past, installations of African objects have been

framed as a necessarily oppositional discourse between the contextual approach of the ethnographic museum and an object-centered, aesthetic approach of the art museum. Such barriers are disintegrating as the discipline of art history itself has become more concerned with contextualization, recognizing that aesthetic perceptions of objects are always filtered through a personal, political and social lens. Still, as James Clifford reminds us, "Ethnographic contextualizations are as problematic as aesthetic ones, as susceptible to purified, ahistorical treatments."[17] How then can museums shape a viewer's encounter with African art in a sensitive and accurate manner?

Though seemingly innocuous, one of the most important decisions made in the display of African art is its arrangement in the gallery space. For the latter half of the twentieth century, the standard approach to museum installations has been a geographic framework that presents African objects as localized, cultural practices. In this way, objects come to signify not individual creation, but whole cultures. Museums "create the illusion of adequate representation of a world by first cutting objects out of specific contexts...and making them 'stand for' abstract wholes – a Bambara [Bamana] mask, for example, becoming an ethnographic metonym for Bambara [Bamana] culture."[18] The view that particular styles correspond to fixed cultural or ethnic borders has, for a long time, been contested by many scholars.[19] More recently, art historians have drawn attention to the fact that such a system neglects works that do not correspond to such categories.[20]

In response, some curators have adopted alternative ways of arranging their collection that question the purported relationship between ethnicity and style. At the University of Iowa Museum of Art, for example, curator Rovine chose to display objects from the collection in thematic groupings. These allowed a variety of approaches to African art, including historical (The Art of Benin), spiritual (Otherworldly Power), stylistic (Yoruba Arts: Diversity of Styles) and formal (Exploring the Form). At the British Museum, the new Sainsbury Galleries have grouped the objects in their collection by material. As explained by the exhibition's organizers, "this is less arbitrary than it might at first seem, as a whole philosophy underlies each different material and technology, and this can be used as a means of shedding light on African history and social life."[21] These broad sections, such as those focusing on wood-carving and metalworking, are crosscut by subsections that address themes like trade/history and male/female.

While these frameworks allow for an in-depth consideration of important topics, they do have certain drawbacks. Western audiences unfamiliar with African art often have a monolithic approach to the art of the African continent and are unaware of its diversity. Placing an object from Mali (in western Africa) next to one from Malawi (in eastern Africa) may provide an interesting comparison, but does the pairing of two works from such diverse regions elide important artistic and cultural differences? An awareness of this potential difficulty led curator Rovine to include a thematic section, entitled "Diversity within Traditions," as well as a large, prominently displayed map in the University of Iowa Art Museum reinstallation. At the Neuberger, my concern that the audience would not have a comprehensive sense of the geography of the African continent led me to strike a balance between the geographic and thematic approach. The gallery is arranged geographically, beginning with the arts of Mali and Burkina Faso and concluding with southern Africa. Within this framework, however, the works are not presented as examples of rigidly defined regional styles, but rather as individual works that demonstrate both the artistic complexities of a society as well as the dynamics of cultural exchange. Furthermore, the objects selected for each section of the African gallery address various broad themes, such as "Masks and Masquerades," "Artists and Patrons," and "Ritual and Performance."

Within the spatial arrangement of a collection, a number of display strategies have been developed that address the multiple ways a museum visitor can learn. A seemingly simple decision such as the mounting of an African object can offer the opportunity to help the viewer understand the object's original context. African art offers a particular challenge because collections of African art are often formed of fragments. Although a wooden mask may seem "whole" to the western viewer, it is only one part of a larger masquerade costume that may include cloth or raffia body-covering and attached decorations, such as anklets, rattles, and animal pelts. Similarly, a small figural work may be part of an assemblage of objects, perhaps meant to be seen as one of many objects in a shrine. Confronted with such "fragments," a curator must decide how to appropriately present the work. For masquerade costumes, one solution is to recreate the body-covering, a practice commonly seen in ethnographic museums in the past and just now beginning to be used in art museums as well. In the African galleries at the Metropolitan Museum of Art, for example, a large, horizontal Banda mask is displayed with a more recently made costume of raffia and printed textiles.

The way an African object is mounted in its museum setting may also respond to the way the object might have been seen in its original setting. Again, at the Metropolitan Museum of Art, a series of cast-brass heads from the former kingdom of Benin (Nigeria) are presented on a low platform. The shift in height of the platform from eye-level, as most works are presented, deliberately evokes the object's original setting on an altar. A nearby photograph depicts a nineteenth-century view of a royal altar in Benin, in which similar heads are displayed, providing another visual strategy that enables the viewer to "read" the work.

Some display techniques do not try to approximate the way an object might have originally been seen but rather encourage other ways of viewing. The recent reinstallation of African art at the University of Iowa Museum of Art includes a large, open storage area that allows the display of many objects of a certain genre, such as masks. The museum visitor can use open storage display to study specific types or simply to gain greater appreciation for a vast range of styles.

In addition to these elements of display, other interpretative strategies mediate a viewer's experience of the object more directly. While in the past African art was identified with only minimal information (culture, date, medium), today museum installations provide descriptive labels, wall text, photos, videotape and other media, such as cd-roms and interactive computer screens. What do these materials contribute to an understanding of the object? How can they be used effectively?

In this age of scholarly reflexivity, even the labeling of an object presents a host of challenges. Curators are often asked to "explain" the object in copy that should be clear, engaging, and concise (75 words or less). We must be both careful with the information we provide and sensitive to the way the information is conveyed. Contextual information on the creation or use of an African object is typically gleaned from field-based scholarship. Scholars are now addressing the historical, social and personal circumstances that inform the creation of such texts. Furthermore, while field-based accounts provide helpful information on a genre, they rarely – if ever – provide data directly related to the actual object on display. At the same time, there is often a disjuncture between the period in which the object was created (most African art in museums dates to the late nineteenth and early twentieth century) and the date of field studies we use to "explain" it (most of which are from the 1970s on). As we create a new narrative that interprets an object for a public audience, curators must examine critically the written sources that inform their texts.

We must be aware not only of the narrative we create by inclusion, but also that which is caused by omission. One of the more difficult issues to resolve may be how to handle information we often lack: the name of the artist. The very idea of art in a western sense is predicated on the notion of the artist as a creative genius creating singular works. In museum installations of African art, the names of artists are often unknown, a legacy of the history of western collecting and the disregard with which these objects were taken from their owners. Addressing this issue, Zoe Strother comments that "stripping off the name was a strategy, like the use of the third-person plural, to transform a particular object from the present time to a generic object of all time and no time."[22] The curator is thus faced with a dilemma: Is it better to refer to an "unknown artist" in the identification label, or does that merely draw attention to our lack of knowledge (and unwittingly suggest the unimportance of the African artist)? If we label the object simply by culture, say "Kongo peoples," does that efface individual artistry in favor of collective creation? Such issues are not easy to resolve in conventional museum practice.

In addition to text, visual materials, such as photographs and video, are increasingly being utilized in museum installations. Although they can be extremely useful in helping a visitor "understand" a work of art by creating a visual context for its use, there are certain problems that arise with their use in the interpretation and display of African art. The groundbreaking research of Christraud Geary has drawn attention to the fact that many ethnographic photographs of ceremonies and rituals are actually staged, posed or reenacted.[23] Curators must be conscious that the circumstances under which a photograph is created may, in fact, be fictitious and be careful in their selection of contextual imagery. Secondly, it is rare to find a photograph that depicts the actual object displayed in the museum. Curators must be sensitive to the fact that the object and photograph may have only a tenuous relationship. Many museum objects, for example, date from the late nineteenth and early twentieth century, but are "explained" through visual images from the late twentieth century. The historical dichotomy, though often neglected in museum display, needs to be addressed.

A greater awareness of the institutional power of the museum and the curatorial role in shaping the way we encounter art raises the possibility of other interpretative strategies. Can African art be meaningful to audiences as a site of departure and investigation rather than an object with a fixed meaning? Encouraging community involvement in museum display offers

an intriguing possibility that has been explored with success in temporary exhibitions. *Wrapped in Pride: Ghanaian Kente and African American Identity,* organized jointly by the UCLA Fowler Museum of Cultural History and the Newark Museum, focused on a single genre of African textile, known as *kente.* The exhibition explored its contemporary production, interpretation and use in Ghana and Togo, as well as its transmission to the United States where it has become an icon of popular culture. The latter aspect of the exhibition was addressed through a collaboration between the museums and local high school students that resulted in an illustration of the ways in which African Americans use *kente* to mark holidays and ceremonies.

Do such strategies of display attract and engage the viewer? As museums in general have grown in popularity in recent years, there is an increasing desire to determine what museum-goers want and which strategies of display are most effective. Some museums have developed innovative ways to test their presentation techniques and interpretative strategies in preparation for reinstallation of the collection. One recent example is the Nelson-Atkins Museum of Art in Kansas City, Missouri, which employed an audience response evaluation to gauge the effectiveness of an exhibition entitled *New Ways of Looking* [24] Created as a prelude to a more extensive reinstallation of the collection, the project was supervised by the museum's Curator of African Art, Elisabeth Cameron, in collaboration with curatorial, education, design, and exhibition staff at the Nelson-Atkins to achieve the final result.

New Ways of Looking presented five cases of African art, each with its own thematic focus and differing strategies of presentation. "Royal Arts" featured three works from the kingdom of Benin, Nigeria, along with background information in the form of labels, a photograph and a map placed at a physical distance from the objects. "Textiles" displayed three African textiles, hung loosely to suggest their use as clothing, with contextual materials placed directly in front of the textiles. This consisted of labels describing their manufacture and photographs depicting people wearing similar textiles as skirts. "Women" featured a cross-cultural exploration of how women are portrayed by presenting three African objects (two masks and a figure), two Mycenaean figures, and one French figure along with interpretative text placed along a rail at the bottom of the case. In "Yoruba Door," the story-telling aspect of a large Yoruba door was emphasized by displaying it alongside a text panel of similar scale that featured questions and answers geared toward 12-year old children.

Finally, "Vessels" included seven African vessels with three labels that provided different kinds of information about the objects, one focusing on the artistic aspects, one on the historical, and one on the functional use.

Viewers responded positively to thematic presentation and preferred an interpretative approach with didactics, rather than simple identification labels. The study found that "overall, the characteristics viewers favored among the different cases are clear presentations of information that give them a context that enriches their understanding of art. Clear presentations include concise, understandable text, labels from which viewers can easily match descriptions to the particular objects, and visuals such as photographs and maps."[25] The information gathered in the audience evaluations informed the new installation of the permanent collection of African art, which opened in April 2001.

In 1940, ethnologist Trevor Thomas observed that:

Installation implies interpretation, for in the extreme sense, display is distortion. As soon as a specimen passes through the door of a museum and is placed on exhibition it enters a foreign environment and embarks on a new function. The curator assumes the role of chaperone to this specimen, introducing a new-comer to a changed sphere and to an unknown circle of acquaintance.[26]

Clearly, the dilemma of displacement and recontextualization facing museums today regarding the exhibition of African art is not new. As curators strive to more accurately and sensitively represent the dynamism of African artistic creation, we are exploring innovative approaches compatible with our mandate to collect, preserve, and present. Is it possible to fully address contemporary theoretical concerns within the institutional framework of the museum? Probably not. We are ultimately focusing on form, and our appreciation of African formal qualities is still filtered through western experience. We can, however, make the viewer more aware of what goes into the creation and use of that form, and provoke the viewer to consider alternate aesthetics that do not rest so rigidly on the visual but are informed by intangibles such as spirituality. And while we explore interpretative strategies that refer to or evoke African philosophies of display and perception, perhaps we can also draw attention to the ways the African object is contextualized within the setting of the western museum, responding to theory by revealing practice.

Notes

1 Susan Vogel, "Always True to the Object, in Our Fashion," in *Exhibiting Cultures: The Poetics and Politics of Museum Display*, ed. Ivan Karp and Steven D. Lavine (Washington and London: Smithsonian Institution Press, 1991) p. 191. In this and other essays, Vogel draws upon her extensive curatorial experience to illustrate, with great clarity and candor, the practical, social, and political implications regarding the display of African art.

2 Annie Coombes, *Reinventing Africa: Museums, Material Culture and Popular Imagination in Late Victorian and Edwardian England* (New Haven and London: Yale University Press, 1994) analyzes the representation of "Africa" in British scientific and popular knowledge from 1890 to 1918; Francis Connelly, *The Sleep of Reason* (Philadelphia: University of Pennsylvania Press, 1995) examines the origins and development of "primitivism" in eighteenth- and nineteenth-century European art and aesthetics. Most recently, Elsbeth Court, "Africa on Display: Exhibiting Art by Africans," *Contemporary Cultures of Display*, ed. Emma Barker (New Haven and London: Yale University Press in association with the Open University) offers a detailed analysis of artists and exhibitions, raising important issues surrounding the display of African art in the late twentieth century.

3 Conversations with colleagues have helped me to shape and clarify my thoughts on this daunting subject, and I am particularly thankful to Elisabeth Cameron, Victoria Rovine, and Bill Siegmann for sharing their insights and experience.

4 Scholarship on the development of private collections of African art in the West include: F. Demé, "L'Approche de l'Art Africain aux Etats Unis d'Amérique," Master's thesis (University of Paris, 1982); Jean-Louis Paudrat, "[The Arrival of Tribal Objects] From Africa," in *"Primitivism" in Twentieth-Century Art: Affinity of the Tribal and Modern* (New York: Museum of Modern Art, 1984); Ezio Bassani and Malcolm McLeod, "African Material in Early Collections," *The Origins of Museums: The Cabinet of Curiosities in Sixteenth- and Seventeenth-Century Europe* (Oxford: Clarendon Press, 1985); Christa Clarke, "John Graham and the Crownishield Collection of African Art," *Winterthur Portfolio* 30/1 (1995): 23–39; and Christa Clarke, "Defining Taste: Albert Barnes and the Promotion of African Art during the 1920s and 1930s," Ph.D. dissertation (University of Maryland, College Park, 1998).

5 James Johnson Sweeney, *African Negro Art 1935* (New York: Arno Press, 1966), p. 21.

6 "Exhibit of Negro Art Shows Influence on Moderns," *The Art Digest* 9 (April 1, 1935): 9.

7 Susan Vogel, "Bringing African Art to the Metropolitan Museum," *African Arts* 15/2 (February 1982): 40.

8 James Clifford, "Histories of the Tribal and the Modern," *Art in America* (April 1985): 164–77, 185.

9 In addition to Clifford 1985 (see note 8), Thomas McEvilley also directly addressed the social and political implications underlying the "Primitivism" exhibition in "Doctor, Lawyer, Indian Chief," *Art Forum* 23 (1984): 54–60. Scholarship that responds more broadly to the issues raised includes: George Stocking, *Objects and Others: Essays on Museums and Material Culture* (Madison: University of Wisconsin Press, 1985); James Clifford, *The Predicament of Culture: Twentieth-Century Ethnography, Literature and Art* (Cambridge, MA: Harvard University Press, 1988); Sally Price, *Primitive Art in Civilized Places* (Chicago: University of Chicago Press, 1989); Marianna Torgovnick, *Gone Primitive* (Chicago: University of Chicago Press, 1990); Ivan Karp and Steven D. Lavine, eds., *Exhibiting Cultures* (Washington, D.C.: Smithsonian Institution Press, 1991) and Susan Hiller, *The Myth of Primitivism* (London: Routledge, 1991).

10 See *ART/Artifact: African Art in Anthropology Collections*, exhibition catalogue (New York: The Center for African Art and Prestel Verlag, 1988).

11 These include *Secrecy: African Art that Conceals and Reveals* (1993), curated by Mary Nooter Roberts, and *Exhibition-ism* (1994), curated by Mary Nooter Roberts and Susan Vogel and in collaboration with Chris Müller. The former explored the relationship between knowledge, power and art, while the latter investigated the process of installation and the debates behind various strategies of display. *African Reflections: Art from Northeastern Zaire* (1991), organized by Enid Schildkrout for the American Museum of Natural History, raised issues of style and patronage in the colonial context of artistic production among the Mangbetu and Zande. Most recently, *Baule: Western Eyes/African Art* (1998), curated by Susan Vogel and originating at the Yale University Art Gallery, acknowledges differences between Baule and western ways of viewing by displaying works according to four degrees of visibility or display as practiced by Baule.

12 Susan Vogel, "Portrait of a Museum in Practice," in *Exhibition-ism: Museums and African Art*, Mary Nooter Robert and Susan Vogel, in collaboration with Chris Müller (New York: The Museum for African Art, 1994). Since the writing of Vogel's article and her later departure, the museum's mission has now changed and now includes a mandate to collect.

13 Several museums have explored new and innovative ways of presenting African art and culture in their reinstallations, including the National Museum of Natural History in Washington, D.C., the Brooklyn Museum of Art in New York, the University of Iowa Museum of Art in Iowa City, the Indianapolis Museum of Art, and the British Museum in London. Additionally, both the Nelson-Atkins Museum of Art in Kansas City and the Newark Museum in New Jersey have recently created prototype installations as precursors to planned reinstallations of their permanent collections.

14 See, for example, Ekpo Eyo, "Putting Northern Africa back into Africa," and Peter Mark, "Historical Contacts and Cultural Interaction," in *Africa: The Art of a Continent* (New York: Guggenheim Museum, 1996).

15 Contemporary western artistic practices can offer similar challenges, as artists such as Andy Goldsworthy create works that are defined by their ephemeral nature.

16 John Picton, "On the Invention of Traditional Art," *Principles of 'Traditional' African Art*, ed. Moyo Okediji (Ibadan, Nigeria: Bard Book, 1992).

17 Clifford, *The Predicament of Culture*, p. 12.

18 James Clifford, drawing upon Susan Stewart's analysis of collecting and display in relationship to western identity formation, in *The Predicament of Culture*, p. 220.

19 See Sidney Kasfir, "One Tribe, One Style? Paradigms in the Historiography of African Art," *History in Africa* 11 (1984): 163–93.

20 See Ikem Stanley Okoye, "Tribe and Art History," *Art Bulletin* 78/4 (1996): 610–15.

21 Christopher Spring, Nigel Barley and Julie Hudson, "The Sainsbury African Galleries at the British Museum," *African Arts* 34/3 (2001): 21, 24.

22 Z. S. Strother, "Gabama a Gingungu and the Secret History of Twentieth-Century Art," *African Arts* 32/1 (Spring 1999): 20.

23 Christraud Geary, "Photographic practice in Africa and its implications for the use of historical photographs as contextual evidence," *Fotografia e Storia dell'Africa*, ed. Alessandro Triulzi (Naples: Istituto Universitario Orientale: 1995), p. 104.

24 *New Ways of Looking* was presented at the Nelson-Atkins from April 27, 2000–February 18, 2001. See Joyce M. Youmans, "African Art at the Nelson-Atkins Museum of Art," *African Arts* 33/4 (2001): 40–61, 94 and also Randi Korn & Associates, Inc., "New Ways of Looking: Formative Testing of the Nelson-Atkins Museum of Art African Art Collection," unpublished manuscript (Kansas City, MO: The Nelson-Atkins Museum of Art, 2000.

25 Randi Korn & Associates, Inc., "New Ways of looking: Questionnaire findings," Unpublished manuscript. Kansas City, MO: The Nelson-Atkins Museum of Art, 2000).

26 Trevor Thomas, "Artists, Africans and Installation," *Parnassus* 12/4 (1940): 24.

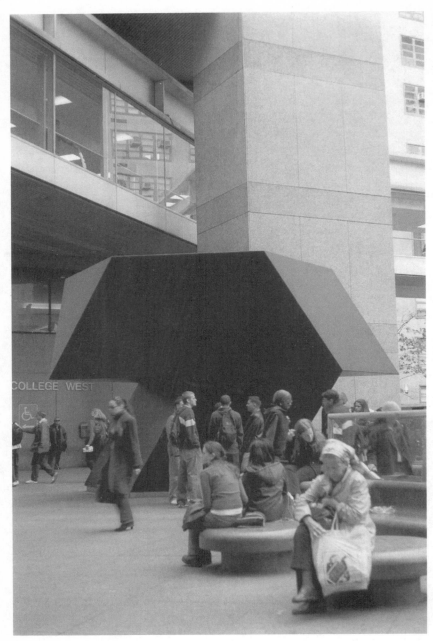

Plate 10 Tony Smith, *Tau*, New York City, 1965. Photograph by Andrew McClellan.

9

Reframing Public Art: Audience Use, Interpretation, and Appreciation

Harriet F. Senie

The public art most people know about is the object of controversy. Richard Serra's *Tilted Arc*, removed from the site in lower Manhattan for which it was commissioned less than 10 years after it was installed, is (in)famous.[1] David Hammons's *How Ya Like Me Now*, a 14 × 16 foot portrait of a white, blond, blue-eyed Jesse Jackson, attacked by a group of young black men even as it was being erected in downtown Washington, D.C., has a similar notoriety in art circles.[2] So does John Ahearn's *Bronx Sculpture Park*, three figures modeled on local residents installed in front of a police station in the South Bronx, removed at the artist's request after some community activists protested its decidedly unheroic subjects.[3] But these 1989 examples are exceptions. Most public art slips into the urban-scape without a ripple, often ignored by its immediate audience or used according to their everyday needs.

I prefer "audience" to public or community; it implicates only those for whom something was created, "an assembly of hearers or spectators . . . the persons reached by a book, radio broadcast, etc.," according to a popular dictionary definition. An audience relates only to the object under scrutiny (or hearing); it does not imply or suggest a larger political or philosophical concept. Arguably there is no public or community for public art, but there certainly is an immediate audience – those who pass it sporadically

or on a daily basis. And there is an indirect audience – those who read about it or see it on television, should it become famous or infamous.

While commissioning agencies now regularly engage community representatives in the development of public art projects, the actual audience for public art remains an imaginary construct. Although there is no shortage of assumptions ("the public will like – or hate – this...") little is known about audience response unless it takes the form of controversy, and even then the largely mediated information it prompts is suspect. I know of no mechanism currently in place and certainly no budget for gathering responses to a work of public art.[4] As an attempt to learn more, I began an ad hoc research project with art history graduate students in seminars on public art at The City College (CCNY) and The Graduate Center (GC) of The City University of New York (CUNY). For the duration of a semester, on different days of the week, at different times, they observed, eavesdropped and engaged the audience for a specific work of public art. Based on a questionnaire developed in class, and then modified to accommodate specific works and circumstances, they inquired about personal reactions to this work and to public art in general.[5] At the end of the semester, students produced a summary paper including audience responses and identifying significant determining factors. The works under scrutiny ranged from traditional heroic or allegorical sculpture to contemporary installations. They included private and public patronage, the well known and the all but unknown, primarily in sites in Manhattan.[6] Far from a "scientific" study, it is, nevertheless, based on direct observation, some works studied repeatedly by different students over a decade.[7] The following observations are based on this field research, my own observations, and pertinent literature.

Site Matters

As William H. Whyte observed in his influential study of urban spaces, some conclusions appear self-evident, but are worth articulating.[8] The general condition of the site directly affects perception of the art. Indeed, as one student observed, this gave site specific a new spin, "It is specifically the site that counts."[9] Consider the memorial dedicated to Ida and Isador Straus, New York philanthropists who died on the Titanic in 1912 (he was one of the developers of Macy's), located in the large traffic island at 106th Street between Broadway and West End Avenue. It consists of a classically

draped bronze female figure representing Memory by Augustus Lukeman and a fountain by Evarts Tracy.[10] In 1993 when this sculpture was observed the pool was empty and the surrounding area was in disrepair. Inhabited by homeless individuals and drug dealers, it was under regular police surveillance. Thus response to the sculpture could primarily be understood as a response to the "park." People sped up as they passed it, even across the street on West End Avenue. Young parents were particularly voluble in their criticism, but park dwellers and users noticed the sculpture. "Public toilet," a homeless man stated as he urinated into the 5-foot space between the niche and the wall supporting the sculpture. Another wished the sculpture "had less clothes on." But outside the park indifference seemed to prevail. A common response was, "I've lived in this area for 10 years and never noticed it until you asked me about it." (Since this man passed the sculpture at least twice a day, the observer calculated that he had not noticed it at least 7,300 times.) Some wished for a real park but felt that was impossible; amazingly enough, it wasn't. On one visit in 1999, after a major renovation, the park was in full use by a range of individuals of different age groups and the fountain served more than one thirsty puppy. Presumably the sculpture is now also appreciated in a different way.

Christopher Park in Sheridan Square (a small triangle surrounded by Christopher, Grove, and West 4th Streets in Greenwich Village), the site of George Segal's *Gay Liberation* (1980, installed 1992),[11] also changed over time, although less radically. In 1993 one student found that it had unofficially been designated by homeless individuals as "their area." Two years later in addition to the homeless, the park was mainly used by gay men and mothers with babies. In 1998 there was still a noticeable homeless contingent, but it no longer seemed forbidding to a young white woman.

Conversely, an attractive site elicits more positive responses, sometimes incorporating the sculpture, sometimes not. Lincoln Center for the Performing Arts, the site of Henry Moore's *Reclining Figure* (1965) and Alexander Calder's *Le Guichet* (1963), prompted enthusiastic comments. One individual called it "the most quiet and beautiful place in the city."

In addition to the site, what people generally do there – sit in a park, wait for a train – directly affects their perception of the art. Consider Maya Lin's *Eclipsed Time* (1994)[12] installed in the ceiling of Penn Station in the concourse at 34th Street between 7th and 8th Avenue. Wanting to reflect on time naturally, Lin created an eclipse by suspending an aluminum disk between a light source and a stationary glass disk. When the upper aluminum disk passes behind the fixed glass disk, a crescent shadow line

is cast on the glass. At midnight the disks are completely aligned; at noon, completely separate. Regular commuters seemed to notice it but never stopped to look. All commented on the problematic, crowded location; who, in the middle of a train station, has the time or inclination to stop and look at the ceiling? Several wondered why the piece wasn't in the waiting room.

People also complained about the placement of *Tau,* Tony Smith's geometric minimal sculpture situated in front of Hunter College on Manhattan's Upper East Side.[13] Most found the sculpture too big for the site: "I prefer to find better ways of interacting with art than bumping into it," or "This big baby is always on top of us." Indeed, the sculpture looms up at you as you ascend from the subway entrance at 68th Street and Lexington Avenue. All would have preferred open space in this decidedly cramped area.

Responses changed as the audience and activities around the site changed. A weekday audience was usually less receptive than a weekend crowd. Weather, too, is an influencing factor. People seemed to like Michael Heizer's *Levitated Mass* situated on the corner of Madison Avenue and 55th Street next to the former IBM building better on the weekends and when the weather was nice.[14] Negative opinions of Smith's sculpture at Hunter were more pronounced during the winter and on rainy days.

Using Public Art

Although some people were initially hesitant to talk about public art, they had no problem using it according to their needs or wants as a photo op, street or playground furniture (depending on age), a place to hang notices, a meeting place or place marker, even a civic logo.

Using public art as a photo op is an acknowledgment of its function as place marker and the perpetual appeal of a souvenir that says "I was here." Whether people like the work or not, or even see it as art, seems to make no difference if it is in the right place and they have a camera. The gilded monument of General Sherman on horseback preceded by a personifica-tion of Victory on foot (1892–1903) by Augustus Saint-Gaudens,[15] located in Grand Army Plaza at Fifth Avenue and 59th Street, across the street from the Plaza Hotel and Central Park, often functions this way.

If a figural work allows for audience inclusion, cameras will be snap-ping. On numerous occasions I have observed people having their picture

taken following *Depression Bread Line* (1991) by George Segal, part of the Franklin Delano Roosevelt memorial in Washington, D.C. At Sheridan Square in New York, many people interacted with the four figures in Segal's *Gay Liberation*, two standing males, and two females seated on one of the many benches in the park. People leaned against them, kissed their faces, put hats on them, and talked to them. Some placed cigarettes either in a male figure's mouth or a female's hand. In Seattle, Richard Beyer's *Waiting for the Interurban*, a group of generalized figures at a bus stop, serves as something of a community mascot, often sporting seasonal attire, attributes of local teams, and balloons for birthdays. Existing in the viewers' space, not elevated on a pedestal, they are part of the environment and the audience treats them anthropomorphically.

Beyond a photo op, public art often functions as street or playground furniture, depending on the age of the user. Weather permitting, Clement Meadmore's *S Curl* (1968)[16] on the Columbia University campus is almost always in use as lawn furniture, something to lean against while sitting on the grass. Some students used it as a musical instrument (it's hollow) and a few young children climbed on it.

People also use public art to post signs, turning it into a kiosk. This was frequently true of Tony Smith's *Tau* at Hunter College before it was cleaned at the time of the Smith retrospective at the Museum of Modern Art in 1998.

Nearly every sculpture in the study at one time or another served as a meeting place, providing an easily recognizable landmark. A mother told her babysitter to meet her at the Meadmore sculpture after class, although she didn't call it that. Residents often used a statue of Abraham Lincoln in Harlem to direct taxi drivers to a specific location. "I'll meet you at the clothespin," is often heard in downtown Philadelphia, a reference to Claes Oldenburg's *Clothespin* (1976); its proximity to City Hall sometimes gives it the appearance of a civic emblem as well. Indeed, a few public sculptures have actually been adopted as civic logos, taking audience use of public art to its (il)logical conclusion. The Chicago Picasso (1967) was initially closely identified with Mayor Richard Daley's Chicago and now the city in general, while the Grand Rapids Calder, actually titled *La Grande Vitesse* (1969), is featured on civic stationary and garbage trucks, while its site has been renamed Calder Plaza.[17] How much of this was a result of audience response or civic public relations is difficult to determine, but general acceptance would indicate that it works for the audience.

Audience use of public art highlights what people find missing in our urban environment: places to sit and/or play, humanizing elements in general, place markers, and a sense of civic identity.

Interpreting Public Art

Whether figurative or abstract, allegorical or representational, public art elicits a range of audience responses impossible to predict. Frequently more imaginative or nuanced than anticipated, they indicate that some of the audience for public art, once prompted, has ideas and opinions, and, consistently, is curious, if not eager, to know more. Often reactions appear to be influenced or determined by gender and age.

A bronze sculpture of a seated Abraham Lincoln and standing boy by Charles Keck[18] cast in 1948 and located in a public housing project at Madison Avenue and 133rd Street in Harlem, prompted varying responses in the 1990s. Seventy-six-year-old Mr. Payne, who had lived in the area over 50 years, remembered when the statue was installed. He had come north during the 'Great Migration' and his reflections revealed "a very different Black America," one of postwar optimism, "that the American Dream might be made more accessible." He saw the statue without bitterness, as part of that historical moment. Younger men were more critical of the piece and young women generally more tolerant or indifferent. A woman who had lived there for over 30 years found it beautiful and remarked that children like to play on it. A man in his early forties also liked it, calling Lincoln "my man." A younger man in his mid-thirties accepted the depiction because "you can't deny what happened in the past." He observed that early in America's history black people had slaves too, and characterized history as a mixed bag, with pros and cons on every side (the observer commented that he often thought that if racial roles had been reversed, black people would not have behaved much differently). While one viewer thought that a statue of someone who is black might have been a better choice, the student would have preferred "Lincoln standing shaking the hand of a standing black man in a Civil War uniform, acknowledging his sacrifice, rather than a poorly-clad young boy with no shoes looking up to this 'great' patriarch."

The immediate audience at the north end of Columbus Park in Brooklyn Heights, near the downtown courts and post office, had no idea of the identity of the statue of Henry Ward Beecher (1951) by J. Q. A. Ward.[19]

They were interested to learn something about the history of the local abolitionist movement and that there was another statue commemorating Beecher at the Plymouth Church of the Pilgrims nearby, where he had been a minister from 1847 to 1887. But even with this information, one woman found the work objectionable, interpreting the sculpture of a standing black woman reaching up to place branches at Beecher's feet as a slave girl engaged in sweeping the floor or shining his shoes. Similarly, one woman misinterpreted a large relief sculpture depicting the Marquis de Lafayette on horseback (1916) by Daniel Chester French,[20] located at the 9th Street entrance to Prospect Park in Brooklyn. Having understood it only in terms of its apparent military reference to a figure on horseback, she changed her view completely when informed of the identity of the rider. Both Brooklyn works have identifying bronze plaques nearby.

Allegorical statues sometimes convey their content in a general way. Thus, Lee Lawrie's mammoth sculpture at Rockefeller Center in front of 630 Fifth Avenue, across the street from St. Patrick's Cathedral, communicates through its size.[21] Most men liked the figure of *Atlas* (erected 1937), while women admired the sphere he carried. Everyone seemed interested in learning more about the sculpture (for example, that the sphere contains the 12 zodiac signs and its axis points to the North Star). Recently a four-year-old boy was overheard asking his mother, "What was he standing on when he held the world on his shoulders?"[22]

Jim Dine's three sculptures of *Venus de Milo* flanking the entrance to the Credit Lyonnais building at 1301 Avenue of the Americas evoked less interest than the pools that form their base.[23] People wanted to know if they actually contained water; children especially liked to make ripples. Two homeless women, recognizing the subject as the Louvre's *Venus de Milo*, admired the sculpture's color and "rough quality." A woman in her 50s liked the work because it was "abstract and modern" and made the building more beautiful, while a man in his 30s objected precisely to this quality; he would have preferred a sculpture that was either "abstract or figural, but not both." Another professional man in his 30s thought the sculptures were more pleasing than many of the buildings on Sixth Avenue. And a young woman who described the sculpture as "grand, marvelous and beautiful in the way it moves," thought it "symbolized people on their way to the Museum of Modern Art" nearby.

Peace Fountain by Gregg Wyatt (1984–5) next to the Church of St. John the Divine in upper Manhattan, a heavily laden symbolic work

surrounded by benches, is both a tourist and neighborhood site.[24] Several residents seemed to hate it – finding it reminiscent of a torture machine used in the Spanish Inquisition, its greenish color somehow related to the military. A homeless man, however, felt protected by it and a local drug dealer thought it made the area "fancy."

Not everyone understood the content of Segal's *Gay Liberation* even though the plaque identifying the subject (and the artist) is on the ground near the seated figures. Heterosexuals were more likely to miss it; they interpreted the sculpture as a statement of friendship. Several mistook one of the seated women for a man. Two gay men disliked the tight looking jeans on the men and the fact that the women were depicted without bras. A lesbian couple differed in their opinion of the sculpture. The younger one, aged 30, liked it because it was the only representation in art of a gay couple she had ever seen; her partner, 46, felt that "it was not a fitting tribute to the gay community. There should be something else in the park to commemorate Stonewall rather than those ragged guys. We are not just about picking each other up." People were curious about Segal's technique. Some interpreted the subject in the context of AIDS, seeing a funereal implication in the white color. The whiteness of the figures seemed to be the single most discussed aesthetic element, generally seen as enforcing a theme of "alienation and isolation."

When viewers are unable to identify the subject matter of a work of art precisely, they often follow a "looks like" comparison and nickname it accordingly. Riders at the subway station at 14th Street and 8th Avenue, the site of Tom Otterness's *Life Underground* (2001),[25] referred to the bronze figures variously as "Doughboys, Ur, gremlins, gizmos, or Lilliputians." Unable to recognize two figures in William King's *Companions* (1985),[26] people seated in front of a residential hi-rise on Second Avenue at 49th Street suggested some kind of animal, most often an elephant. The only one to identify the subject matter correctly was a youngster no more than ten years old. Interestingly, the sculpture was named by children from nearby Public School 59.[27]

Even if people appear unresponsive to a work, it doesn't necessarily mean that they are not interacting with it on some level. Henry Moore's *Reclining Figure* (1965)[28] at Lincoln Center seemed to elicit an unconscious visceral response. One observer who spoke to some 100 people noticed a few individuals who insisted that the sculpture did nothing for them but went out of their way to sit as close to it as possible. In a similar

vein, many people sitting on the surrounding benches often ended up unintentionally imitating the pose of the reclining figure while lounging in the sun.

On the whole, abstract works faired less well with their audience than their figurative counterparts.[29] At Columbia University people complained that they didn't understand Meadmore's abstract *S-Curl* or know what it was supposed to be. People referred to the sculpture as the "big, black blob," or "horrible black squiggle." No one seemed pleased with it. Students felt there should be something that related to the adjacent building (the business school); perhaps a memorial to someone or something. A cashier from the school's cafeteria suggested "a large plaque of the *Wall Street Journal*."

However, a different abstract work, one that was movable, found an enthusiastic audience. Bernard (Tony) Rosenthal's *Alamo* (1967),[30] at Astor Place adjacent to Cooper Union, was part of NYC's first major public art exhibition. People are often seen spinning "the cube" (as it is known), sitting on the base, and using it for graffiti. "People don't ask you (when you're sitting at the base of the cube) if they can move it," one student observed, "they just start pushing." Two homeless men, David and Jim, selling books and pornographic magazines nearby, had been observing the sculpture for quite some time. "Once there was a fire in the cube and Jim put it out. It was late at night. Jim pushes the cube for exercise every day, look how strong he is! I love it and I have for thirty years. I remember when they installed it." An African-American man in his thirties, encouraged his nephew to "PUSH IT, PUSH IT, PUSH IT!" He recalled, "I remember coming to the cube with my three brothers. We would each take a corner of the cube and turn it 360 degrees each way before going to play in Washington Square Park. It was like a ritual." Some men thought the sculpture was about "abstract art (not about anything…that it makes a statement by the artist (attention-getting)," while women thought that "it looked like a puzzle, balance and the threat of something dark, crushing you; permanence and the legend of Sisyphus; also the contradiction of something permanent yet you are able to move it." Almost everyone liked the work in that space and thought they would miss the piece if it were gone. Skateboarders used it as a backdrop. While the audience appreciated the sculpture as "a fixture, a daily presence in their lives," one student remarked that she liked "its ability to maintain its dignity under less than dignified circumstances."

Appreciation

Interactivity of any kind seems to prompt a positive audience response. All those interviewed approved of Michelle Green's *Rail Rider's Throne* (1990),[31] a tall chair, at the 116th Street station of the IRT 1 and 9 trains (the Columbia University stop). It was often used, although no one could recall any information about it or the artist (even those who had just read the accompanying plaque). Everyone interviewed said they would miss it if it were gone.

Audience response to George Rhoads' *42nd Street Ballroom* (1983)[32] in the Port Authority Bus Terminal near the 42nd Street entrance between 8th and 9th Avenues was directly dependent on the movement of its colorful components and the resulting emanating sounds. When the sculpture is in working order, it attracts a good deal of attention. At other times it might as well be invisible. While women might glance at it, men stopped and looked. A common sight was a man looking at the piece while a woman stood next to him with her back to the work. Women paid more attention when they were with children who wanted to stop and watch it.[33]

Men also seemed to be the primary audience for Christopher Janney's *Reach New York* (1996)[34] at the 34th Street Herald Square N/R subway platform. Passing your hand in front of the green metal bar about 7 feet above the ground activates a computer producing a wide range of sounds, from melodic instruments to simulated environmental noises. One woman dismissed the sound sculpture as "just a big toy" while a man defended it as "interactive," explaining that "you can create a variety of sounds by fooling around with it." It also provided a conversation starter since the two were strangers. The majority of subway riders ignored the work but those who responded seemed to enjoy it. Most, however, seemed to feel it was not art "because it is not visual, or [doesn't] . . . have artistic designs, or . . . any underlying message." The observer believed that the fact that it "is extremely undemanding and unimposing . . . contributes to the perception of its 'non-art' status." Three transit employees who worked in the station felt "that the work improves the environment inside the station and adds liveliness to the platform."

Another observer prompted a range of interesting interpretations among the 50 people she questioned. Nine said that it was for "entertainment/fun/playing around," seven didn't know or had no clue, four thought

it was for making music, three stated that it was providing music for people, and two people thought it was about noises in the forest. Others felt that the artwork was intended "to create serenity in the middle of madness; that it was about Chinese music; that it gave people an opportunity to express themselves through light and sound; that it was about birds and pianos; imagining; relieving the stress of the everyday; that it was soothing; nice; interesting; about sound, the sounds of nature, the urban environment, public interaction, relaxing, musical novelty, creating harmony through individual creation, Einstein's theory of chaos, combining nature with city life; to encourage people to move around; beauty; to raise people's spirits, make them smile, pass the time, or relieve the sadness of the subway." And there was one man in his thirties who admitted that he had no idea that this was a public work of art. He had used this subway for years and had always assumed that "it was a device that was put up by the MTA to scare away any birds that lost their way into the platform space." As the observer concluded, "there are some responses that you never could have anticipated in a million years."

The "is it art" question prompted by Janney's sound piece was also raised by the audience at Martha Schwartz's redesign of Federal Plaza[35] in lower Manhattan where Richard Serra's *Tilted Arc* once stood. Although the bright green benches arranged in serpentine patterns were partially used, weather permitting, no one considered it art or in any way understood Schwartz's intended art references (the benches were not seen as references to hedges, nor was the overall design perceived as "a criticism of Frederick Law Olmstead and the naturalistic look"). The observer concluded that Schwartz's formal language and intentions were understandable only to landscape architects, and she succeeded only in "providing a colorful outdoor cafeteria."

Nearly everyone enjoyed and seemed to understand Tom Otterness's *The Real World* (1992)[36] in Hudson River Park just north of Battery Park City in lower Manhattan (near Wall Street), an array of miniature bronze figures and animals chasing each other around pursuing coins. A 50–year-old Chicano man observed that it has "many statements not just one message. It is a criticism of capitalism and machismo." The audience varied with the time of day and week, with heaviest crowds on the weekends. Many were repeat visitors. Everyone talked about and interacted with the sculptures. Children played on them constantly, inventing new roles for the figures. A group of young girls aged 8–10 counted all the penises on the male figures. A couple had a champagne and candle light

dinner on a picnic table in the company of some of the sculptures. One student observer complained that it was impossible to elicit a negative response to this work even if the viewer was led.

Conclusions

For the most part, public art is invisible to its immediate audience as art. They seem simply, as one student put it, "to ingest public works as part of the larger cityscape in which they move. However, when encouraged to take the time to think about [it], many had insightful things to say and went on at great length offering... positive or negative opinions, all the while apologizing for not being arts professionals."

Consistently omitted from public education, generally ignored by the media except as the object of controversy, theft, or the expenditure of large sums of money, art is rarely understood as such. If people get information about art only from television, they see a different art world. A significant study of art and artists on network news by sociologist John Ryan and curator Deborah A. Sim confirms a pattern.[37] Of the art features aired on the three major networks from January 1976 to August 1985, "only 14 (28 %) dealt with art or artists that could even remotely be considered as representative of the main currents, past or present, of the art world." The art depicted on television consisted of "baglady art, art made with the exhaust of jet engines, sports art, space shuttle art, freeway art and a sculpture made by crashing a plane into the ground." Always aired in the last ten minutes of the program after the serious news was over, art was the subject of "cute, poignant, or humorous stories."

Nevertheless, audiences for public art, for the most part, seemed willing, even eager to engage it. Once asked, people wanted to know more, specifically what works meant and how they were made. Even though Maya Lin's time piece in Penn Station was subtle, all but two of the individuals queried knew that it was some kind of clock. Several people thought it was some kind of sundial. Only the policeman assigned to this area and one middle-aged white male commuter understood how the piece worked. All, however, would have liked more information and more extensive, more visible wall text. Except for two who had heard of Maya Lin, all assumed the artist was male. Upon learning that the artist was an Asian-American woman in her thirties, a Hispanic woman wanted

to know if there were any books at the public library about her. She wanted to know more.

Interestingly nearly everyone asked approved of spending taxpayers' money for art, except the audience outside Columbia University's business school (the site of Meadmore's abstract sculpture). Among the most frequently supportive and often informed audience were homeless individuals; after all they, like museum guards, live with the art. Age and gender were often determining factors in audience response. Children were often the most perceptive audience. As Michael Brenson commented (about Tom Otterness's *Real World*), "If you make sculpture that speaks directly to children, boundaries between audiences, even between classes, do not seem so insurmountable."[38]

Certainly, the audience for public art, although initially shy in entering a discussion about art, does not hesitate to use the work that exists in their spaces. Far from being perceived as an imposition of power, public art is adopted or adapted according to audience activities and inclinations. Functioning variously as photo op, street furniture, playground, kiosk, or meeting place; understood in terms of the already familiar or likened to known references from visual culture, public art is reframed by its immediate audience to fit the parameters of everyday life. Although this audience may not be the one envisioned by artists and public art administrators, it is a pro-active, potentially responsive, but thus largely untapped, audience. Left to their own devices, however, the only frame that may consistently be missing from their perception is the art frame that guides public art's creators and commissioners.

Notes

An earlier version of this subject, "Field Observations: Public Art and Audience Response" was presented at O-oh, Aah...oh! Art Audience Response, 1999 Arts Now Conference,SUNY, New Paltz, organized by Patricia Phillips. See also, Harriet F. Senie, "Baboons, Pet Rocks, and Bomb Threats: Public Art and Public Perception," in Harriet F. Senie and Sally Webster, eds., *Critical Issues in Public Art* (Washington, D.C.: Smithsonian Institution Press, 1998), pp. 237–46.

1 For an analysis of this controversy see Harriet F. Senie, *The Tilted Arc Controversy: Dangerous Precedent?* (Minneapolis: University of Minnesota Press, 2001), especially the chapter on public response.

2 Hammons's piece was part of a larger exhibiton, *The Blues Esthetic: Black Culture and Modernism*, organized by the Washington Project for the Arts known as the WPA, an arts organization recognized for its challenging exhibitions. (It was the WPA that displayed the exhibition of photographs by Robert Mapplethorpe that had been censored by the Corcoran Gallery and, together with an exhibition of photographs by Andreas Serrano, prompted major attacks and near defunding of the National Endowment for the Arts (NEA) in 1989). After the attack on the Hammons piece, the WPA followed the artist's request that the piece be displayed "as is" in the gallery. A few weeks later they received an emotional phone call of thanks for exhibiting what an albino black man saw as the first image of someone like himself that he had ever seen.

3 For an excellent discussion of this controversy see Jane Kramer, *Whose Art Is It?* (Durham and London: Duke University Press, 1994).

4 Catherine Hannah Behrend (deputy director, Percent for Art Program, City of New York Department of Cultural Affairs) chaired a discussion group "Project Evaluation for the Public Art Network Pre-conference program, 'Compel and Provoke,' on July 26, 2001. She distributed four examples of public art evaluation forms. The Colorado Council on the Arts' Art in Public Places program evaluation forms included an agency evaluation of the "artist project." An additional form addressed the client's evaluation. Neither queried audience response. The Maine Art Commission survey asks "What has been the community's response to the work?" but does not specify how this might be determined. The following question asks: "Has the artwork been used for any educational programs, art lessons, or curriculum inclusion?" and "Has the project been covered in the local Press?" Philadelphia-based independent curator Julie Courtney included an audience survey in her temporary exhibition, *Points of Departure: Art on the Line* (1988–2001). For a discussion of received responses, see Harriet F. Senie, "Public Art in Transit(ion)," in the forthcoming exhibition catalogue.

5 Each class develops its own questionnaire and uses it as a starting point, allowing respondents to raise other issues as well as ask questions. The following list was used by students at the CUNY Graduate Center in the spring 2001 seminar:

> How often do you come to this place/park?
> Have you noticed this work before?
> Have you ever stopped to look at it?
> What do you think this work is about?
> Why do you think this work was placed here?
> Do you like this work; does it add to your experience of this place/park?
> Would you miss this work if it were removed?
> Do you think that public money should be used for work like this; should there be more work like this around the city?

6 General information on nearly all the sculptures discussed may be found in Margot Gayle and Michele Cohen, *Manhattan's Outdoor Sculpture* (New York: Prentice Hall Press, 1988).

7 Some aspects of this material were presented in my paper "Field Observations: Public Art and Audience Response."

8 See William H. Whyte, *The Social Life of Small Urban Spaces* (New York: Project for Public Spaces, 1980).

9 Carina Evangelista (CCNY, 1993).

10 Carina Evangelista (CCNY, 1993).

11 Julie Moffat (CCNY, 1993); Gen Watanabe (CCNY, 1995); Jen Hochhauser (GC, 1998). For a detailed study of the problematic history of this sculpture, see Joseph Disponzio, "George Segal's Sculpture on a Theme of Gay Liberation and the Sexual-Political Equivocation of Public Consciousness," in Senie and Webster, eds. *Critical Issues in Public Art*, pp. 199–214.

12 Elizabeth Dunbar (City, 1995); Terry Randall (GC, 2001).

13 In a study of 41 public art projects prepared for the Princeton University Center For Arts and Cultural Policy Studies, Steven J. Tepper notes that "abstract art provoked more controversy than representational art" ("Unfamiliar Objects in Familiar Spaces: The Public Response to Art-in-Architecture," August 1, 2000), 13.

14 Lise Kjaer (GC, 1998).

15 Alyssa Weiss (CCNY, 1993).

16 Taryn N. Matusik (CCNY, 1993).

17 See Harriet. F. Senie, *Contemporary Public Sculpture: Tradition, Transformation, and Controversy* (New York: Oxford University Press, 1992), ch. 3.

18 Edric Debos (CCNY, 1993). A resident of the neighborhood, Debos observed, "There is a certain protocol that is called for when one operates in an environment such as this. For instance, I would approach people slowly and make sure that both of my hands were visible as I spoke loudly from a distance of about eight feet away. Once it was clear that I was talking about the sculpture and that I seemed normal enough, people would open up a bit."

19 James Romaine (GC, 2001).

20 Iris Klein (GC, 2001).

21 Huey-Fen Chu (CCNY, 1993).

22 See Enid Nemy, "Metropolitan Diary," *New York Times*, August 20, 2001, B2, letter from Nancy Rudolph.

23 Kelly T. Keating (GC, 1994).

24 Hitomi Iwasaki (CCNY,1993).

25 Elisabeth Tiso (GC, 2001).

26 John Angeline (GC, 1994).

27 Gayle and Cohen, *Guide to Manhattan's Outdoor Sculpture*, p.132.

28 Hsiao-nin Tu (CCNY, 1993); Sheila Gerami (CCNY, 2000); Elizabeth M. Book (GC, 1994). A more complete discussion of these findings are included in Harriet F. Senie, "Implicit Intimacy: The Persistent Appeal of Henry Moore's Public Art," in Dorothy Kosinski, *Henry Moore: Sculpting the 20th Century* (Dallas Museum of Art, 2001; distributed by Yale University Press), 277–85.

29 Alyssa Weiss (CCNY, 1993); Jose Castano (CCNY, 1995).

30 Ellen Rauch (CCNY, 1995); Yael Reinharz (GC, 2001).

31 Taryn Matusik (CCNY, 1993).

32 Wendi Furman (GC, 1998).

33 I did an informal update of Furman's observations since I often passed this sculpture. Until the fall of 1999, my observations supported hers 100 percent. Then I began to see a few women, separately or in pairs, stopping to gaze at the work with the same apparent interest as the men. I have no explanation for this.

34 Poyin Auyeung (GC, 1998); Emily Rekow (GC, 2001).

35 Jeanne Kolva's (GC, 1998).

36 Amy Young (CCNY, 1995); Michel Caratala (GC, 1994).

37 John Ryan and Deborah Sim, "When Art Becomes News: The Portrayal of Art and Artists On Network Television News, *Social Forces*, March 1990, pp. 869–89.

38 Michael Brenson, "The Sculpture Object," *Sculpture*, November 1992, p. 33.

Bibliography

Adam, T. R., *The Civic Value of Museums*, New York: American Association for Adult Education, 1937.

Adorno, Theodor, "Valéry, Proust, Museums," in *Prisms*, trans. Samuel and Sherry Weber, London: Spearman, 1967.

Altshuler, Bruce, *The Avant-Garde in Exhibition: New Art in the 20th Century*, New York: Harry N. Abrams: 1994.

Arnold, Matthew, *Culture and Anarchy*, Samuel Lipton, ed., New Haven and London: Yale University Press, 1994.

Barnett, Henrietta O., "Pictures for the People," in *Practicable Socialism*, 2nd edn., London: Longman, 1894.

Baudrillard, Jean, "The Beaubourg-effect: Implosion and deterrence," *October*, 20 (1982).

Bennett, Tony, *The Birth of the Museum*, London and New York: Routledge, 1995.

Berger, John, *Ways of Seeing*, London: BBC and Penguin, 1972.

Borzello, Frances, *Civilizing Caliban: The Misuse of Art, 1875–1980*, London & New York: Routledge, 1987.

Bourdieu, Pierre and Alain Darbel, *The Love of Art: European Art Museums and their Public*, trans. C. Beattie and N. Merriman, Cambridge: Polity Press, 1991.

Bourdieu, Pierre, *Distinction: A Social Critique of the Judgment of Taste*, trans. R. Nice, Cambridge, MA: Harvard University Press, 1984.

Burt, Nathaniel, *Palaces for the People: A Social History of the American Art Museum*, Boston: Little, Brown & Co., 1977.

Burton, Anthony, *Vision & Accident: The Story of the Victoria & Albert Museum*, London: Victoria & Albert Museum, 1999.

Coles, Robert, "The Art Museum and the Pressures of Society," in Sherman Lee, ed., *On Understanding Art Museums*, Englewood Cliffs, NJ: Prentice-Hall, 1975.

Conforti, Michael, "Hoving's Legacy Reconsidered," *Art in America*, June 1986.

Coombes, Annie, "Museums and the Formation of National and Cultural Identities," *Oxford Art Journal,* 11, 1988.

Corrin, Lisa, ed., *Mining the Museum: An Installation by Fred Wilson,* New York: The New Press, 1994.

Crimp, Douglas, *On the Museum's Ruins,* Cambridge, MA: MIT Press, 1993.

Crow, Thomas, "The Birth and Death of the Viewer: On the Public Function of Art," in Hal Foster, ed., *Discussions in Contemporary Culture* 1, Seattle: Bay Press, 1987 .

Cuno, James, "In the Crossfire of the Culture Wars: The Art Museum in Crisis," Occasional Papers, Harvard University Art Museums, 3, 1995.

Danto, Arthur, "Postmodern Art and Concrete Selves: The Model of the Jewish Museum," in *Philosophizing Art: Selected Essays,* Berkeley and London: University of California Press, 1999.

Dana, John Cotton, *The New Museum: Selected Writings of John Cotton Dana,* The Newark Museum and the American Association of Museums, 1999.

Different Voices: A Social, Cultural, and Historical Framework for Change in the American Art Museum, New York: American Association of Art Museum, 1992.

DiMaggio, Paul, and P. Useem and P. Brown, *Audience Studies of the Performing Arts and Museums: A Critical Review,* National Endowment for the Arts, Research Division, Report no. 9, New York: Publishing Center for Cultural Resources, 1979.

DiMaggio, Paul, "Cultural Entrepreneurship in Nineteenth-Century Boston," *Media, Culture, and Society,* 4, 1982.

Duncan, Carol, *Civilizing Rituals: Inside Public Art Museums,* London and New York: Routledge, 1995.

Duncan, Sally Anne, *Paul J. Sachs and the Institutionalization of Museum Culture Between the World Wars,* Ph.D. Dissertation, Tufts University, 2001.

"Excellence and Equity: Education and the Public Dimension of Museums," *Journal of Museum Education* 16, Fall 1991.

Falk, John H., "Visitors: Who Does, Who Doesn't and Why," *Museum News,* March–April 1998.

Falk, John H. and Lynn D. Dierking, *The Museum Experience,* Washington, D.C.: Whalesback Books, 1992.

Fraser, Andrea, "Museum Highlights: A gallery talk," *October,* 57, 1991.

Fyfe, G. and M. Ross, "Decoding the Visitor's Gaze: Rethinking museum visiting," in S. Macdonald and G. Fyfe, eds., *Theorizing Museums,* Oxford: Blackwell, 1996.

Georgel, Chantal, ed., *La Jeunesse des Musées,* Paris: Musée d'Orsay, 1994.

Gilman, Benjamin Ives, *Museum Ideals of Purpose and Method,* Boston: Museum of Fine Arts, 1918.

Glueck, Grace, "The Ivory Tower Versus the Discotheque," *Art in America,* May–June 1971.

Gopnik, Adam, "The Death of an Audience," *The New Yorker,* October 5, 1992 .

Graña, César, "The Private Lives of Public Museums: Can art be democratic?," in *Fact and Symbol: Essays in the Sociology of Art and Literature,* Oxford and New York: Oxford University Press, 1971.

Greenberg, Reesa, Bruce W. Ferguson and Sand Nairne, *Thinking about Exhibitions*, London and New York: Routledge, 1996.

Greenwood, Thomas, *Museums and Art Galleries*, London: Simpkin, Marshall, & Co., 1888.

Haacke, Hans, "Museums, Managers of Consciousness," *Art in America*, February 1984.

Haacke, Hans, *Unfinished Business*, Cambridge, MA: MIT Press, 1986.

Harris, Neil, *Cultural Excursions: Marketing Appetites and Cultural Tastes in Modern America*, Chicago and London: University of Chicago Press, 1990.

Harris, Neil, "The Divided House of the American Art Museum," *Daedalus*, 128, Summer 1999.

Harris, Neil, "The Gilded Age Revisited: Boston and the Museum Movement," *American Quarterly*, 14, Winter 1962.

Hein, George, *Learning in the Museum*, London and New York: Routledge, 1998.

Heinich, Nathalie, "The Pompidou Centre and its Public: The limits of a utopian site," in Robert Lumley, ed., *The Museum Time-Machine: Putting Cultures on Display*, London and New York: Routledge, 1988.

Holt, Elizabeth Gilmore, *The Triumph of Art for the Public, 1785–1848: The Emerging Role of Exhibitions and Critics*, Princeton: Princeton University Press, 1979.

Hooper-Greenhill, Eilean, ed., *Cultural Diversity: Developing Museum Audiences in Britain*, London: Leicester University Press, 1997.

Hooper-Greenhill, Eilean, *Museums and the Shaping of Knowledge*, London and New York: Routledge, 1992.

Hoving, Thomas P.F., "Branch Out!," *Museum News*, 47, September 1968.

Hutchinson, Charles L. "The Democracy of Art," *American Magazine of Art*, 7, August 1916.

Impey, Oliver, and Arthur MacGregor, *The Origins of Museums: The Cabinet of Curiosities in Sixteenth- and Seventeenth-Century Europe*, Oxford: Clarendon Press, 1985.

Jevons, William Stanley, "The Use and Abuse of Museums," in *Methods of Social Reform*, London: Macmillan, 1883.

Karp, Ivan, and Steven D. Lavine, *Exhibiting Cultures: The Poetics and Politics of Museum Display*, Washington, D.C.: Smithsonian Press, 1988.

Karp, Ivan, Christine M. Kreamer and Steven D. Lavine, *Museums and Communities: The Politics of Public Culture*, Washington, D.C.: Smithsonian Press, 1992.

Kinard, John, "To Meet the Needs of Today's Audience," *Museum News*, 50, May 1972

Klonk, Charlotte, "Charles Eastlake and the National Gallery of London," *Art Bulletin*, LXXXII, June 2000.

Kramer, Jane, *Whose Art Is It?*, Durham and London: Duke University Press, 1994.

Krauss, Rosalind, "The cultural logic of the late capitalist museum," *October*, 54, 1990.

Lee, Sherman, "The Art Museum in Today's Society," *Dayton Art Institute Bulletin*, 27, March 1969.

Levy, Florence, "The Service of the Museum of Art to the Community," *American Magazine of Art*, 15, November 1924.

Low, Theodore L., *The Educational Philosophy and Practice of Art Museums in the United States*, New York: Columbia University Press, 1948.

Low, Theodore L., *The Museum as Social Instrument*, New York: Metropolitan Museum of Art, 1942.

Luke, Timothy W. *Shows of Force: Power, Politics, and Ideology in Art Exhibitions*, Durham and London: Duke University Press, 1993.

Maclagen, Eric, "Museums and the Public," *Museums Journal*, 36, August 1936.

Malraux, André, *Museum Without Walls*, trans. S. Gilbert and F. Price, London: Secker & Warburg, 1967.

Mayer, Alfred, "Educational Efficiency of our Museums," *North American Review*, 177, July–December 1903.

McClellan, Andrew, *Inventing the Louvre: Art, Politics, and the Origins of the Modern Museum in Eighteenth-Century Paris*, New York and Cambridge: Cambridge University Press, 1994.

McShine, Kynaston, *The Museum as Muse: Artists Reflect*, New York: Museum of Modern Art, 1999.

McTavish, L., "Shopping in the Museum? Consumer spaces and the redefinition of the Louvre," *Cultural Studies*, 12, 1998.

Melton, Arthur, *Problems of Installation in Museums of Art*, Washington, D.C.: American Association of Museums, 1935.

Merriman, Nick, "Museum Visiting as a Cultural Phenomenon," in Peter Vergo, ed., *The New Museology*, London: Reaktion Books, 1989.

Montebello, Philippe de, "Musings on Museums," *CAA News*, March–April 1997.

Moore, J., "Poverty and Access to the Arts: Inequalities in Arts Attendance," *Cultural Trends*, 31, 1998.

Morris, Rudolph, "Leisure Time and the Museum," *Museum News*, 41, December 1962.

The Museum Educates, Toledo: Toledo Museum of Art, 1935.

Museums: Their New Audience, Washington, D.C.: American Association of Museums, 1972.

Museums USA, Washington, D.C.: National Endowment for the Arts, 1974.

Perl, Jed, "Welcome to the Funhouse," *The New Republic*, June 19, 2000.

Pommier, Edouard, ed., *Les musées en Europe à la veille de l'ouverture du Louvre*, Paris: Klincksieck, 1995.

Pointon, Marcia, ed., *Art Apart: Art Institutions and Ideology Across England and North America*, Manchester and New York: Manchester University Press, 1994.

Prior, Nick, *Museums and Modernity: Art Galleries and the Making of Modern Culture*, Oxford: Berg, 2002.

Putnam, James, *Art and Artifact: The Museum as Medium*, London: Thames and Hudson, 2001.

Rectanus, Mark W., *Culture Incorporated: Museums, Artists, and Corporate Sponsorship*, Minneapolis and London: University of Minnesota Press, 2002.

Rensselaer, Mariana van, "The Art Museum and the Public," *North American Review*, 205, January 1917.

Ripley, S. Dillon, *The Sacred Grove. Essays on Museums*, Washington, D.C.: Smithsonian Press, 1969.

Robert, Mary Nooter, et al., *Exhibition-ism: Museums and African Art*, New York: The Museum for African Art, 1994.

Roberts, Lisa, *From Knowledge to Narrative: Educators and the Changing Museum*, Washington, D.C.: Smithsonian Press, 1997.

Robertson, Bryan, "The Museum and the Democratic Fallacy," in Brian O'Doherty, ed., *Museums in Crisis*, New York: Braziller, 1972.

Rosler, Martha, "Lookers, Buyers, Dealers, and Makers: Thoughts on audience," in *Art After Modernism: Rethinking Representation*, New York: The New Museum of Contemporary Art, 1984.

Sandell, Richard, ed., *Museums, Society, Inequality*, London and New York: Routledge, 2002.

Schneider, Beth B., *A Place for All People*, Houston: Museum of Fine Arts, 1998.

Senie, Harriet S., *Contemporary Public Sculpture: Tradition, Transformation, and Controversy*, Oxford and New York: Oxford University Press, 1992.

Senie, Harriet and Sally Webster eds., *Critical Issues in Public Art*, New York: HarperCollins, 1992.

Senie, Harriet S., *The Tilted Arc Controversy: Dangerous Precedent?*, Minneapolis and London: University of Minnesota Press, 2001.

Sherman, Daniel J., *Worthy Monuments: Art Museums and the Politics of Culture in Nineteenth-Century France*, Cambridge, MA and London: Harvard University Press, 1989.

Sherman, Daniel J. and Irit Rogoff, eds., *Museum Culture: Histories, Discourses, Spectacles*, Minneapolis and London: University of Minnesota Press, 1994.

Smith, Roberta, "Memo to Art Museums: Don't give up on art," *New York Times*, December 3, 2000.

Starr, Mark, "Museums and the Labor Unions," *Museum News*, 26, January 1, 1949.

Stonge, Carmen, "Making Private Collections Public: Gustav Friedrich Waagen and the Royal Museum in Berlin," *Journal of the History of Collections*, 10, 1998.

Sweeney, James Johnson, "The Artist and the Museum in Mass Society," in N. Jacobs, ed., *Culture for the Millions? Mass Media in Modern Society*, Princeton: Van Nostrand, 1961.

Taylor Francis Henry, *Babel's Tower: The Dilemma of the Modern Museum*, New York: Columbia University Press, 1945.

Thelan, David, "Learning Community: Lessons in Co-Creating the Civic Museum," *Museum News*, May–June 2001.

Thomas, Trevor, "Artists, Africans and Installations," *Parnassus*, 12, 1940.

Tomkins, Calvin, *Merchants and Masterpieces: The History of the Metropolitan Museum of Art*, New York: E.P. Dutton & Co., 1970.

Vogel, Susan, *Baule: Western Eyes/African Art*, New Haven and London: Yale University Press, 1998.

Waagen, Gustav, "Thoughts on the New Building to be Erected for the National Gallery of England," *Art Journal*, V, May 1, 1853.

Walker, John, *Self-Portrait with Donors. Confessions of an Art Collector,* Boston: Little, Brown & Co., 1974.

Wallach, Alan "Class Rites in the Age of the Blockbuster," *Harvard Design Magazine,* 11, Summer 2000.

Wallach, Alan, *Exhibiting Contradiction. Essays on the Art Museum in the United States,* Amherst: University of Massachusetts Press, 1998.

Wallach, Alan, "The Norman Rockwell Museum and the Representation of Social Conflict," in Patricia Johnston, ed., *Between High and Low: Representing Social Conflict in American Visual Culture,* Berkeley and London: University of California Press, forthcoming.

Wallinger, Mark and Mary Warnock, eds., *Art for All? Their Policies and Our Culture,* London: Peer, 2000.

Waterfield, Giles, *Palaces of Art: Art Galleries in Britain,* London: Dulwich Picture Gallery, 1991.

Weil, Stephen E., "From Being *about* Something to be Being *for* Somebody: The Ongoing Transformation of the American Museum," *Daedalus,* 128, Summer 1999.

Whitehill, Walter Muir, *Museum of Fine Arts, Boston, A Centennial History,* 2 vols. Cambridge, MA: Harvard University Press, 1970.

Wittmann, Otto, *Art Values in a Changing Society,* Toledo: Toledo Museum of Art, 1974.

Youmans, Joyce M., "African Art at the Nelson-Atkins Museum of Art," *African Arts,* 33, 2001.

Youtz, Philip, "Museumitis," *Journal of Adult Education,* 6, 1934.

Youtz, Philip, "Museums Among Public Services," *Museum News,* 11, September 15, 1933.

Youtz, Philip. "The Sixty-Ninth Street Branch Museum of the Pennsylvania Museum of Art," *Museum News,* 10, December 15, 1932.

Zeller, Terry, "The Historical and Philosophical Foundations of Art Museum Education," in N. Berry and S. Mayer, eds., *Museum Education: History, Theory, and Practice,* Reston, VA: Art Education Association, 1989.

Zolberg, Vera L., "American Art Museums: Sanctuary or Free-For-All?," *Social Forces,* 63, 1984.

Zolberg, Vera L., "Barrier or Leveler? The Case of the Art Museum," in M. Lamont and M. Fournier, eds., *Cultivating Differences: Symbolic Boundaries and the Making of Inequality,* Chicago and London: University of Chicago Press, 1992.

Zolberg, Vera L., "Tensions of Mission in American Art Museums," in Paul DiMaggio, ed., *Nonprofit Enterprise in the Arts,* Oxford and New York: Oxford University Press, 1986.

Index